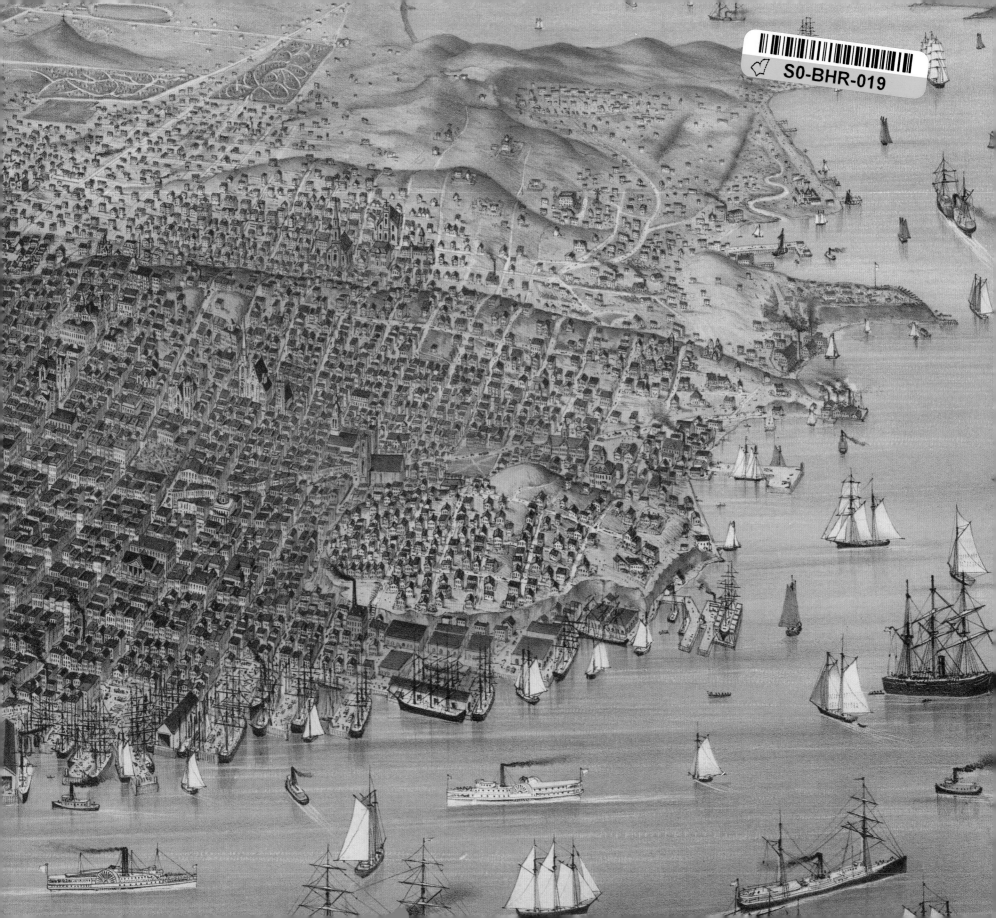

LOST SAN FRANCISCO

We would like to dedicate this book to the memory of Bay Area visionary Richard Tuck who left a legacy to a very special part of Lost San Francisco: Playland at the Beach.

We would like to especially thank Jeff Thomas at the San Francisco Public Library for his help with the library's photo collection.

Bibliography

Books
William Bronson, *The Earth Shook Sky Burned: A Photographic Record of the 1906 San Francisco Earthquake and Fire* (1996)
Rand Richards, *Historic Walks in San Francisco: 18 Trails Through the City's Past* (2001)
James R. Smith, *San Francisco's Lost Landmarks* (2004)

Web sites
National Archives, San Francisco Earthquake, 1906 (www.archives.gov/legislative/features/sf/)
The Virtual Museum of the City of San Francisco (www.sfmuseum.org)
San Francisco Public Library (www.sfpl.org)
Cliff House Project (www.cliffhouseproject.com)
Herbert Fleishhacker article, Time Magazine (www.time.com/time/magazine/article/0,9171,788910,00.html)
Hunters Point Community (www.hunterspointcommunity.com/history/)
University of California Lick Obervatory (http://mthamilton.ucolick.org/)
John W. Blackett, San Francisco's Cemeteries (www.sanfranciscocemeteries.com/)
Letterman Army Medical Center, California State Military Museum (www.militarymuseum.org/LettermanAMC.html)
San Francisco Cable Car Museum (www.cablecarmuseum.org)
San Francisco's Fox Theater (www.historigraphics.com/fox/)
San Francisco History, Wharves and Buried Ships (www.sfgenealogy.com/sf/history/hgshp4.htm)

First published in the United Kingdom in 2011 by
PAVILION BOOKS
10 Southcombe Street, London W14 0RA
An imprint of Anova Books Company Ltd

© Anova Books, 2011

ISBN: 978-1-86205-934-4

A CIP catalogue record for this book is available from the British Library.

10 9 8 7 6 5 4 3 2

Repro by Rival Colour Ltd, UK
Printed by 1010 Printing International Ltd, China

www.anovabooks.com

LOST SAN FRANCISCO

Dennis Evanosky and Eric J. Kos

PAVILION

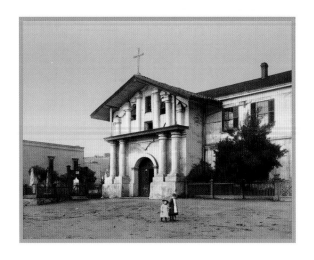
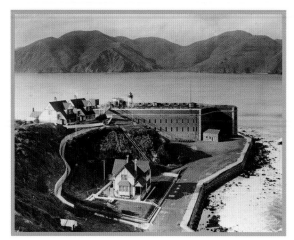
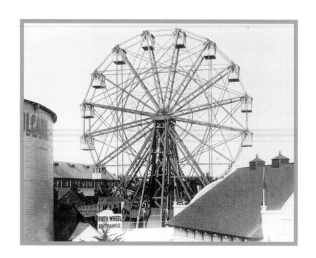
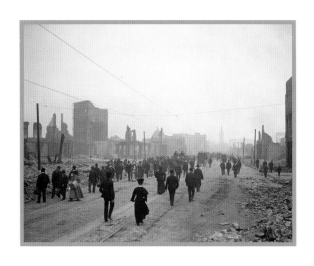

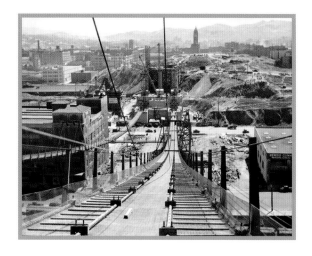
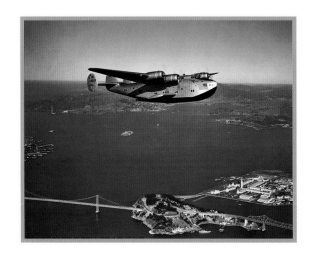
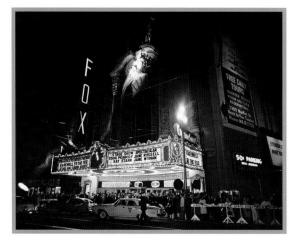

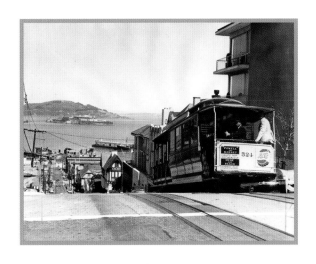

LOST IN THE...

Mission Dolores SECULARIZED 1834

Father Pedro Font described the day he discovered the site for Mission Dolores in his diary from 1776. "We rode about one league to the east (from the Presidio) going over hills covered with bushes, and over valleys of good land. We thus came upon two lagoons and several springs of good water, meanwhile encountering much grass, fennel and other good herbs. When we arrived at a lovely creek, which because it was the Friday of Sorrows (the Friday before Palm Sunday), we called the creek 'Arroyo de los Dolores.' On the banks of the arroyo we discovered many fragrant chamomiles and other herbs, and many wild violets. Near the streamlet, the lieutenant planted a little corn and some garbanzos in order to try out the soil, which to us appeared good."

Lieutenant Moraga and Captain Quiros of the ship *San Carlos* sent men from the Presidio to build the mission. Father Pedro Font's fellow missionary, Father Palou, later recalled that the mission measured 10 varas (28 feet) long and five varas (14 feet) wide. Workers plastered the wooden structure with clay and made a roof with reeds called "tule." They also built a church, which measured 18 varas (50 feet) in length. "Adjoining it, in the rear of the altar, was a small room which served as a vestry," Father Palou wrote. When the mission, church and vestry were complete "all the Spanish from the ship entered the church and sang the 'Te Deum

Laudamus.' The ringing of bells, the salvos of cannon, pistols and muskets punctuated the moment." First called "Misión San Francisco de Asís," locals later referred to the place as "Mission Dolores," for the Arroyo de los Dolores. All this was lost to us in 1834, when the Governor of Alta California Province, General José Figueroa, enforced Mexico's new Secularization Laws with a decision to disband all the California missions and sell their lands. An administrator, who valued "Mission Dolores" at $67,227.60, turned the mission into a parish church and left only a small plot of land to the new entity. By 1842, only eight Indian Christians remained.

Three years later, the last Franciscan, Fray José Real, left for Santa Clara and the following year the United States claimed the land. In 1849, gamblers bet on horse races where the mission once stood. On March 3, 1851, the American government confirmed that the former mission owned just four acres of its once vast holdings. In 1876, another church was built next to the old Mission Dolores. This Gothic Revival structure was destroyed by the 1906 earthquake and a new church, now known as the Mission Dolores Basilica, was built between 1913 and 1918. The older adobe church from the lost mission, which retains the name "Mission Dolores," was restored at the same time. The cemetery is the only one within city limits today.

RIGHT *The two-story seminary and rectory adjoining the church (far right) help to date this photo. These additions were torn down in 1876.*

BELOW LEFT *The Mission fell into disrepair after the Franciscans abandoned the site in 1834. Shown here circa 1865, part of the structure was converted to a two-story wooden wing for use as a seminary and priests' quarters, while another section (far right) became the "Mansion House," a popular tavern and way station for travelers.*

BELOW CENTER *By 1876, the seminary, rectory and mansion house had been razed and replaced with a large Gothic Revival brick church. The cemetery, the only one remaining today within the city limits, is visible to the left.*

BELOW RIGHT *The Mission as it looked in 1936.*

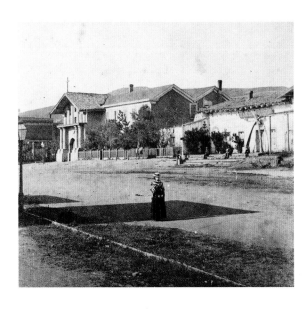

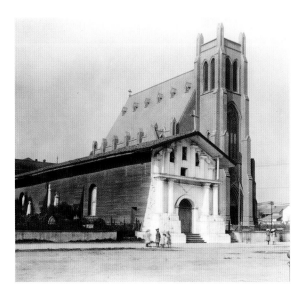

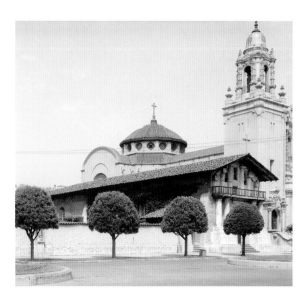

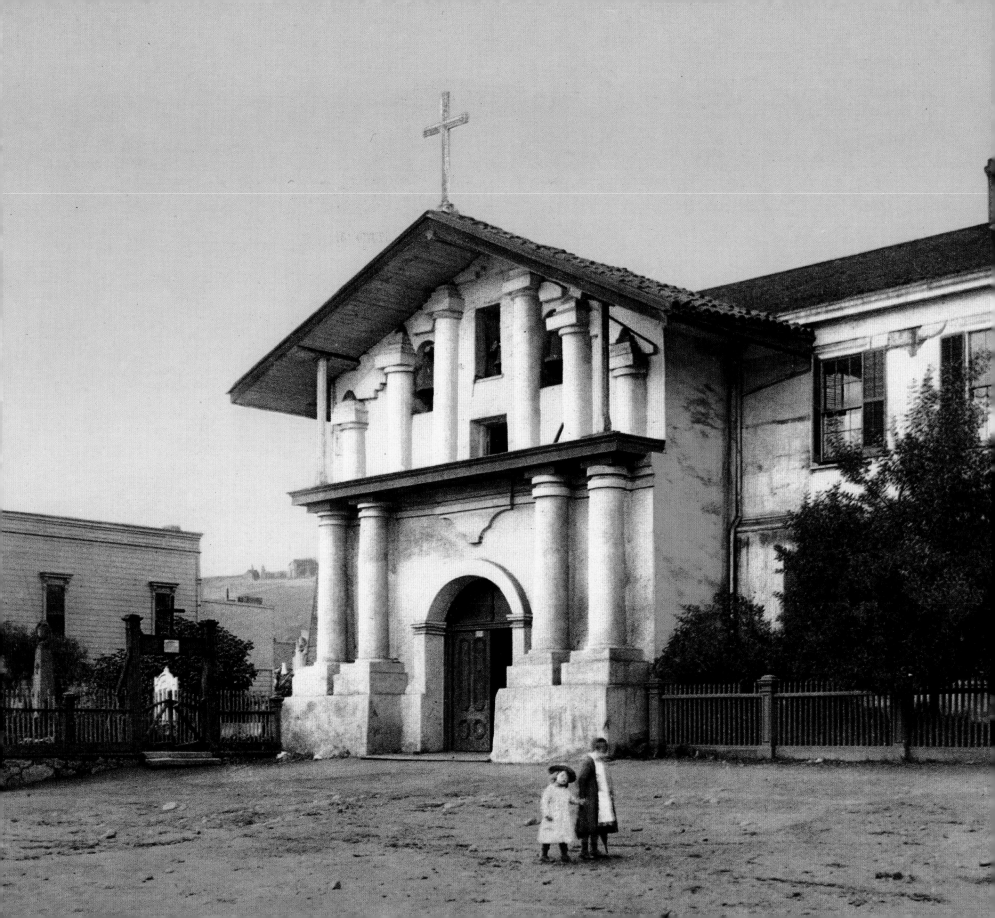

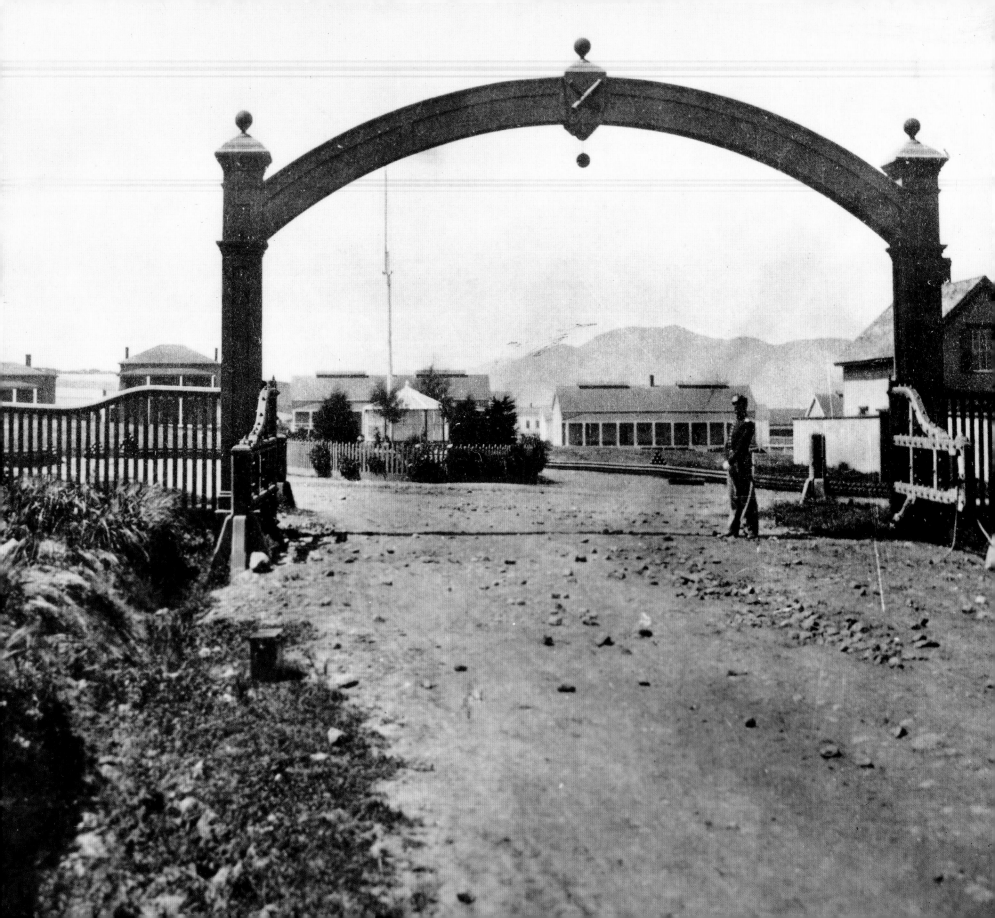

The Presidio

The 1834 Secularization Law that spelled the end of Mission Dolores (see page 6) also sounded the death knell for San Francisco's Presidio (Spanish for "fort") that was founded in 1776 along with the mission. On October 23, 1775, Juan Bautista de Anza left Sonora, Mexico, with a party that included Franciscan Padre Pedro Font and 193 colonists and soldiers. They arrived in what would become San Francisco on June 27, 1776, and established a presidio at the entrance to the bay that the Spanish ship *San Carlos* had entered the previous August. This new presidio was part of a network of presidios, missions and pueblos that extended south into Mexico.

In 1792, Captain George Vancouver of the British Frigate HMS *Discovery* visited the Presidio and reported it poorly supplied and fortified. The following year, the Spanish reacted to Vancouver's report by ordering the construction of two additional forts. The first was the Castillo de San Joaquin (above what is now Fort Point) on La Punta de Cantil Blanco (the Point of the White Bluffs), which was leveled to build Fort Point. In 1794 the Spanish built the second fort, the Bateria de Yerba Buena (at present-day Fort Mason). The Spanish

armed these new bastions with bronze cannons cast in Lima, Peru, and delivered here aboard the Spanish royal frigate *Aranzazu*. Six of these guns remain at the Presidio today, as the city's oldest artifacts. An earthquake in 1808, along with its aftershocks, wreaked havoc at the Presidio. On July 18, 1808, Captain Luis Argüello Captain of the Presidio wrote to Governor Arrillaga, "I have to report to your Excellency that since the 21st of June last to the present date, twenty-one shocks of earthquakes have been felt in this Presidio."

Argüello told the governor that some of these shocks were so severe that "all the walls of my house have been cracked, owing to the bad construction of the same, one of the ante-chambers being destroyed; and if up to this time no greater damage being done, it has been for the want of materials to destroy, there being no other habitations." He reported that the Castillo de San Joaquin had been threatened with ruin, and he feared if these shocks continued, "some unfortunate accident will happen to the troops at the Presidio." Neither the Castillo nor the Bateria survived until 1834 when General Mariano Guadalupe Vallejo ordered the entire army garrison stationed on the Presidio to abandon the site and moved some 45 miles north to Sonoma.

In 1835, U.S. President Andrew Jackson offered the Mexican government $5 million for the entire Bay Area, an offer the Mexicans turned down.

On July 9, 1846, John C. Fremont, "The Pathfinder" took over the Presidio without firing a shot. In 1848, due to desertions, U.S. troops at the Presidio stood at thirteen men with three officers commanding them. The Presidio survived until the U.S. Government decommissioned the military activities there in 1989. The property transferred to the National Park Service in 1994. At the time of its closure, the Presidio was the oldest continuously operating military post in the United States.

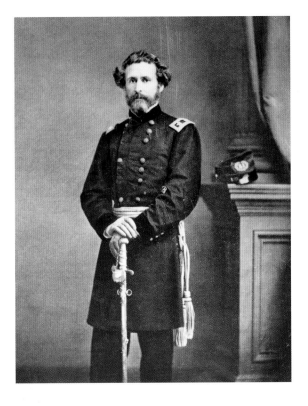

OPPOSITE PAGE *A lone soldier stands guard at the Presidio's main gate in this photo from 1869.*

FAR LEFT *The Buffalo Soldiers of the Ninth Cavalry camped in Sibley tents on the Presidio before departing for China in 1900 to help quell the Boxer Rebellion.*

LEFT *The Presidio serves as the foreground in this sweeping 1898 view of the Golden Gate and Marin County. Eight years later the Presidio would host many more tents for refugees from the San Francisco earthquake.*

ABOVE *Pathfinder and Union General John C. Fremont photographed by Matthew Brady.*

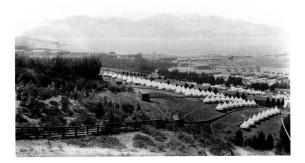

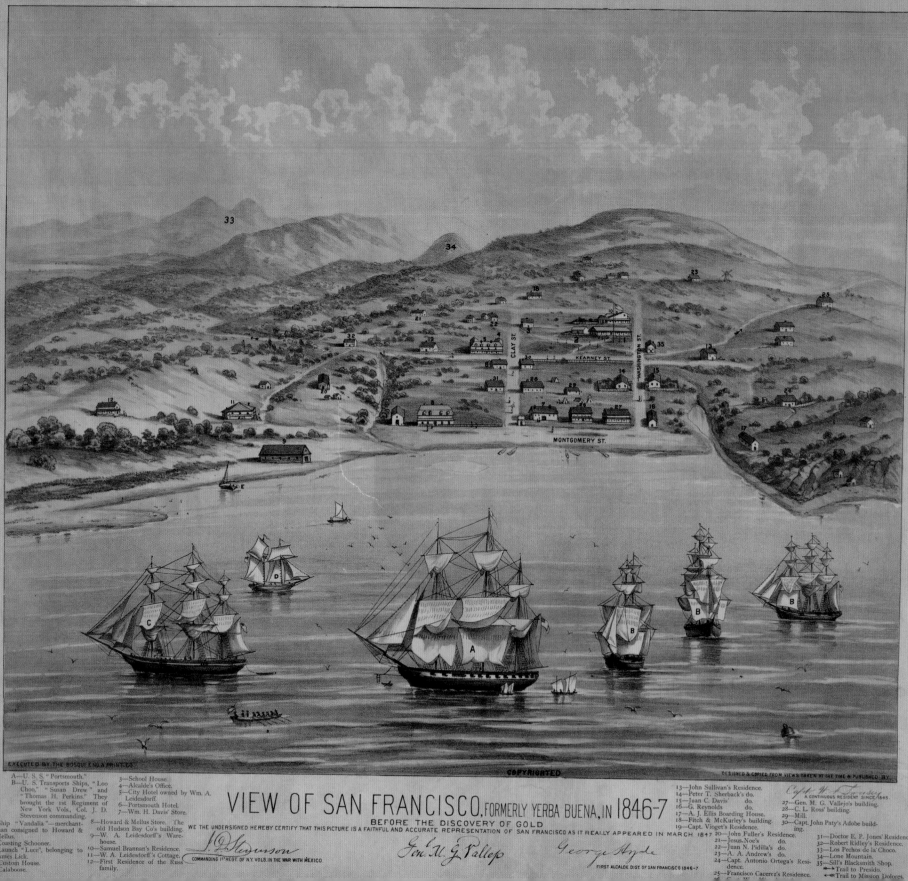

EXECUTED BY THE BOSQUI ENG.& PRINT.CO.

COPYRIGHTED

DESIGNED & COPIED FROM VIEWS TAKEN AT THE TIME & PUBLISHED BY

VIEW OF SAN FRANCISCO, FORMERLY YERBA BUENA, IN 1846-7
BEFORE THE DISCOVERY OF GOLD
WE THE UNDERSIGNED HEREBY CERTIFY THAT THIS PICTURE IS A FAITHFUL AND ACCURATE REPRESENTATION OF SAN FRANCISCO AS IT REALLY APPEARED IN MARCH 1847

A—U. S. S. "Portsmouth."
B—U. S. Transports Ships, "Loo Choo," "Susan Drew" and "Thomas H. Perkins." They brought the 1st Regiment of New York Vols., Col. J. D. Stevenson commanding.
C—Ship "Vandalia"—merchantman consigned to Howard & Mellus.
D—Coasting Schooner.
E—Launch "Luce", belonging to James Lick.
1—Custom House.
2—Calaboose.

3—School House.
4—Alcalde's Office.
5—City Hotel owned by Wm. A. Leidesdorff.
6—Portsmouth Hotel.
7—Wm. H. Davis' Store.
8—Howard & Mellus Store. The old Hudson Bay Co's building.
9—W. A. Leidesdorff's Warehouse.
10—Samuel Brannan's Residence.
11—W. A. Leidesdorff's Cottage.
12—First Residence of the Russ family.

13—John Sullivan's Residence.
14—Peter T. Sherback's do.
15—Juan C. Davis' do.
17—A. J. Ellis Boarding House.
18—Fitch & McKurley's building.
19—Capt. Vioget's Residence.
20—John Fuller's Residence.
21—Jesus. Noe's do.
22—Juan N. Pidilla's do.
23—A. A. Andrew's do.
24—Capt. Antonio Ortega's Residence.
25—Francisco Cacerez's Residence.

Capt. W. Fraser
A CONTINUOUS RESIDENT SINCE 1845.
27—Gen. M. G. Vallejo's building.
28—C. L. Ross' building.
29—Mill.
30—Capt. John Paty's Adobe building.
31—Doctor E. P. Jones' Residence.
32—Robert Ridley's Residence.
33—Los Pechos de la Choco.
34—Lone Mountain.
35—Sill's Blacksmith Shop.
→ Trail to Presidio.
← Trail to Mission Dolores.

J. D. Stevenson
COMMANDING 1ST REGT. OF N.Y. VOLS. IN THE WAR WITH MEXICO.

Gen'l M. G. Vallejo

George Hyde
FIRST ALCALDE DIST. OF SAN FRANCISCO 1846-7

Yerba Buena Cove FILLED IN BY 1860

Clinopodium douglasii, a trailing perennial evergreen herb with small white flowers, gave San Francisco its first name, "Yerba Buena." The name is an alternate form of the Spanish *hierba buena*, which means "good herb." Nineteenth-century settlers bestowed this, the plant's most common name, on the place they called home; a place that became San Francisco in 1847.

Settlers also named the cove just off their settlement "Yerba Buena." This cove had only a half mile of shoreline embraced by Punta del Rincon (Point of the Corner) to the south and what became Punta del Embarcadero (Point of Embarkation) to the north. Punta del Embarcadero was the only safe place a small boat was able to land when the tide ebbed. Here, the shoulders of a high hill that the settlers dubbed "Loma Alta" (High Hill), today's Telegraph Hill, met the water. The cove itself was shallow; ebb tide revealed about a quarter mile of mud flats. The cove's water deepened to some 180 feet then to about 90 feet out to an island about a mile away, which the Spanish called Alcatraz and the British renamed Yerba Buena. Punta del Embarcadero was later named Clark's Point for William S. Clark who built a wharf and warehouse there; Punta del Rincon retains the name Rincon Point.

The cove's sandy bottom allowed boats to land at the beach. From north to south, the cove formed an arch with a shoreline that began roughly where Battery Street meets Broadway. It angled southwest to Sansome and Pacific streets. At Montgomery and Jackson a saltwater lagoon, the Laguna Salada, caused a bulge in the shoreline.

William Sturgis Hinckley built a bridge here in 1844, the city's first. Once over Sturgis's bridge, the shoreline ran just west of Montgomery Street, crossing Washington and Clay streets to Sacramento Street. William Eddy's "Official Map of San Francisco" from 1849 shows Portsmouth Square, the nineteenth-century city center just to the south. In 1849, a walk along the shoreline would then take the ambler southeast to today's First and Market streets.

Waves lapped the shore at what later became the intersection of Fremont and Howard streets. The shoreline then angled to today's Folsom and Beale streets where it turned southeast to meet Rincon Point.

The discovery of gold in the Sierra Nevada in 1848 attracted ships full of anxious miners. From December 1848 to February 1849, some 136 vessels cleared Atlantic ports, en route to San Francisco. The rest of 1849 saw the arrival of 775 ships that carried gold-seekers from all over the world, many of them abandoned in Yerba Buena Cove. Some of these were later entombed in the cove.

By 1850 a substantial arrangement of wharves projected across the shallow waters of the cove. The wharves and the businesses built upon them served a burgeoning maritime trade. By 1860 the entire cove, which acted as a refuge for the boats and ships that served the small village of Yerba Buena, had been filled in.

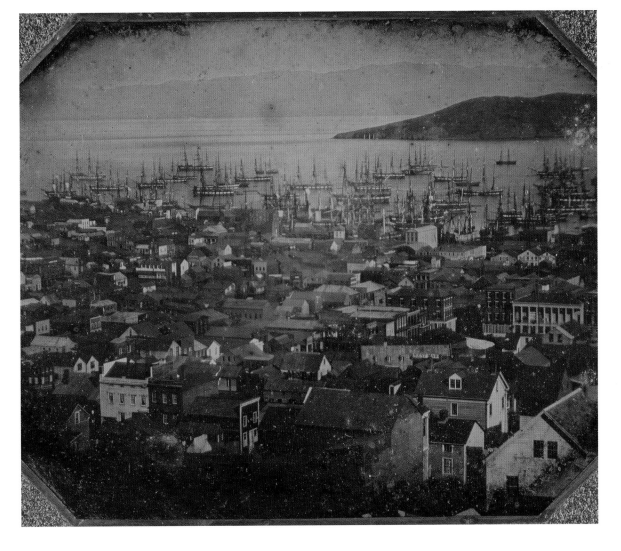

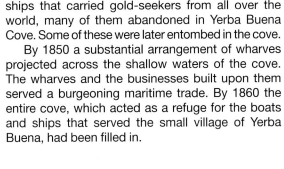

OPPOSITE PAGE *This drawing shows Yerba Buena before the Gold Rush in 1847. The large ship (marked "A") is the USS* Portsmouth. *The building with the American flag (marked "1") is the Custom House.*

LEFT *After the Gold Rush, Yerba Buena Cove became a graveyard for ships that brought people to the gold fields, as this 1851 photograph attests. The town of San Francisco grew considerably during this period.*

Telegraph Hill SEMAPHORE REMOVED 1862

Early settlers had a simple name for the steep hill that descended onto Punta del Embarcadero. They just called it "Loma Alta" (High Hill). Apolinario and Juana Briones de Miranda arrived on the slopes of Loma Alta in 1832 and raised cattle for the hide-and-tallow trade on its slopes. Juana was born in 1802 in Santa Cruz, California.

Her maternal grandparents and mother arrived in California in 1776 as members of the de Anza expedition. Juana grew up on the Presidio. In 1820 she married a soldier, Apolinario, who was stationed on the Presidio as a soldier. The couple had nine children; their brood included a Native American child whom the couple adopted.

When Apolinario retired, in 1832, the family moved to the foot of Loma Alta. Fourteen years later on July 9, 1846, Captain John B. Montgomery's USS *Portsmouth* sailed into San Francisco Bay.

On July 11, Montgomery ordered a fort to be constructed "on the hill off the point of Yerba Buena."

Adobe bricks were hauled up Loma Alta's north slope to build "Fort Montgomery," more popularly known as "The Battery." No shot was ever fired from the fort, which fell into disuse. Battery Street owes its name to this forgotten structure.

The Gold Rush brought new settlers who called the hill "Goat Hill" and "Prospect Hill." The hill offered a direct view of the Golden Gate and advanced notice of approaching ships, valuable information at the time. In 1850 business owners erected a semaphore on the crest of Prospect Hill that communicated with a similar facility at Punta de los Lobos, today's Land's End.

These enterprising men posted crews atop Prospect Hill to relay information provided by observers at Punta de los Lobos. Using semaphore signals, crewmen would "telegraph" the name of an approaching ship and its likely cargo to anxious subscribers in the city below.

The crews atop the hill also had their eyes on the Golden Gate. As vessels made their way into San Francisco Bay, a lookout arranged the two arms of the semaphore to indicate the type of craft approaching. The arrangement of the arms could also indicate whether the vessel was friend or foe, or in distress. A special arrangement of the semaphore's arms generated a lot of excitement in the streets below, as it signaled the arrival of the Pacific Mail Steamer with long-awaited mail from the East Coast. The advance information the semaphore provided allowed business owners a distinct advantage over their competition.

Those in the know would have opportunity to buy or sell certain commodities prior to the ship's arrival in port. The presence of the semaphore atop the mount gave the hill a new name: Telegraph Hill. Ironically, it was the arrival of the telegraph in 1862 that spelled the end of the use of semaphore signals from Telegraph Hill.

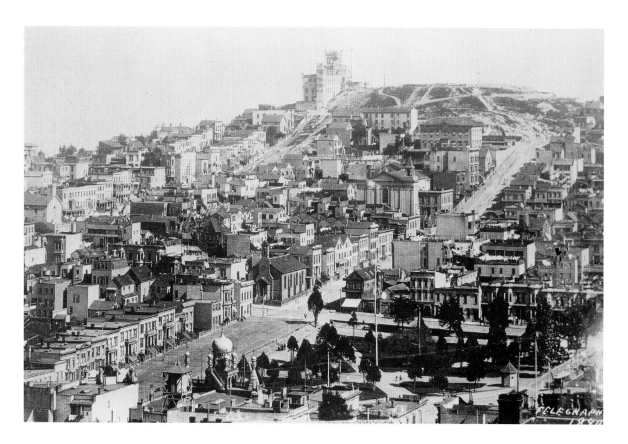

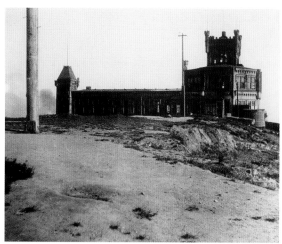

RIGHT *A crowd gathers on Telegraph Hill on April 23, 1899, to watch the arrival of the troop ship* Sherman. *The city learned of the ship's arrival from the Philippines by way of the first ship-to-shore wireless message in U.S. history from Lightship No. 70 to a coastal receiving station at the Cliff House.*

LEFT *Telegraph Hill in 1890.*

ABOVE *An 1890s photograph of the "Old German Castle" on Telegraph Hill. This entertainment pavilion and observatory burned down in 1903.*

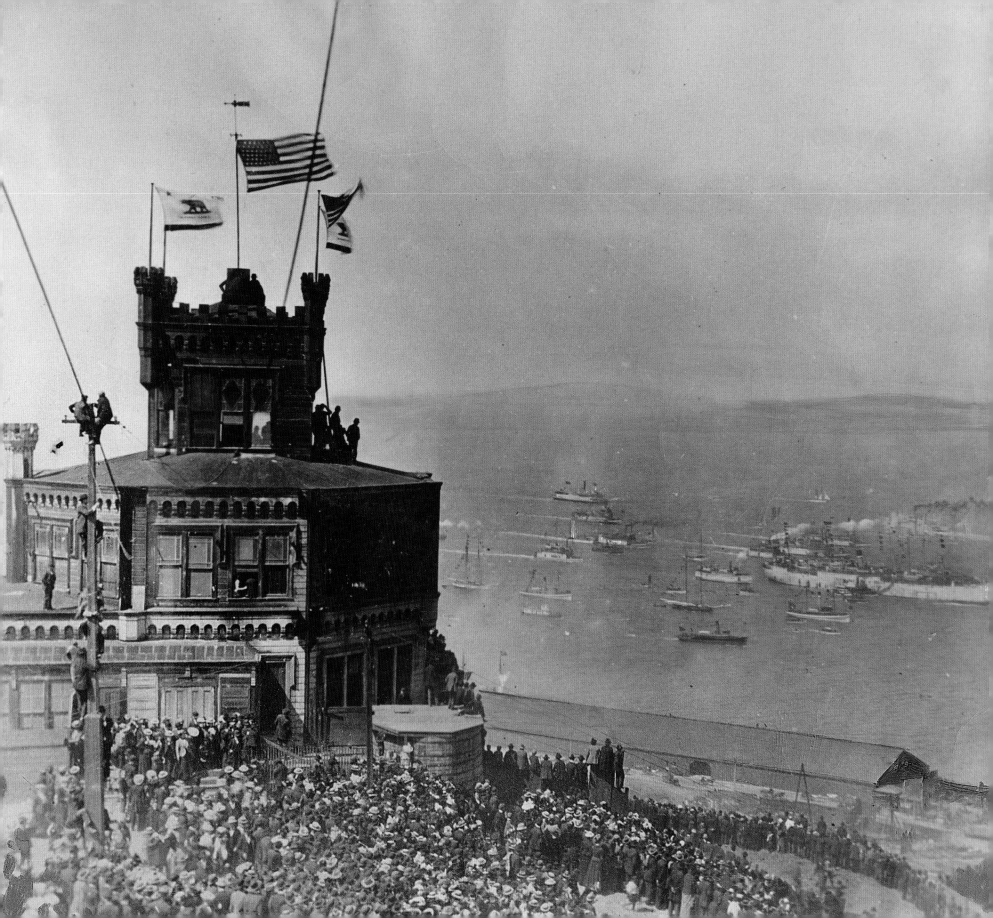

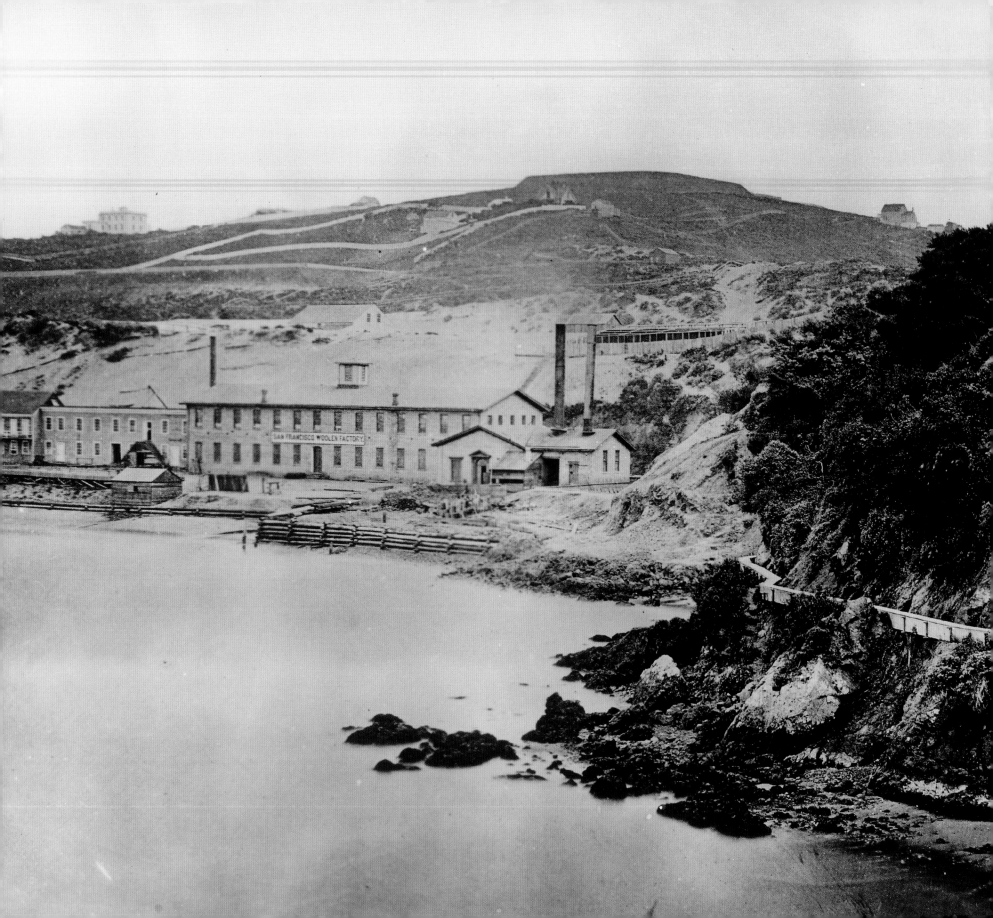

Point San Jose and Black Point

COMMANDEERED 1863

In the 1850s the federal government designated Point San Jose, located on today's Fort Mason, as a government reserve. In 1863, the army decided it needed the land for a fort to serve as a back up for the one they planned to build on Alcatraz. There was a problem, however. Squatters had moved in and these were not the usual riffraff, but well-connected members of society. Citizens had erected large, well-built homes on Point San Jose, which most called "Black Point."

The well-to-do had built homes and even paid taxes to the city. No less a personage than "the Pathfinder," John Charles Fremont, had lived in a frame cottage on 12 acres on the Point. Leonidas Haskell, who developed Black Point, owned a home that became a shrine of sorts: it was there that Senator David Broderick had breathed his last after David Terry shot him in a duel.

Many Black Point residents are familiar with the events that took place in 1853 when the government ordered Captain E. D. Keyes to roust squatters from Rincon Point. When the Rincon Point squatters were told they would have to go, they sued. The judge dismissed their suit but one of the jurors told Keyes how lucky he was; the jury was set to find him guilty for rousting the underdogs. Little had changed in 10 years. The Army had little interest in evicting the squatters. "Combinations of land-grabbers and land-jumpers so harassed this officer [Keyes] that he wrote in despair that he could not protect the government property," General Irvin McDowell told his superiors. "They have seized on Point San Jose and have it in complete possession."

The military value of the Point was established by 1797 when the Spanish built Bateria San Jose (the "Battery at Yerba Buena") at the tip of the Point. The sand hills and their scrub brush gradually reclaimed the area. By the time that Mexico took over San Francisco, in 1822, the site became known as Black Point, due to the dark underbrush that covered everything.

An 1856 report suggested that the U.S. Army build a permanent 20-gun battery at Point San Jose. The report said that the army should construct a "barbette with earthen parapet, breast height of bricks, a small magazine and a brick building for ordnance stores and a guardhouse." At 6 a.m. on October 3, 1863, General George Wright received a telegram instructing him to build the battery. Wright ordered the 9th Infantry to the point to "take and hold military possession of such land as necessary for the erection of batteries." Almost immediately the squatters lodged complaints that the soldiers had destroyed some shrubbery.

The soldiers did more than that, however. They commandeered houses and removed those in the way of the engineers' plans. They razed Fremont's cottage and touched off a series of legal disputes that went to the United States Supreme Court, which determined that the property belonged to the United States "whether or not they were by sufficient authority appropriate for public use."

OPPOSITE PAGE *The Pioneer Woolen Mills as seen from Black Point in 1864. The Ghirardelli Chocolate Works (on Ghirardelli Square) occupies the woolen mills site today.*

BELOW *This 1870 Lawrence & Houseworth photograph shows how quickly the area around Black Point developed.*

RIGHT *David Broderick photographed between 1855 and 1859. After his death an obelisk was raised to the Senator in Lone Mountain Cemetery. It was renamed Laurel Hill Cemetery in 1867 but subsequently razed.*

SENATOR DAVID BRODERICK

David C. Broderick was born in Washington, D.C. on February 4, 1820. His father worked as a stonemason on the U.S. Capitol Building. When Broderick was three, his family moved to New York City, where he attended school and apprenticed as a stonecutter. In 1846, he ran unsuccessfully in New York for a seat in the U.S. House of Representatives. Three years later he was in California. He set up shop smelting gold coins and used his profits to pursue a political career. He served in the California senate in 1850. He became a U.S. Senator in 1857. Broderick called Judge David Terry "a damned miserable wretch," and Terry challenged Broderick to a duel. The pair met near Lake Merced on September 13, 1859. Terry mortally wounded Broderick. Friends brought Broderick to the home of Leonides Haskell on Black Point. The wounded man lingered for three days and died on September 16, 1859; the only sitting U.S. senator ever killed in a duel.

Fort Point STOOD DOWN 1865

Spain realized the strategic importance of the hills above the Golden Gate. In 1776 they created their presidio there. For further protection from sea-bound intruders, the Spanish fortified the high white cliff that they called La Punta de Cantil Blanco in 1794, by building the Castillo de San Joaquin at the narrowest part of the bay's entrance. It was an adobe structure bristling with cannon.

When Mexico won its independence from Spain in 1821, it gained control of the region and the fort. In 1835 they secularized their holdings in Alta California and the army moved to Sonoma. The elements collapsed the Castillo's adobe wall. On July 1, 1846, after the Mexican-American War broke out, the United States—in the persons of Captain John Charles Fremont, Kit Carson and a band of ten followers—captured the empty Castillo and spiked its cannons.

The Americans defeated the Mexicans in 1848; two years later, California became the 27th state in the Union. By then the Gold Rush was on. The federal government recognized Northern California's commercial and strategic importance and recommended a series of fortifications to secure San Francisco Bay. The U.S. Army Corps of Engineers began work on Fort Point in 1853. Plans specified that the lowest tier of artillery be as close as possible to water level so cannonballs could ricochet across the water's surface to hit enemy ships. To achieve this, the 90-foot-high La Punta de Cantil Blanco was blasted down to 15 feet above sea level.

A crew of 200, many unemployed miners, labored for eight years on the fort, which boasted seven-foot-thick walls and multi-tiered casemated construction typical of Third System forts.

Engineers sited the fort to defend the maximum amount of harbor area. While there were more than thirty such forts on the East Coast, Fort Point was the only one on the West Coast. In 1854, Inspector General Joseph K. Mansfield declared Fort Point the "key to the whole Pacific Coast." In 1861 the Army mounted the fort's first cannon. Colonel Albert Sidney Johnston, commander of the Department of the Pacific, prepared the defenses and ordered in the first troops to the fort. Kentucky-born Johnston then resigned his commission to join the Confederate Army. Throughout the Civil War, artillerymen at Fort Point stood guard for an enemy that never came. In August 1865, the Confederate raider CSS *Shenandoah* planned to attack San Francisco, but on the way, the captain learned that the war was over.

Troops soon left Fort Point; the army never used it again. In 1869 a granite seawall was completed to protect the fort. In 1870, some of the fort's cannons were moved to Battery East on nearby bluffs, where they were more protected. In 1882 Fort Point was officially named Fort Winfield Scott after the famous hero from the war against Mexico. The name never caught on and was later applied to an artillery post at the Presidio. Today Fort Point lies tucked under the Golden Gate Bridge, which was designed in a way that would protect this landmark.

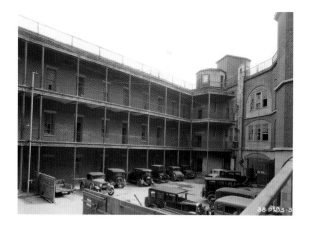

RIGHT *The Marin Headlands serve as backdrop to Fort Point, which still exists beneath the Golden Gate Bridge.*

LEFT *In the 1920s, long before the Golden Gate Bridge flew overhead, the fort was used for storage and at one stage a dormitory.*

BELOW LEFT *This view from the west shows the Golden Gate with Fort Point. The fort was built in 1853.*

BELOW *One of the cannons on display at Fort Point, which was built to protect the Golden Gate from an invasion that never came.*

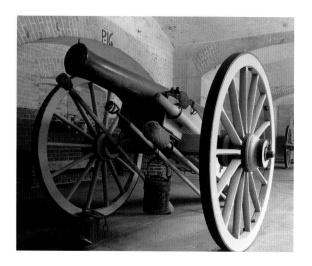

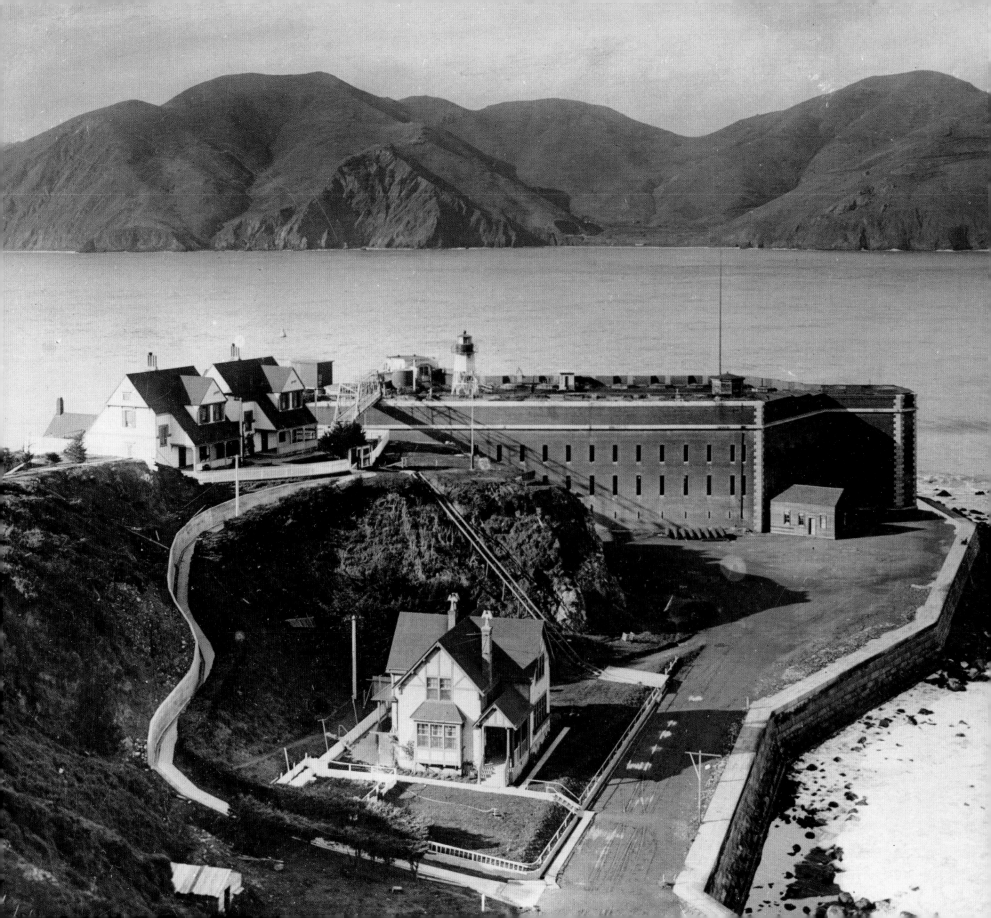

Woodward's Gardens

CLOSED DUE TO "ODORS AND HORRIBLE NOISES" 1891

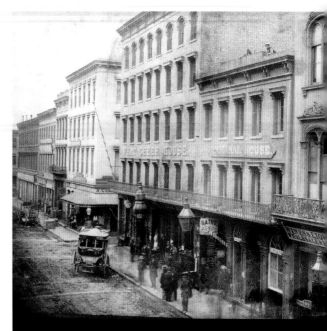

In 1865 the Woodward family opened the grounds that surrounded their home to the public as Woodward's Gardens Amusement Resort. Woodward established a horse-car line, the City Railroad Company, which took passengers along Mission Street, and ended conveniently at the front gate of Woodward's Gardens. The Woodward's collections and lavish grounds captivated San Franciscans, to the extent that they were considered to offer the most comprehensive zoo on the West Coast. Animals such as ostriches, deer and flamingos roamed the gardens, while visitors peered at caged animals that included monkeys, wolves, bears, lions and camels.

Woodward also displayed hundreds of stuffed animals and "animal curiosities," like a five-legged dog and a two-headed calf. The gardens housed four museums and an art gallery with hundreds of paintings, crystals, precious stones, petrified fossils and an insect display. Visitors enjoyed boat rides, an aquarium, hot-air balloon rides, plus a merry-go-round and an oversized roller-skating rink for the youngsters. Woodward charged an admission fee of 25 cents for adults and 10 cents for children. To make things more convenient for visitors, Woodward had a tunnel built under 14th Street, allowing people to walk from one block to the other without having to cross an outside street.

The family later moved to "Oak Knoll," a farm in Napa County, but Woodward continued to run Woodward's Gardens. Woodward died in 1879 and the grounds fell into disrepair. It survived for twelve more years. However, following neighbors' protests about "odors and horrible noises," Woodward's Gardens finally closed in 1891.

OPPOSITE PAGE *Woodward's Gardens was all the rage in the late nineteenth century, with crowds often lining up to get in. Today, only a landmark plaque placed on December 6, 1949, reminds passers-by of the long-disappeared Woodward's Gardens.*

ABOVE RIGHT *The "Rotary Boat" attraction in Woodward's Gardens, photographed on May Day 1887.*

RIGHT *Woodward's Gardens camel rides predated those given at the Midwinter Fair by some twenty years or so.*

Two years later the family held an auction, with Adolph Sutro walking away with "stuffed beasts and birds, relics of the past, curios, bric-a-brac, etc." He purchased the benches, the pipe organ and several statues for his estate above the Cliff House. The Woodward family split up the land into thirty-nine parcels and auctioned it all off.

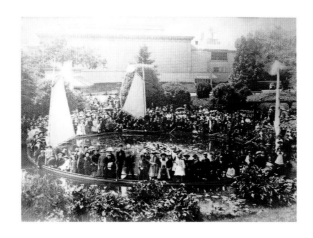

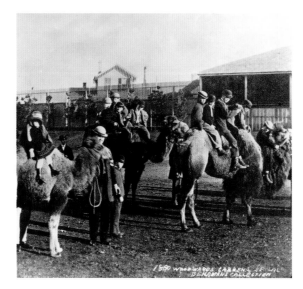

ROBERT BLUM WOODWARD

R. B. Woodward was the proprietor of a successful hotel, the What Cheer House (pictured above), on the southwest corner of Sacramento and Liedesdorff streets. In 1849, he sailed from Providence, Rhode Island, aboard the schooner *Naumkeag* with a stock of building materials and $1,000 worth of groceries and provisions. The schooner sailed around Cape Horn and arrived in San Francisco on November 19, 1849. Woodward established himself in Gold Rush San Francisco with a grocery store, a hotel and a restaurant. In 1852 he opened the What Cheer House. By 1857 the men-only hotel proved such a success that Woodward sent for his family.

Until 1861 he lived with his wife, Mary, and their four children on fashionable Rincon Hill, but decided that life there had gotten too crowded. The family purchased John Charles Fremont's estate in today's Mission District, bordered by Mission, Valencia, 13th and 50th streets. (The Central Freeway obliterated 13th Street.) Woodward Street, located in the confines of the former estate, was named in memory of this illustrious man.

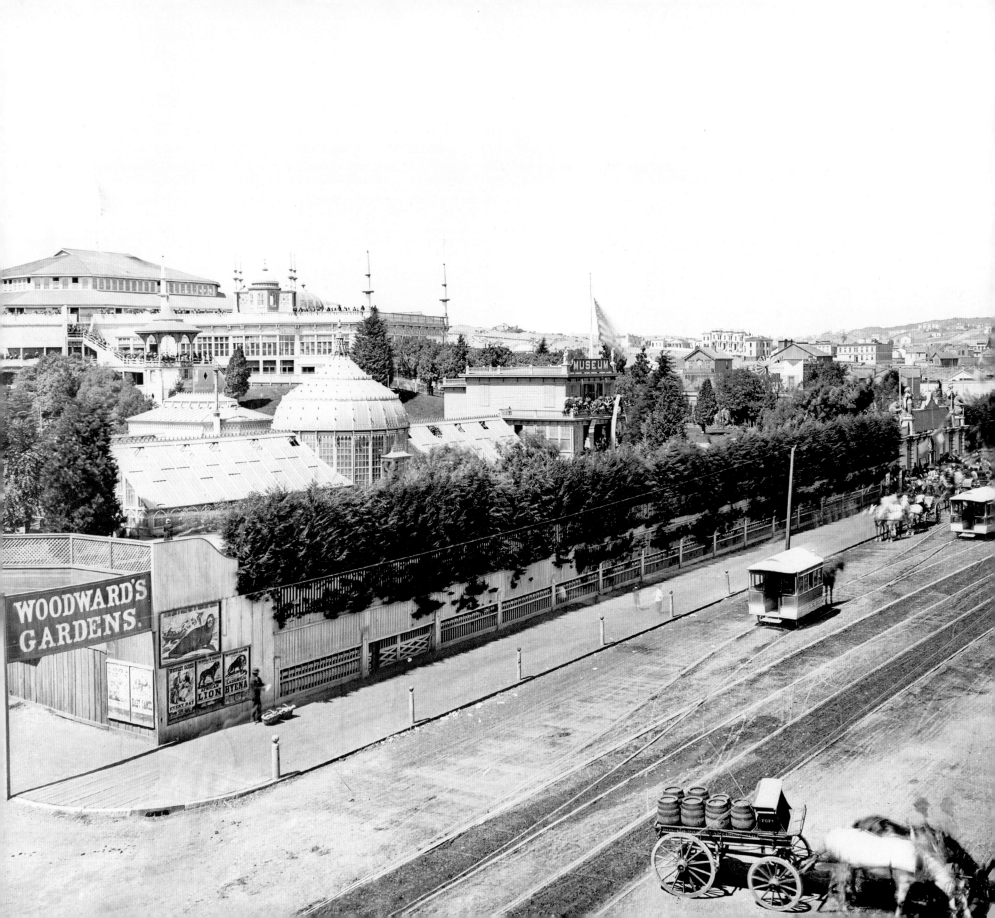

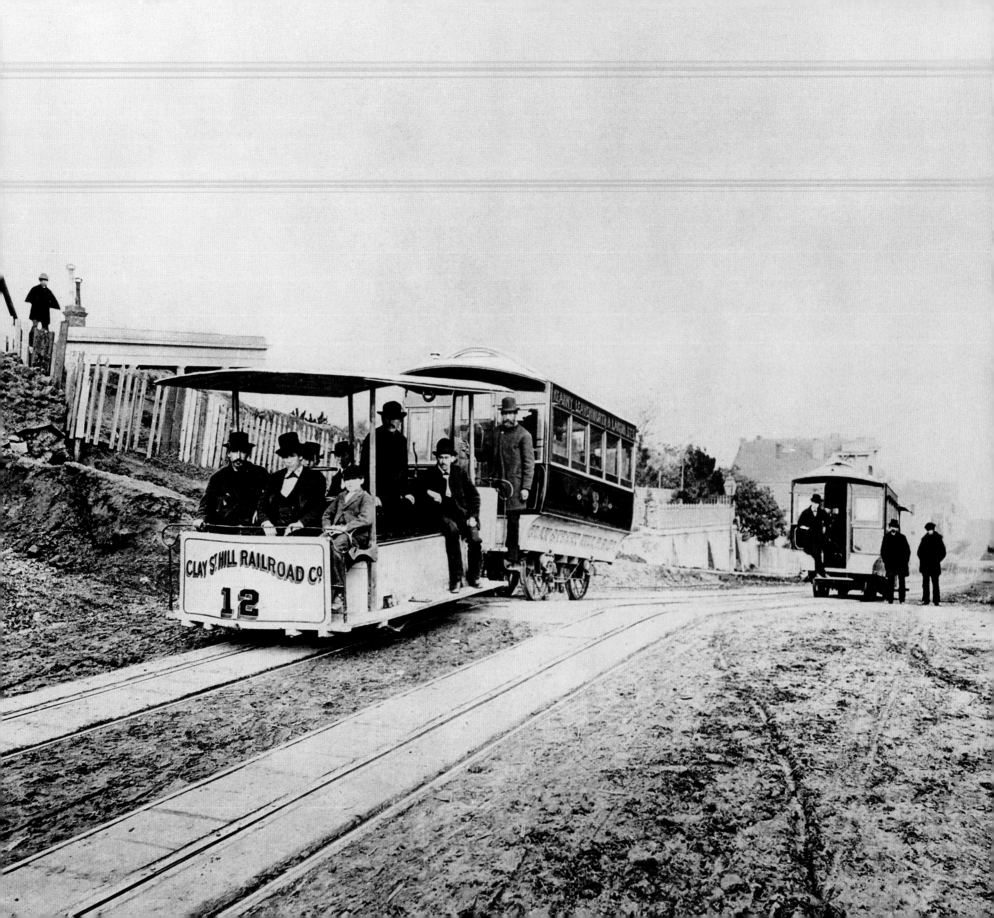

Clay Street Line CLOSED 1891

The Clay Street Hill Railroad, the world's first cable car line, had its maiden trip up Clay Street to Jones Street on August 2, 1873, with inventor, London-born Andrew S. Hallidie handling the grip. Some accounts say that the first gripman Hallidie hired took one look down the steep Clay Street hill and refused to operate the car, so Hallidie took the grip himself. Hallidie first surveyed California Street for his line, but decided not only would it be cheaper to build on Clay Street, but Clay Street also came closer to the peak of Nob Hill.

On September 1, 1873, the line began carrying paying passengers on its cable trains—each train consisted of a grip car, also called a dummy, and a trailer. The line began at Kearny Street and took its customers up a 16 percent grade to Leavenworth Street, the site of the system's powerhouse—a two-story affair with the engine room and boilers in the basement, car storage on the first floor and a car-repair and paint shop on the top floor. Hallidie placed the winding machinery in a vault some fifteen feet below the sidewalk. Inside that vault the cable passed through pulleys and sheaves to maintain tension on the line.

Outside the powerhouse, more sheaves moved the cable into a conduit with cast iron yokes. The cable ran under Clay Street through a 22 x 16-inch wooden tube with a three-quarter-inch slot that allowed the grip car to attach to the cable. The grip was a large hollow screw that the grip man raised and lowered into the tube with a hand wheel. An upper wheel and lower wheel brought the grip in contact with the cable and moved the car along the line. The gripman employed a series of shoe and pedal brakes to stop the car and an iron drag pole to prevent slipping on grades. The car had a crude emergency brake as a last resort. Four years after it began operations, the company extended the line to Van Ness Avenue.

The California Street Railroad built a competing line on California Street, which opened on April 10, 1878, and carried paying passengers from Kearny Street to Fillmore Street. In 1888 the Ferries & Cliff House Railway purchased the Clay Street Hill Railroad. On September 30, 1888, the Ferries & Cliff House Railway opened a new line known both as Ferries & Cliff House line and the Sacramento line. The Clay Street Line was discontinued on September 9, 1891 when streetcars began running one block over on Sacramento Street.

The September 12, 1891, edition of *The San Francisco News Letter* described the end of the Clay Street Hill Railroad: "The last car on the old line left Powell and Clay streets at 11:30 o'clock on Wednesday night with a number of railway officials and a few of the old-timers who had worked on the road for a number of years. At Van Ness Avenue, Assistant Superintendent Skinner broke a bottle of champagne over the grip, and the line ceased to be."

OPPOSITE PAGE *The Clay Street Line cable car on its "maiden voyage," August 2, 1873.*

BELOW LEFT *Hallidie's line began its trek up Clay Street at Kearny Street. In this 1873 photograph cable cars vie for space with horses and buggies.*

BELOW *A circa 1880 engraving showing the grades along three challenging routes. Missing are the Sutter Street Railroad and Presidio Railroad grades, which were substantially flatter.*

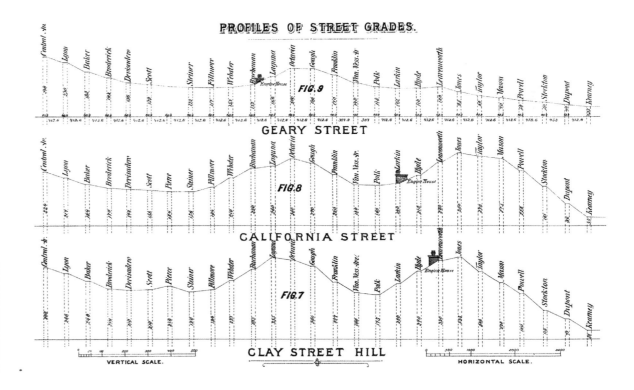

PROFILES OF STREET GRADES.

GEARY STREET

CALIFORNIA STREET

CLAY STREET HILL

FIG. 9
FIG. 8
FIG. 7

VERTICAL SCALE.
HORIZONTAL SCALE.

Old Ferry Building DEMOLISHED 1892

Beginning in 1863, train passengers on their way to San Francisco from the East Bay cities of Alameda and Oakland boarded ferries that landed at the foot of Davis Street. In 1869 the Central Pacific Railroad completed the transcontinental railroad. The decision to run its trains first into the East Bay city of Alameda and then into neighboring Oakland presented San Francisco-bound passengers and travelers with a dilemma that still exists today: these trains do not travel to or from San Francisco. Travelers in either direction, whether leaving or arriving in San Francisco, have to travel to or from the East Bay: first by ferry, and later over the Bay Bridge. The first transcontinental passengers alighted in Alameda on September 8, 1869. Two months later the cross-country trains were carrying their passengers to Oakland instead. The coming of the transcontinental railroad to San Francisco Bay enticed the Central Pacific to build more commodious accommodations at the foot of Market Street, just one block west of Davis Street.

In 1877 the railroad invested some $93,000 in the 350-foot-long wood-framed Union Depot and Ferry House.

The building, which was really a series of sheds with a unifying roof and a central clock tower, replaced the area's wharves. At first there were three ferry slips with connections to the East Bay: two for the Central Pacific Railroad and one for the narrow-gauge South Pacific Coast Railroad. Later the depot was expanded to four boat slips. Then increased traffic forced the Central Pacific to extend the structure some 250 feet east in order to add three more slips. This addition gave the terminal seven slips: four handled the ferry traffic from Oakland; one was reserved for South Pacific Coast's passengers from Alameda and the other two for Marin County and North Coast traffic.

In 1883 the depot became a key transit point, when the Southern Pacific Railroad's Market Street Cable Railway began operating, using the depot as its hub. Five lines converged onto Market Street

and the ferry terminal. During rush hour, a cable car left that terminus every 15 seconds.

On November 1, 1891, California voters approved the San Francisco Ferry Depot Act by the slimmest of margins. Some 180 men went to the polls (women couldn't vote until August 1920). The bond measure for money not to exceed $600,000 passed by just 866 votes. The act provided San Francisco with state bond money "to create a fund for the construction and furnishing, by the board of state harbor commissioners, of a general ferry and passenger depot in the city and county of San Francisco."

The following year, the wooden Union Depot and Ferry House had a date with the wrecking ball as work began on Arthur Page Brown's Ferry Building to replace the outdated structure. Brown's building was completed in 1898. It survived both the 1906 and 1989 earthquakes and stands at the foot of Broadway as one of the city's most recognizable landmarks.

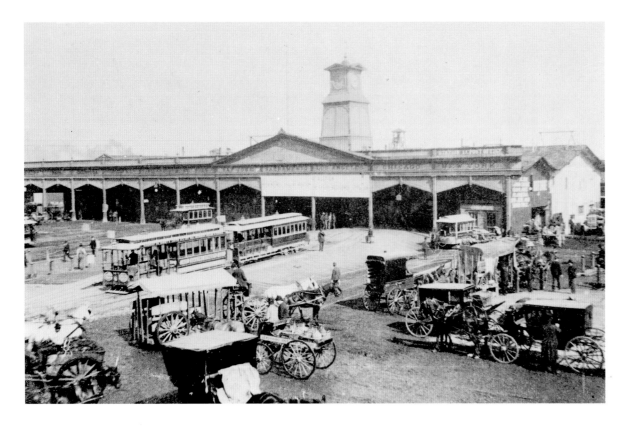

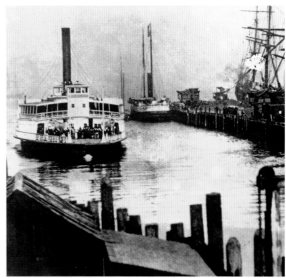

RIGHT *Horsecars await passengers in front of the Ferry Building in this circa-1880 photograph.*

LEFT *This photograph shows a bustling Ferry Building in 1886.*

ABOVE *The ferryboat* Alameda *arrives at the Davis Street Pier, the predecessor to the Ferry Building.*

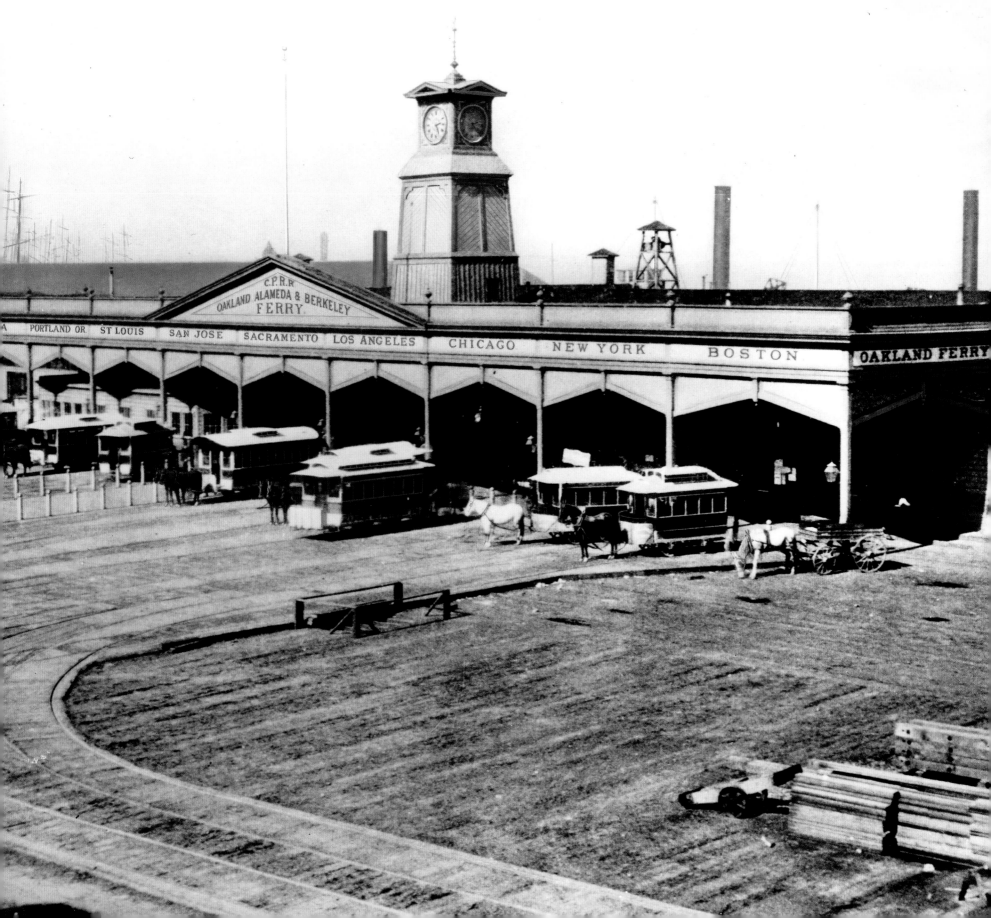

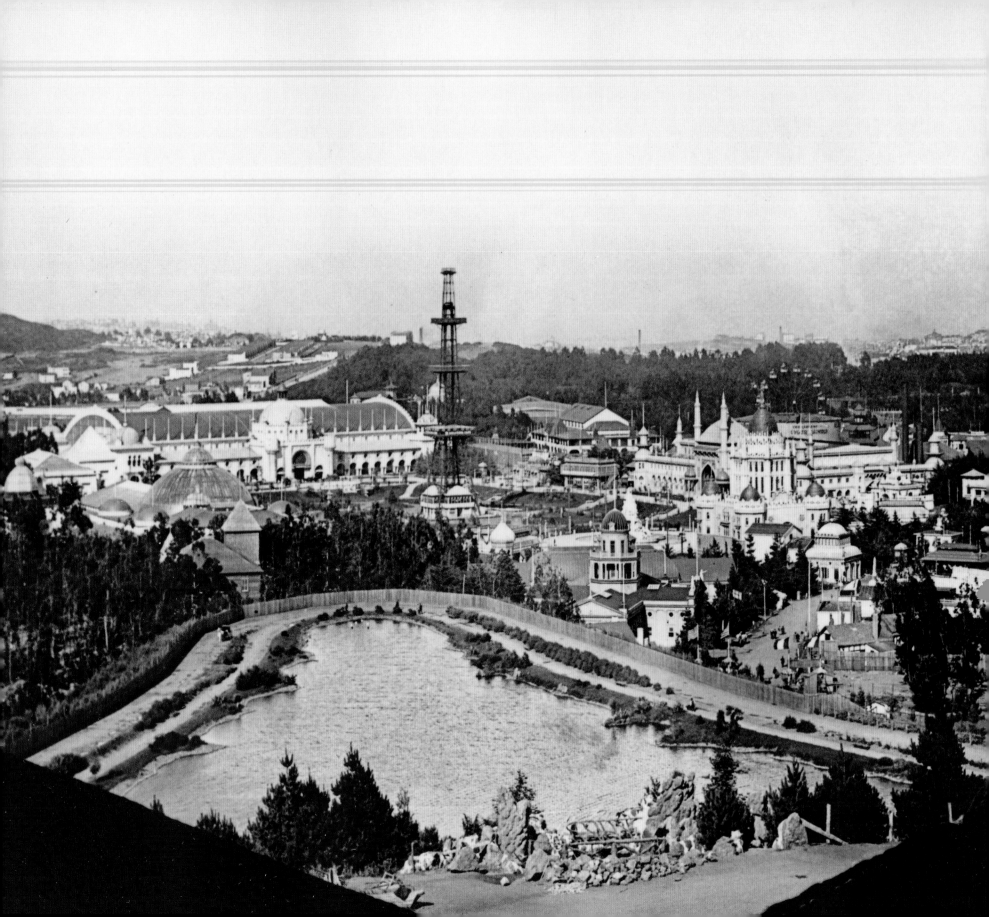

Midwinter Fair CLOSED JULY 5, 1894

San Francisco Chronicle owner Michael H. de Young traveled to Chicago's World's Columbian Exposition in 1893. President Benjamin Harrison had appointed de Young as a national commissioner to the "White City," as the Columbian Exposition was known. The *Chronicle* owner returned home energized and inspired. Why not create a similar exposition here in San Francisco?

San Francisco was in the midst of an economic slump, something called the Panic of 1893, so what better way to get out of the fiscal doldrums than host an exposition as Chicago did? Maybe San Francisco could "borrow" a few items from Chicago? De Young convinced the business community that the success in Chicago could be echoed here on the West Coast. The business community convinced the city and in the middle of June, 1893, the board of supervisors approved the idea. From this discussion came the California Midwinter International Exposition of 1894, which contemporaries called the "Midwinter Exposition" or the "Midwinter Fair."

The city approached Golden Gate Park superintendent William Hammond Hall and park horticulturalist John McLaren, about holding the fair in the park. The pair wanted to see the fair take root, but not in Golden Gate Park; de Young argued that the park was the best and only place to hold the fair; the influential newspaper owner won out.

The fair caught public imagination and some 60,000 people attended the groundbreaking ceremonies in August 1893. Of course, de Young became the fair's director-general and just as de Young suggested, the fair made use of some of Chicago's exhibits. They wanted to open the gates to the fair on January 1, 1894, but snowstorms delayed the trains with the exhibits from Chicago. The fair opened just 26 days late on January 27, 1894.

More than 77,000 people came through the gates on opening day to ogle at some 180 structures, representing California's counties and 18 foreign countries.

They meandered around the fairs' primary exhibits in the inner circle, which included the Mechanical Arts, Horticulture and Manufacturers' buildings. They also visited the midway attractions on the outer circle: the Firth Wheel (San Francisco's version of the Chicago Ferris Wheel), a Cyclorama and Boone's Animal Arena. Another main attraction was the Fine Arts Building, which would later become the De Young Museum.

In the center of it all stood the 272-foot-tall Bonet's Electric Tower, the fair's tallest structure. An electric elevator carried fairgoers to its top. Each night of the fair a searchlight scanned the skies and could be seen for miles.

The fair closed on July 5, 1894, after more than two million visitors had passed through its gates. The M. H. de Young Memorial Museum and the Japanese Tea Garden remain today as lasting legacies of those six-plus months during the late Victorian era.

AFTER THE FAIR

When the fair was over Adolph Sutro bought the Camera Obscura and the Firth Wheel (pictured below), incorporating them into the attractions at Sutro Baths. When Golden Gate Park wasn't restored, as had been promised, John McLaren had his revenge. His men tore down the buildings and sold the lumber. They dynamited Bonet's Tower and sold the metal as scrap. McLaren kept the proceeds for the park improvement fund. Makoto Hagiwara's Japanese Village made a deep impression on McLaren. He asked that Hagiwara make the village a permanent part of Golden Gate Park. Hagiwara obliged and the Japanese Tea Garden was born. Hagiwara and his family cared for the garden until 1942 when the federal government ordered the family into a relocation camp.

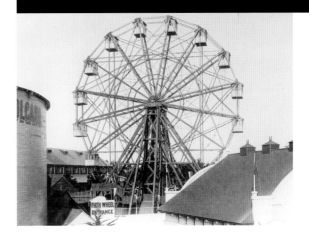

OPPOSITE PAGE *The panorama of attractions.*

FAR LEFT *A popular fair attraction of the nineteenth century was to show indigenous people and their lifestyle. The Midwinter Fair was no different, importing "Esquimaux," their dogs and reindeer, along with tents and mock igloos.*

LEFT *The view from the San Joaquin County building; to the right is the Alameda County building. There were also buildings from Sonoma, Kern and Placer counties along with a Persian Theater in the Oriental Village.*

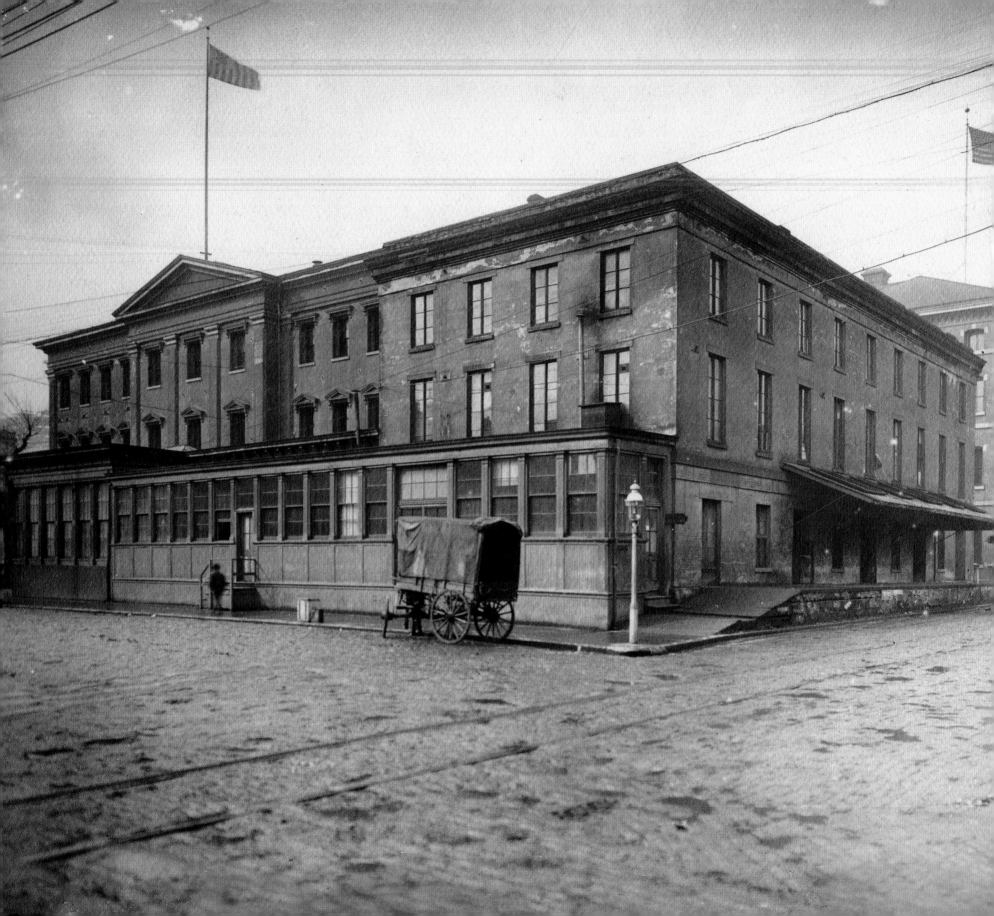

Custom House DEMOLISHED 1905

San Francisco has been home to custom houses since its inception as Yerba Buena. The city's first Custom House was the Mexican government's adobe-brick affair on Portsmouth Square. The building was completed sometime in 1845 and housed the village's *Alcalde*—the equivalent of a mayor—and the tax collector. Captain John Montgomery raised the American flag in front of this building on July 9, 1846. He used the first customs building to house his troops.

By 1850 California had become a state, and its first senators, William McKendree Gwin and John Charles Fremont, chose San Francisco as the city to set up government shop. The federal government needed a building to house its customs regulators and other federal workers.

William Heath Davis built the first brick building in San Francisco in September 1849, on the northwest corner of Montgomery and California streets, and he began leasing space to the federal government for $3,000 a month. Five years later the federal government built a new custom house. On May 9, 1854, the U.S. Treasury paid the state of California $150,723.50 for a plot of land on Battery Street between Washington and Jackson streets. The government hired Boston architect Gridley J. Bryant. Bryant's Custom House was a three-story Classical Revival-style building made of granite and brick, and dressed in stucco. Bryant's design included a two-story pillared portico. The Custom House took two years to build (1855–56) and ended up costing the federal government $866,000, much of the money sunk into the foundation piles and granite base.

In 1905 Bryant's building was demolished to make way for a modern replacement. On January 28, 1906, about three months before the earthquake, ground was broken for the new Custom House. The temblor delayed construction, and the building was not completed until 1911; it stands today, 100 years later.

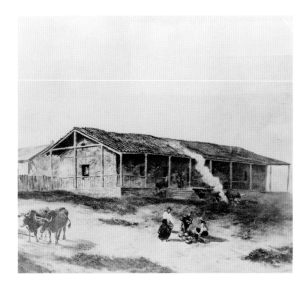

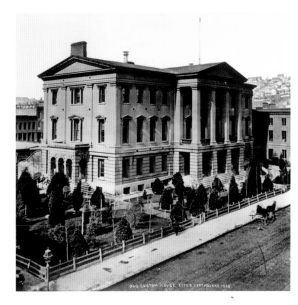

LEFT *This 1903 photograph shows the changes made to the 1856 Custom House at Battery and Jackson streets. The colonnaded pediment was removed after being damaged in the 1868 earthquake and an additional building was added to the right. The Custom House was torn down in 1905.*

TOP *The first Custom House (1845) was located on Portsmouth Square in what was then Yerba Buena.*

ABOVE *The 1856 Custom House and Post Office some time between 1866 and 1868. While some sources suggest this Lawrence and Houseworth image is from 1866, others suggest it was taken after the 1868 earthquake.*

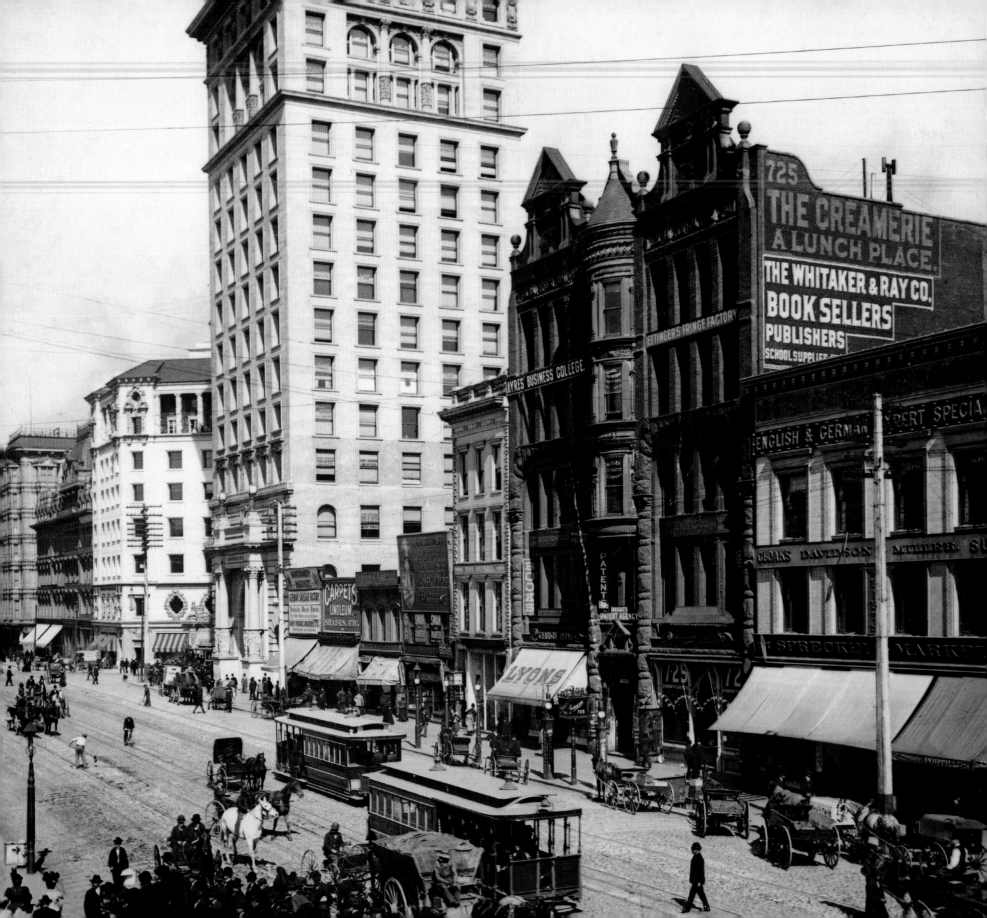

The Slot ABANDONED 1906

Mention SOMA to San Franciscans today, and they will know you're talking about the South of Market neighborhood. Late nineteenth- and early twentieth-century San Franciscans would more likely have referred to that section of the city as "South of the Slot." When they did, they were referring to the area's location in relation to an iron slot that held the mechanism that drove the cable cars which ran up and down Market Street.

In the late 1850s entrepreneurs attempted to build a horse-car line on Market Street from Third Street to Valencia. The grade proved too steep for the horses to handle and a steam locomotive was placed in service instead, starting on July 4, 1860. On March 6, 1867, encouraged by public complaints about noise and soot, the company regraded the road and replaced the steam dummies with horses. In 1883, cables, rather than horses, were propelling the cars on Market Street. The cables pulled the cars along on a slot that ran down the middle of the street. Writer Jack London believed that the slot symbolized all that divided society. In 1909 he wrote a short story, "South of the Slot," where he expressed his feelings about the dividing line. According to London, respectable folks lived north of the Market Street dividing line, while you could find the working class "south of the slot." Jack was born to Flora Wellman on January 12, 1876, and Flora was living with the Slocum family at 615 Third Street, some seven blocks south of the slot. The California Historical Society has placed a plaque at the site of the Slocum home. The house itself was destroyed in the devastating fire that came on the heels of the April 18, 1906, earthquake.

The slot began operations on August 22, 1883. Streetcars ran from East Street, today's Embarcadero, to Valencia Street, where the powerhouse that drove the slot was located. A second slot along Valencia took streetcars to Mission Street. The Yellow Line that took passengers from Market McAllister Street opened in late 1883. Like the first line that opened in August, the Yellow Line began its run on East Street. It carried passengers out from McAllister to Stanyan Street at Golden Gate Park.

The Red Line also opened in late 1883 and took passengers to the Haight District. The slot also accommodated the White Line to the Castro District and the Green Line to Hayes Street. On August 22, 1893, the Southern Pacific Railroad formed the Market Street Railway and merged all the Market Street cable car companies into one. On March 8, 1902, the United Railroads of San Francisco took over the Market Street Railway.

After the 1906 earthquake the slot was abandoned on Market Street and the cable cars dumped near the ocean. People squatted in the abandoned cable cars for a time giving rise to the impromptu Carville neighborhood.

OPPOSITE PAGE *Cable-powered streetcars making use of the "slot" on Market Street around 1900. After the earthquake of 1906 the streetcar line ran on overhead power cables.*

BELOW *A horse-drawn streetcar competes with cable cars on Market Street in 1899. Beyond the Welcome arch is the San Francisco Call building (1898), then the tallest building west of the Mississippi.*

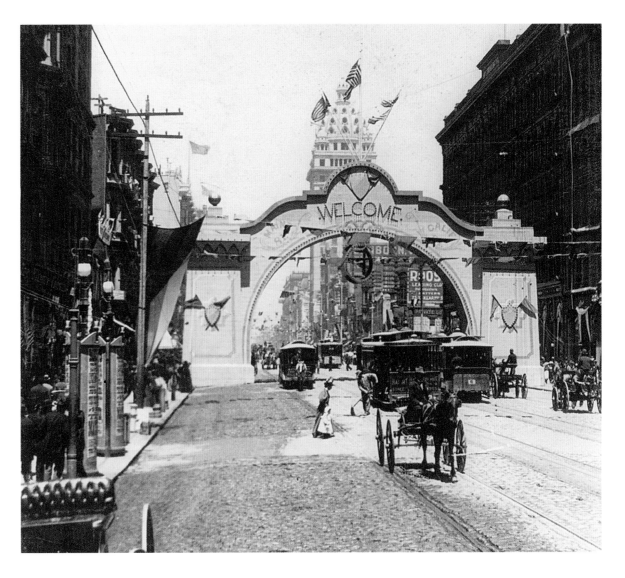

Earthquake of 1906

On April 18, 1906, at precisely 5:12 a.m., the hint of an earthquake awakened many sleeping San Franciscans and alerted those already awake that something wasn't quite right; some 20 to 25 seconds after this foreshock, a large earthquake struck with strong shaking that lasted from 45 to 60 seconds. By 5:14 a.m. the Great San Francisco Earthquake had done its damage. A fire on the temblor's heels burned until April 21.

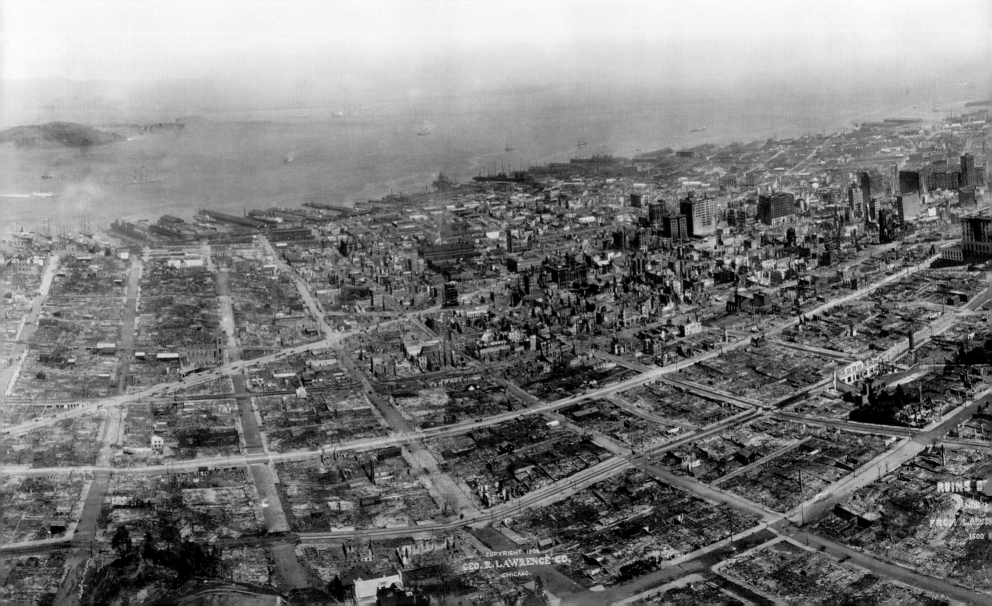

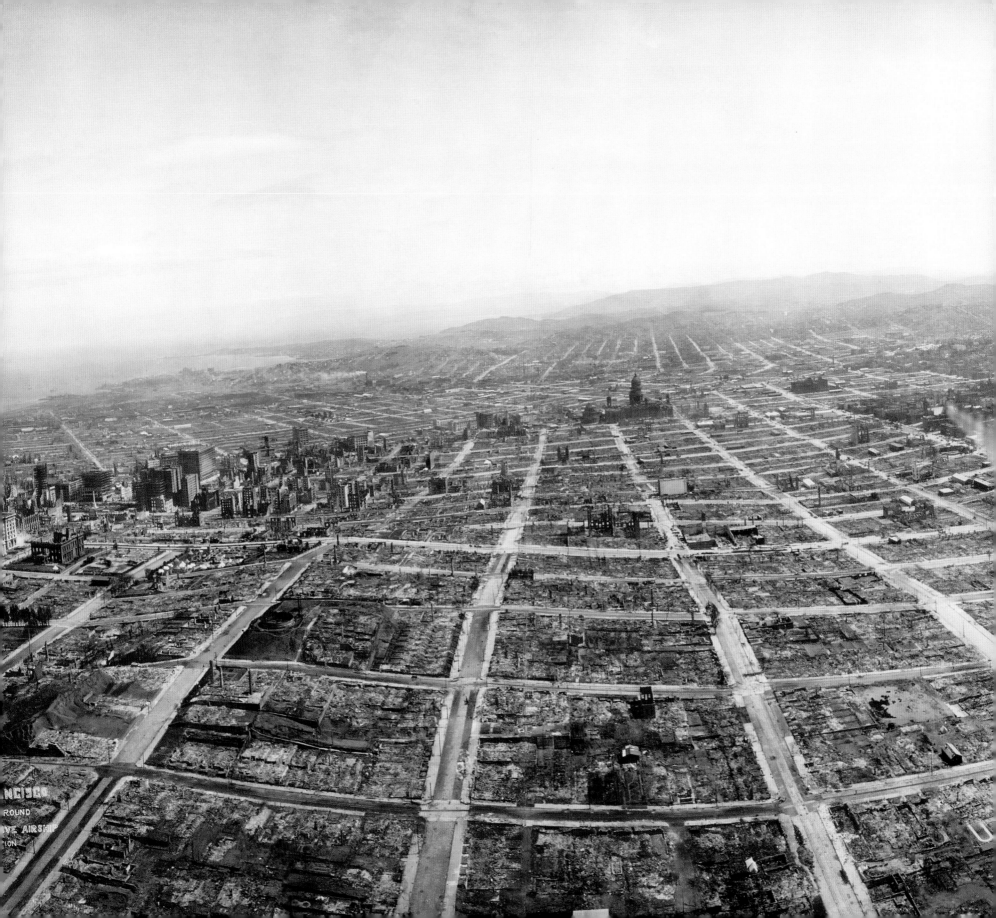

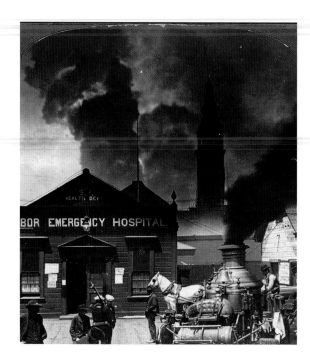

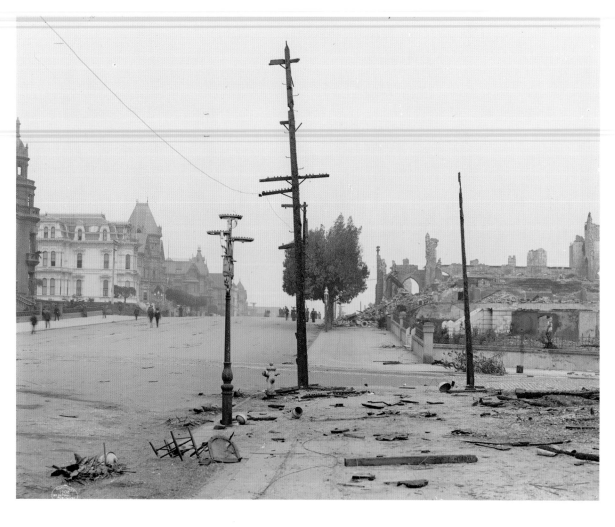

OPPOSITE PAGE *Where the fire stopped; the corner of Franklin and Sacramento streets marked the line that divided the fortunate and unfortunate.*

ABOVE *One half of a stereoscopic view; sailors on guard duty outside the Harbor Emergency Hospital—near the Ferry Building—can only watch as the fires continue to rage on April 21, 1906.*

RIGHT *The wide expanse of Van Ness Avenue proved to be an ideal fire break and marked the limit of the fire.*

The 1906 earthquake ruptured the northernmost 296 miles of the San Andreas Fault from San Juan Bautista to Cape Mendocino. People up and down the Pacific Coast from southern Oregon to Los Angeles felt the shaking. Those living inland as far as central Nevada also experienced the temblor. Ruptured water and sewer mains flooded the streets with a toxic mixture. Fires broke out, but the city's 600 firefighters could do little.

After raging for three days and cutting a three-mile path through the city, the fire could find no more fuel to feed its advance and extinguished on its own.

The entire south side of Market Street "below the slot" was in flames. Eventually flames also engulfed the commercial buildings north of Market Street. Fire reached the Opera House and ignited the building's gashouse and the ensuing explosion

brought with it the realization that normal firefighting tactics were of little use. "The three-day conflagration following the earthquake caused substantially more damage than did the earthquake," the National Oceanic and Atmospheric Administration (NOAA) reported in 1971. The area of the burned district covered 4.7 square miles.

Ruptured gas mains set off some 30 fires. Firefighters, untrained in the use of dynamite, attempted to demolish buildings to create firebreaks. This resulted in the destruction of more than half the buildings that would have otherwise survived. According to NOAA, in terms of 1906 dollars, the total property damage amounted to about $24 million from the earthquake and $350 million from the fire. The fire destroyed around 28,000 buildings in a 520-block area.

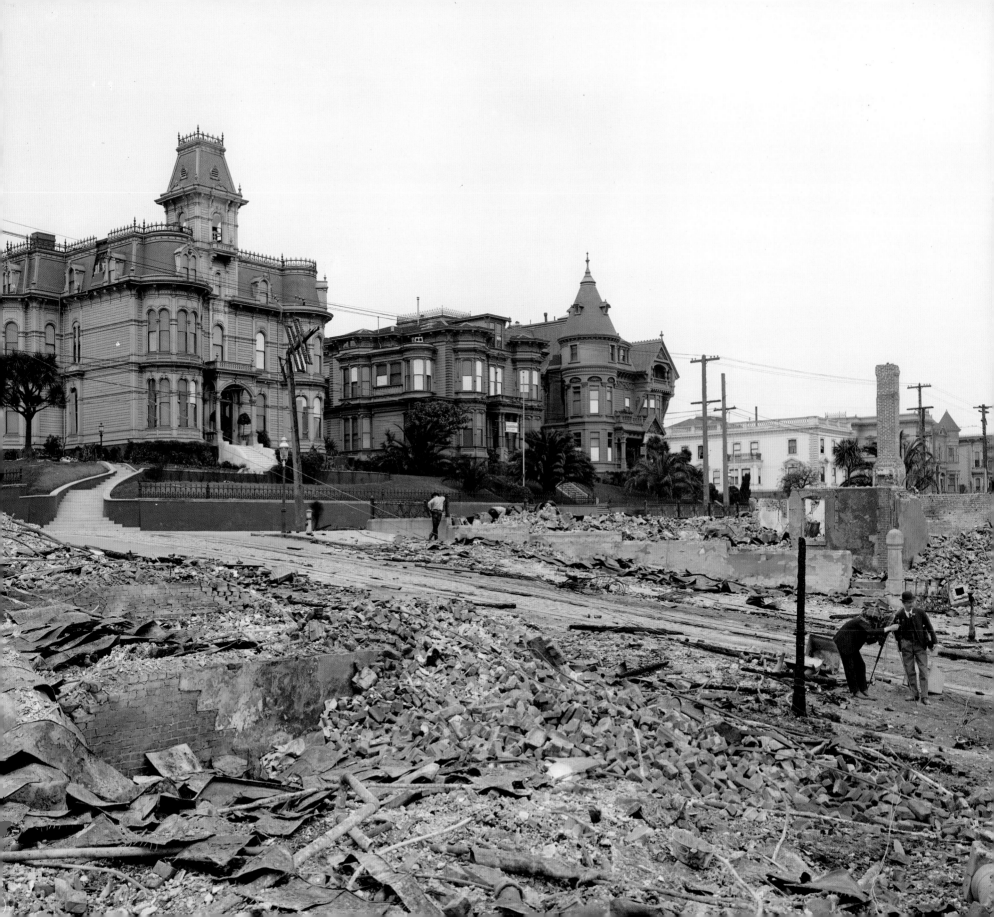

A 1906 report filed by the U.S. Army recorded 664 deaths: 498 in San Francisco, 64 in Santa Rosa and 102 in and around San Jose. Sixty-five years later NOAA suggested that 700–800 was a more reasonable figure. Then in 1989—the year the Loma Prieta Earthquake struck San Francisco—Gladys Hansen and Emmet Condon estimated that the temblor caused more than 3,000 deaths among a population of 400,000, and of these 400,000 people, the earthquake left about 225,000 of them homeless.

The U.S. Army built 5,610 redwood and fir "relief houses" to accommodate 20,000 of these displaced people. The army painted the houses olive drab because the military had large quantities of olive drab paint on hand. The houses were grouped in 11 camps and rented for two dollars a month. The camps had a peak population of 16,448 people; by 1907 most people had moved out. In 2006, during the 100th anniversary of the earthquake, someone paid $600,000 to own one of the few remaining shacks.

In the end, the quake cost some $400 million in damage: $80 million from the earthquake and the balance from the ensuing fires. The earthquake was the worst single incident for the insurance industry before the September 11, 2001 attacks, and the largest U.S. relief effort to this day, including even the response to Hurricane Katrina.

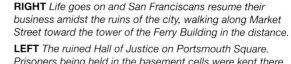

RIGHT *Life goes on and San Franciscans resume their business amidst the ruins of the city, walking along Market Street toward the tower of the Ferry Building in the distance.*

LEFT *The ruined Hall of Justice on Portsmouth Square. Prisoners being held in the basement cells were kept there until the fire approached and then were transferred four blocks to the Broadway Jail. When that came under threat they were marched to Fort Mason.*

BELOW *Market Street at Montgomery with the intact but fire-damaged Crocker Building. The Postal Telegraph Company set up a tent outside its building and continued business as best it could from there.*

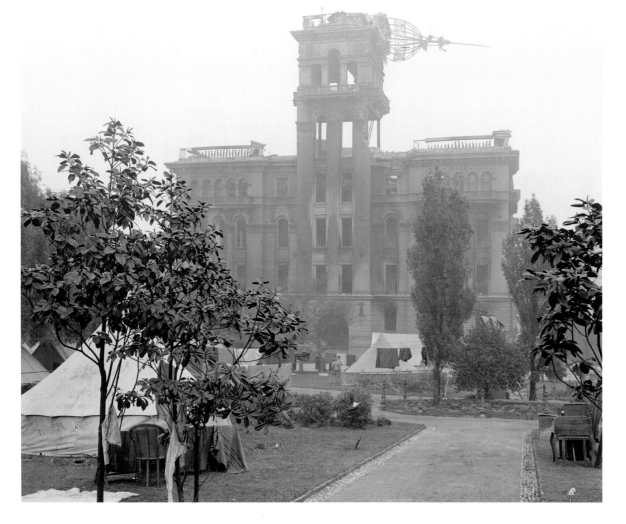

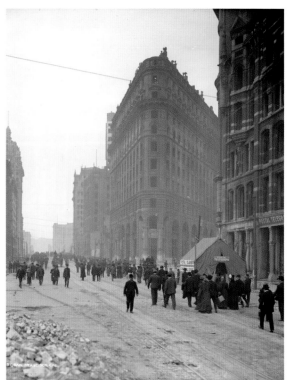

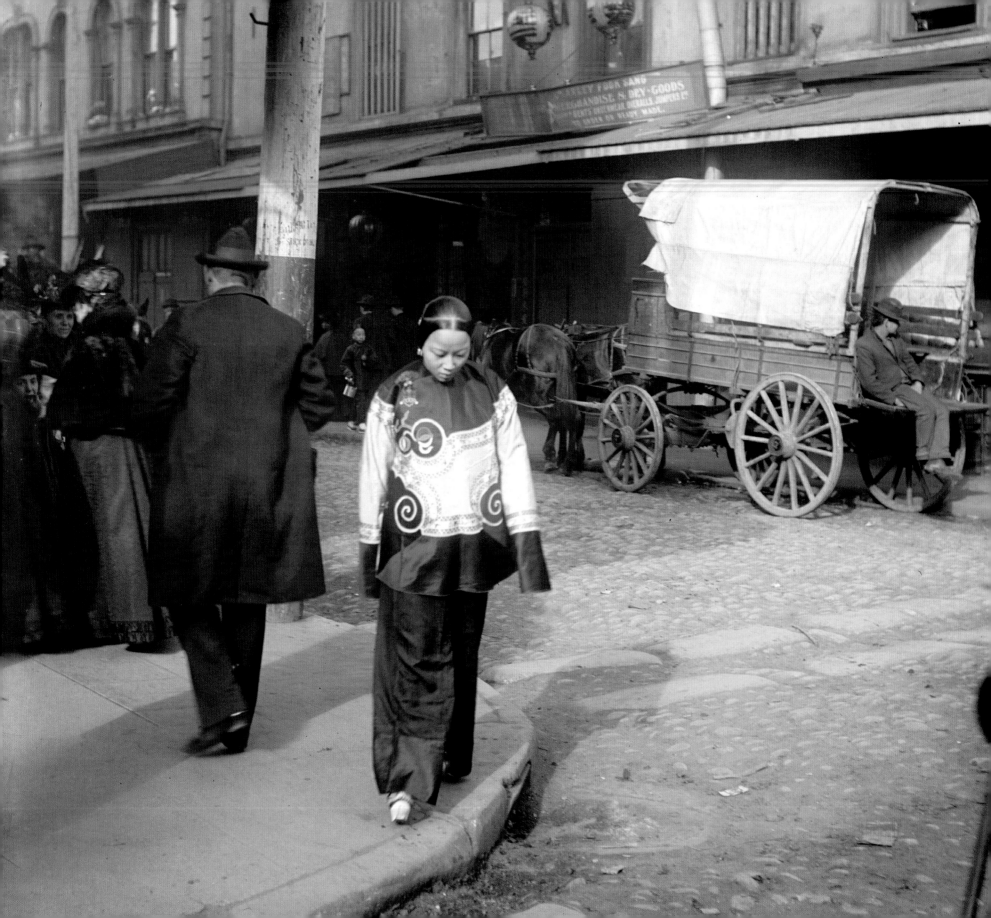

Original Chinatown VICTIM OF 1906 EARTHQUAKE

To outsiders, San Francisco's Chinatown, with its 20,000 residents, is a tourist attraction, a special place to shop or stroll along the streets. For the Chinese, however, it is "Tangrenbu," the port of the city of Tang. Today, Chinatown represents the combination of neighborhood and capital of West Coast Chinese culture.

Until April 17, 1906, Tangrenbu was a ghetto where outsiders forced the Chinese to live. The Great San Francisco Earthquake and Fire that shook, then burned, the city on April 18, 1906, swallowed Tangrenbu whole. Residents wept over the loss of life and neighborhood that included their temples and homes along with their shops, stores and restaurants. Women with bound feet could be seen teetering along the ruined streets in a frantic movement of people.

Some outsiders rejoiced over the destruction of what they considered an exotic ghetto that included gambling dens, opium cellars and brothels. In the earthquake and fire's aftermath, outsiders got a glimpse of a world hidden until then. "Fire has reclaimed to civilization and cleanliness the Chinese ghetto, and no Chinatown will be permitted in the borders of the city... it seems as though a divine wisdom directed the range of the seismic horror and the range of the fire god," the *Overland Monthly* wrote.

Some of San Francisco's politicians agreed with the editor of the *Monthly* and considered the earthquake an opportunity to rid the city of the Chinese, take over the prime real estate where they lived, and move them, perhaps to Hunters Point.

OPPOSITE PAGE *Photographer Arnold Genthe worked extensively in Chinatown before the 1906 earthquake. This image, taken around 1900, was originally titled "Slave girl in holiday attire" and also "Lily-foot woman, Chinatown."*

BELOW LEFT *A family from the Chinese Consulate on its way to a ceremonial function.*

BELOW *One of the many alleys bisecting Chinatown that would be swept away in the rebuilding of the city.*

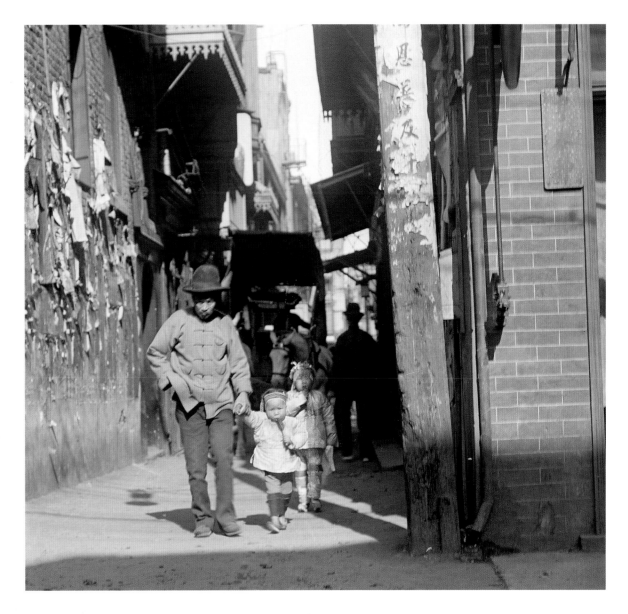

Chinatown Crisis

The Chinese government voiced its displeasure at plans to relocate Tangrenbu. "I have heard the report that the authorities intend to remove Chinatown, but I cannot believe it," a member of the Chinese delegation told California Governor George Pardee, who was across San Francisco Bay in his hometown of Oakland after the temblor.

The delegation told Pardee that the Chinese Government owned the lot on which the Chinese Consulate of San Francisco formerly stood. Chow-Tszchi, the first secretary of the Chinese Legation at Washington, and Chung Pao Hsi, China's Consul-General of San Francisco, made it clear to Pardee that the Chinese government intended to construct a new building on the same site.

At the delegation's request, Pardee wrote letters to authorities in San Francisco authorizing them to grant properly accredited Chinese representatives the right to enter guarded sections of Chinatown and care for the distressed Chinese, as well as provide protection for burned Chinese places of business. Pardee also permitted some 500 Chinese, who fled San Francisco for Oakland, to return from Oakland. The move couldn't come soon enough for the residents of Oakland.

The *Oakland Herald* reported on April 27 that prejudice had raised its ugly head in Oakland. "On Franklin Street, near Eleventh, two blocks beyond the former limits of the Chinese quarter, it has been found necessary to put up the sign, 'No Chinese or Japanese wanted here,'" the newspaper stated. "White families in the neighborhood are moving away, unwilling to be surrounded by the degradation, the filth, and the vice that a Chinatown means." When he arrived back in San Francisco, Chow-Tszchi expressed great satisfaction with the help extended to the Chinese there and expressed his anxiety to learn when rebuilding work would begin.

In the end, leaders of San Francisco's Chinese community convinced authorities and landlords to rebuild Tangrenbu in a style that would attract tourism and business. They not only agreed to rebuild, but, more importantly, they decided to rebuild Tangrenbu on its original site.

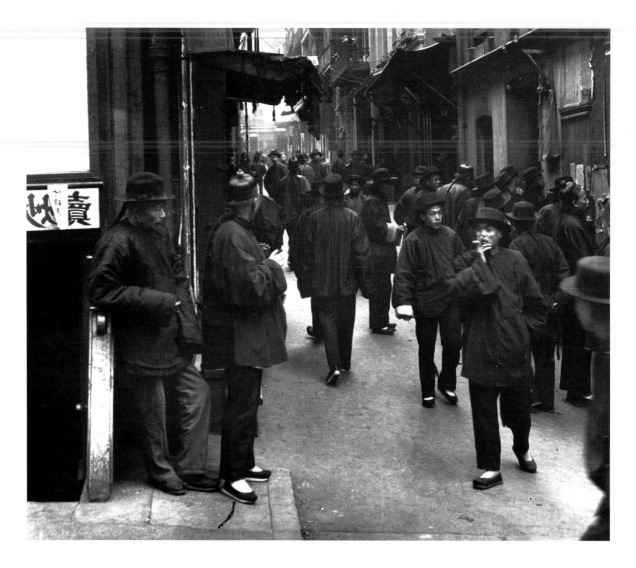

OPPOSITE PAGE *A Chinese woman stands transfixed by the fire that is about to sweep up the hill.*

ABOVE *Photographer Arnold Genthe called this picture "the street of the gamblers." Gambling was a major issue for the city at the turn of the century. In 1903, 11 members of the Chinese See Yup Society were arrested and charged for conspiring to murder the 300 members of the Chinese Society of English Education, for exposing gambling corruption.*

RIGHT *After the fire, a man walks through what was once the heart of a thriving Chinatown.*

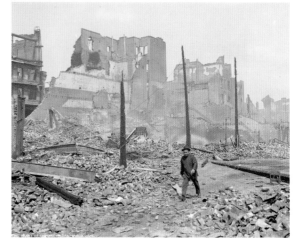

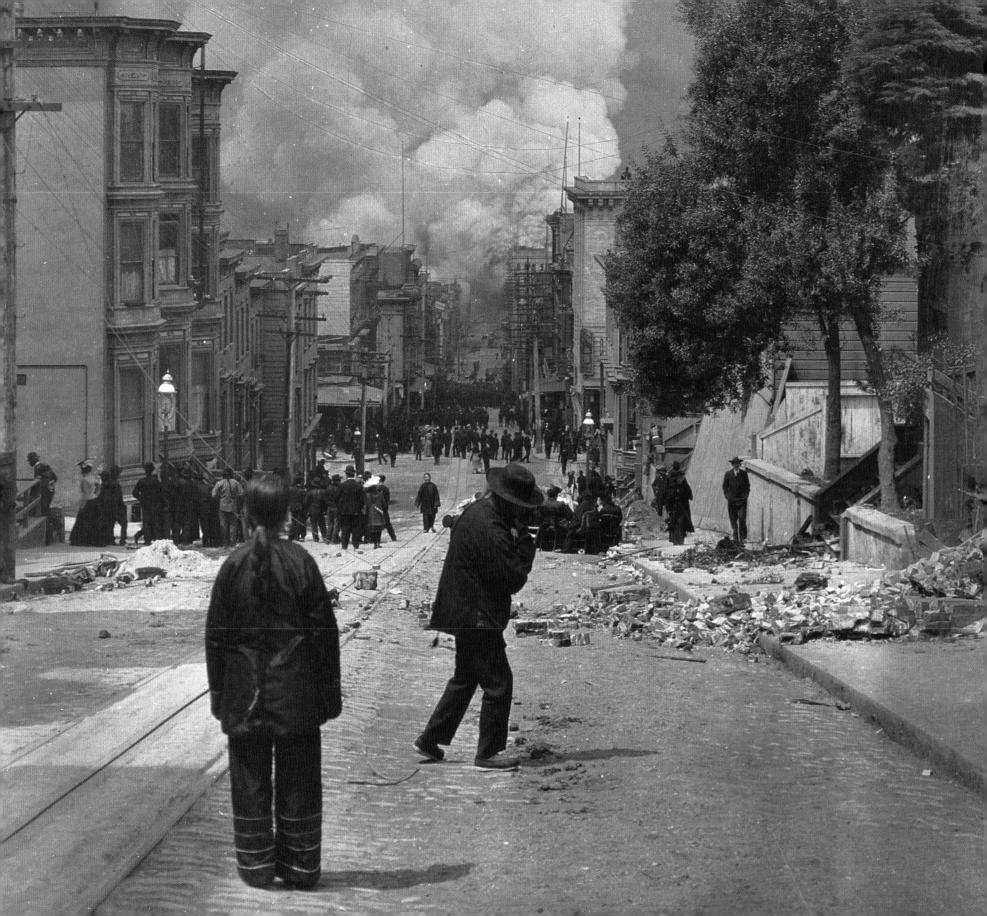

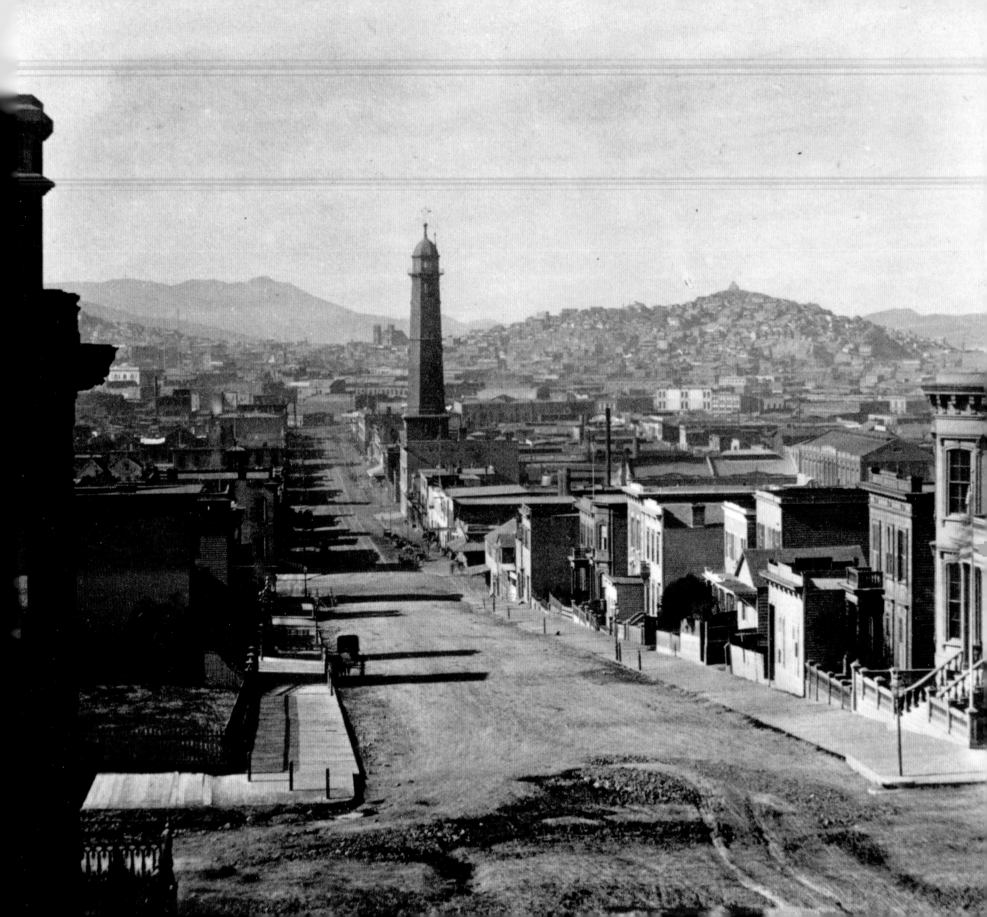

Selby Shot Tower VICTIM OF 1906 EARTHQUAKE

Thomas Henry Selby was born on May 14, 1820. At the age of 29 Selby joined the California Gold Rush, arriving in San Francisco in August 1849. The following year, he put up a brick building on the north side of California Street, where he established Thomas H. Selby & Co. Selby and his partner, fellow New Yorker Peter Naylor, organized the Selby Smelting and Lead Company in 1865. The interest of the partners lay chiefly in refining lead, which they used at their shot tower and lead manufactory, situated on the corner of Howard and First streets.

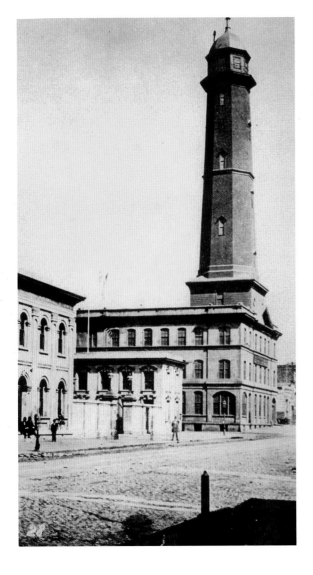

Using a process William Watts of Bristol, England, invented, lead was heated until molten, and then dropped through a copper sieve high up in the shot tower. The liquid lead solidified as it fell, forming tiny spherical balls. The balls fell into a water-filled basin on the tower's floor. Once the balls cooled, workers checked them for roundness and sorted them by size.

Workers used an inclined table with holes to make sure the balls were round; those that were "out of round" were simply remelted. In the final step workers lubricated the balls by polishing them with a small amount of graphite, which also prevented oxidation.

In 1865, the Selby Smelting and Lead Company built the 200-foot-tall Selby Shot Tower to manufacture bullets and shot. Built in part to satisfy the demand for ammunition during the Civil War, the structure, which sat at the southeast corner of First and Howard streets, served as the South of Market's most prominent industrial structure for 42 years.

In 1873, Selby bought Naylor out, and continued the business until he passed away on June 17, 1875. His son Prentiss took over the operations. On November 12, 1875, Prentiss incorporated the

Selby Smelting and Lead Company with a capital of $200,000 and in 1879 he purchased the Pacific Refinery and Bullion Exchange. The company continued to refine gold, silver and lead, and became the only refinery outside the United States Mint. The refinery was located at North Beach until 1884, when the plant's neighbors forced the company to move because of its round-the-clock operations and air pollution issues.

Prentiss moved the Selby Smelting Works first to a spot in Hercules near the dynamite plant, before purchasing property along the Carquinez Strait across from the city of Vallejo from Patrick Tormey.

The tower survived the 1906 temblor, but was destroyed in the ensuing fire. Following the fire, several hundred tons of lead, zinc and other metals were found melted into a solid block under the shot tower's ruins. The bed of metal was three to four feet thick, and covered the entire area of the ruins of the tower. At first, workers were unable to raise or break the mass into sizes small enough to handle. After removing several tons of brick and debris, workers cut channels through the great block of metal using a new metal-cutting and welding technique that made use of an electric arc. The men protected themselves by wearing canvas hoods with panels of smoked glass. The metal was recovered in blocks, each weighing about a ton.

OPPOSITE PAGE *This early view of First Street shows Selby Shot Tower and the nearby Miners Foundry Machine Works around 1866. The shot tower stood for 42 years.*

FAR LEFT *Selby's tower dominates the surrounding neighborhood at First and Howard streets.*

LEFT *The view from Rincon Hill looking north. Today the Orrick Building stands on the Shot Tower site. The building is part of "Foundry Square," a complex of four 10-story buildings; each on a different corner of the intersection of First and Howard streets.*

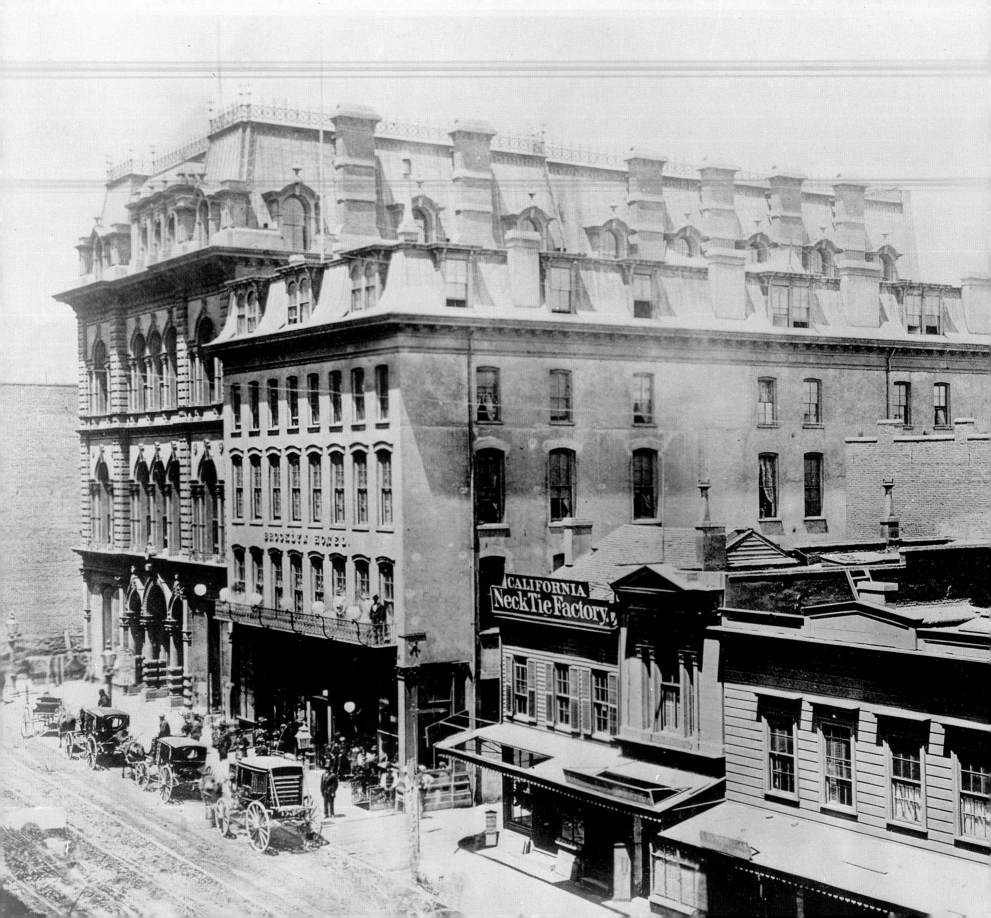

Mercantile Library Building VICTIM OF 1906 EARTHQUAKE

Mercantile libraries—predecessors of today's public libraries—were membership libraries; subscriptions and gifts from the members supported mercantile libraries, so-called because the founders were merchants and clerks. San Francisco's Mercantile Library began life at City Hall in the Chamber of the Board of Aldermen on December 22, 1852. "Notwithstanding the inclemency of the weather, the meeting was numerously attended, showing that a deep interest was felt among all classes of the community," the library's catalog stated. A little over a month later on January 24, 1853, the library was officially organized with a handsome subscription of $82,000.

The library opened on the second floor of the California Exchange Building on Portsmouth Square on March 1, 1853. A contemporary description called its rooms "commodious, well arranged and handsomely appointed." Almost 55,000 volumes filled the library's shelves, while its reading rooms were "amply supplied with papers and magazines from the Eastern States and Europe." The building also had a chess room and a ladies' parlor.

"The Library shall be opened every day throughout the year, from 10 o'clock, a.m. to 10 o'clock, p.m., excepting Sundays, the Fourth of July, Thanksgiving Day, Christmas, and New Year," the library's catalog informed its membership. Members could borrow either one or two books, depending on the books' sizes. "Every member may detain (borrow) each book or set delivered if it be a folio or quarto, four weeks; an octavo, three weeks; or a book or set of less size, two weeks." The library imposed fines on any member whose books were returned late or damaged. "Any member who shall detain a book or set longer than the time above limited, respectively, shall forfeit and pay to the Librarian, for every day a volume is so detained, if it be a folio, twenty cents; a quarto, fifteen cents; an octavo, ten cents; a duodecimo or smaller volume, five cents."

Books on the library's shelves included John H. Wabland's *The Plume: A Tuft of Literary Feathers*; Count Philip Segar's *Expedition to Russia* of 1812; and Mary Somerville's *Connection of the Physical Sciences*. Magazines on the shelves included *Harpers' New Monthly*, *Putnam's Monthly*, *Graham's Magazine*, and the *Missionary Herald*.

In 1872, the Mercantile Library moved into a larger building on the north side of Bush Street, between Sansome and Montgomery. The building (shown in both photographs) had a Mansard roof in the tiered style of the French Renaissance, massive chimneys, wrought-iron cresting atop the roof, and rusticated piers.

In January 1906, the Mercantile Library collection was absorbed into the Mechanics' Library at 31 Post Street. Unfortunately, just three months later, the fire that came on the heels of the April 18 earthquake destroyed the library. The Mechanics' Library set up temporary quarters at Grove Street. By 1910, a new facility was completed and on July 15, 1910, the Mechanic's Institute moved into a new nine-story building at 57 Post Street. By 1912, the collection totaled some 40,000 books.

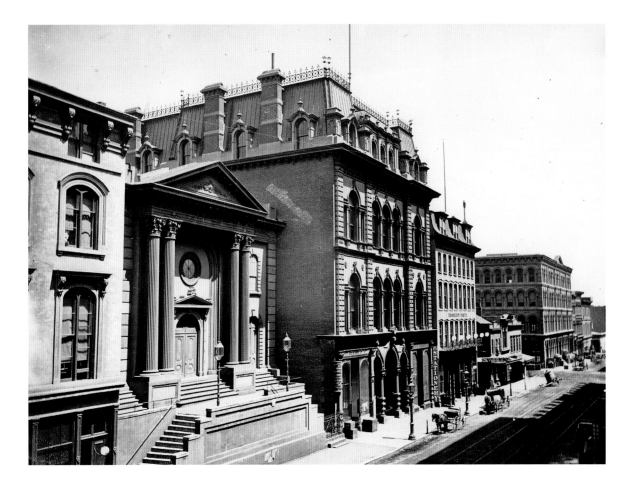

OPPOSITE PAGE *The Mercantile Library, shown here in 1875, stood on Bush Street, next door to the smaller Brooklyn Hotel and the California Neck Tie Company.*

LEFT *The Calvary Church (to the left of the Mercantile Library building) relocated to the corner of Geary and Powell streets in 1868, the year this photograph was taken.*

The Old Palace Hotel VICTIM OF 1906 EARTHQUAKE

Architect John Palmer Gaynor designed the Palace Hotel for banker William Chapman Ralston. Before Gaynor, who had already designed Ralston's home "Ralston Hall" in Belmont, got to work on his blueprints, Ralston sent him off to Chicago and New York to seek inspiration from luxury hotels there. When he returned, the architect rolled up his sleeves and gave his boss the "Grande Dame of the West." Gaynor's $5 million plan took up two acres of valuable downtown San Francisco real estate. Some 7,000 windows on seven floors let sunlight into 755 20-square-foot rooms with 15-foot-high ceilings. Fifteen marble companies supplied 804 fireplace mantels, 900 washbasins, and 40,000 square feet of flooring.

Work began in early 1873 on a two-and-a-half acre site on the southwest corner of Market and New Montgomery streets, across New Montgomery from the four-story Grand Hotel, an earlier Ralston project. Ralston purchased the site, essentially a large hill of sand, for $400,000. The Remillard Brick Company across San Francisco Bay in Oakland supplied 1.5 million bricks for the structure; the majority of the bricks came from the company's factory in San Rafael. Ralston also acquired an entire forest in the Sierra Nevada to provide the wood for the hotel's construction. After four years of building work the Palace Hotel finally opened its doors on October 2, 1875.

Ralston did not live to see its completion. He drowned 36 days earlier, on August 27, while swimming in San Francisco Bay. Some say he committed suicide because his Bank of California had failed the previous day. Ralston's business partner, U.S. Senator William Sharon, who had helped cause the bank's collapse when he dumped his Comstock Lode stock, fared quite well when Ralston died. Sharon ended up controlling the bank and Ralston's debts, which he paid off at just pennies in the dollar. He also acquired the almost-completed Palace Hotel. Sharon took over Ralston's stately home, Ralston Hall and paid the late banker's widow just $50,000 for the multi-million-dollar estate. He lived there until his death in 1885.

Five hydraulic elevators carried guests to their air-conditioned rooms, where they could summon help with electric call buttons. For the first 25 years of the hotel's existence, guests entered through the Grand Court, a graveled carriage entrance set in the middle of the hotel. Shortly after 1900 the Grand Court was converted to a gracious central lounge called the Palm Court. The hotel had separate Grille Rooms—one for the ladies, and another for the gentlemen. The Maple Hall was available for receptions; the Tapestry Room accommodated private dinners. Three Louis XV-style parlors, which could be combined into a single large room, were also available for public and private functions. A Colonial-style billiard room provided a place for gentlemen guests to relax, as did the magnificently appointed bar.

The Palace Hotel had a cistern and four artisan wells in the sub-basement, a 630,000-gallon reservoir under the Grand Court, and seven roof tanks on the roof that held 130,000 gallons of water—all to defend against earthquakes and fire. None of this helped when the earthquake struck on April 18, 1906. The temblor and the ensuing fire left the building a shell of its former self.

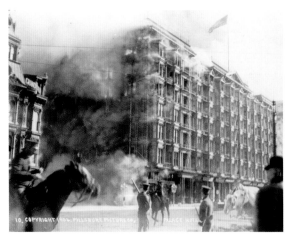

RIGHT *The burned out shell of the Palace Hotel prior to its demolition. The structure withstood the blaze better than the fancier Grand Hotel next door, which is almost entirely gone.*

FAR LEFT *William Ralston's Palace Hotel reigns over Market Street. Further down Market is another Ralston creation, the gingerbread Grand Hotel, seen far left in this photograph. The Grand stood across New Montgomery Street from the Palace. A bridge connected the two.*

LEFT *Troops watch as fire takes hold of the Palace Hotel on April 18. The Grand Hotel looks yet to be affected.*

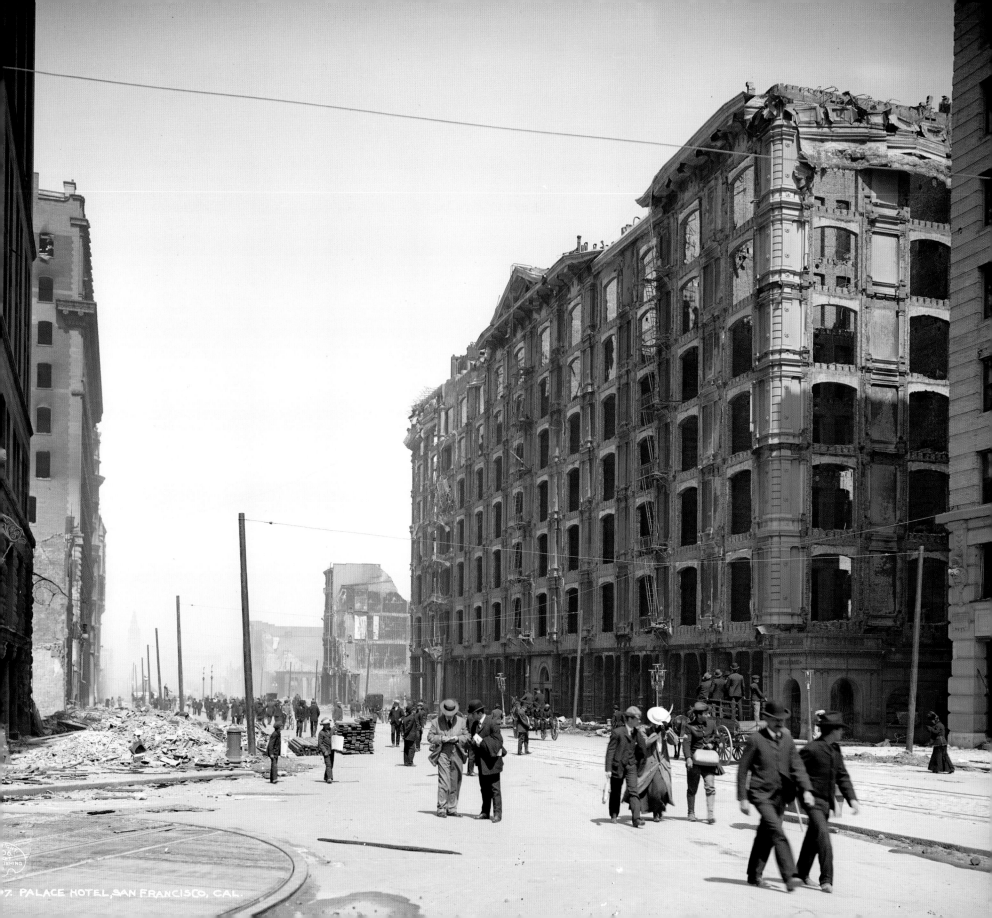

PALACE HOTEL, SAN FRANCISCO, CAL.

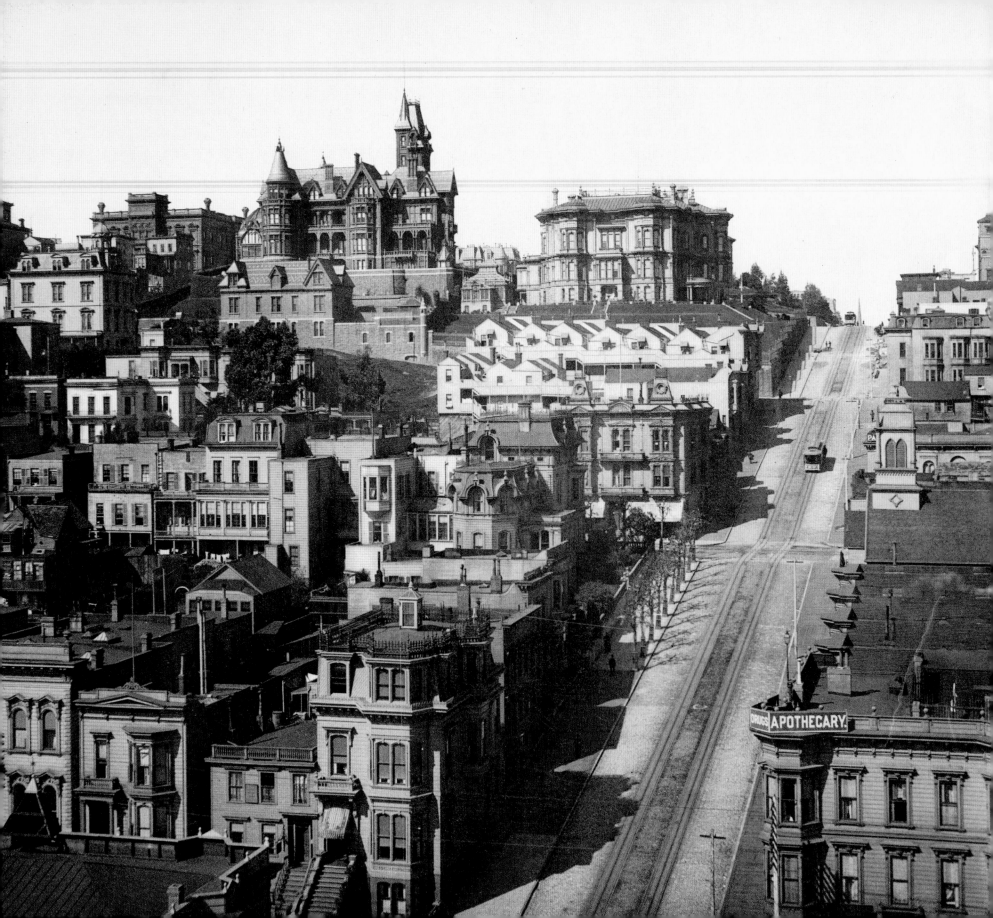

Nob Hill VICTIM OF THE 1906 EARTHQUAKE

Some early maps identified one of San Francisco's steepest hills as "Knob Hill." Houses appeared on its slopes as early as 1850. In 1872, Central Pacific Railroad attorney David Douty Colton built an impressive Italianate-style mansion on California Street near the top of the hill. Colton, his wife Ellen, and their two daughters entertained in the mansion with style and splendor. His was the first of many mansions to appear here after the Second Street Cut took away part of Rincon Hill and stripped away Rincon's attraction to the wealthy residents who were calling that place home.

In 1874 Colton played an important role in securing a second cable car line to his neighborhood. In 1877 two members of the Central Pacific Railroad's "Big Four," Leland Stanford and Charles Crocker, chose to join their attorney and both built mansions on "Nob Hill" (the "K" having been inauspiciously and conveniently dropped). Colton died in 1878, but lived long enough to see his investment pay off as cable cars began climbing California Street. Ellen Colton closed the couple's home and moved to Washington, D.C. That same year Mark Hopkins joined his partners and built a mansion atop Nob Hill.

Crocker was hoping to own the entire block of land bounded by California, Taylor, Sacramento and Jones streets. He was able to acquire all the property except for a small lot on the corner of Sacramento and Taylor streets where an undertaker named Nicholas Yung lived with his family. Yung refused to sell; in retaliation, Crocker built a "spite fence," a 40-foot-tall wall around three sides of Yung's home. The fence soon became the symbol of the defiance of the common man against the rich in nineteenth-century San Francisco. Crocker became the butt of jokes, bawdy songs and cartoons. To defy Crocker, Yung hoisted a coffin, and skull and cross bones, to the top his home, forcing the Crockers to look at these symbols of his profession whenever they gazed out their windows. One version of the story claims that Yung went so far as to snub Charles Crocker by writing "RIP CC" on the coffin. When Yung died, Crocker purchased the land from his heirs, and the fence was torn down.

The fourth member of the Big Four, Collis P. Huntington, joined his three partners in 1892, when he purchased the Colton mansion. He lived in the home with his wife, Arabella, until he died in 1900.

Arabella remained there until the 1906 earthquake and fire struck. In 1915, she donated the land where the property had stood to the City of San Francisco to be used as a park—a spot called "Huntington Park" today.

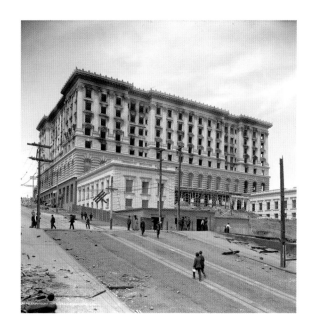

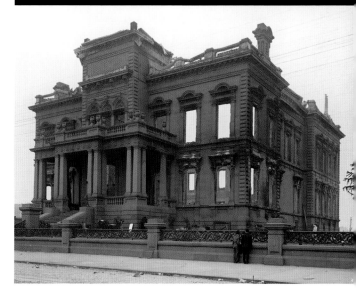

OPPOSITE PAGE *The Mark Hopkins and Leland Stanford mansions sit atop Nob Hill in this pre-1906 view of a cable car on Powell Street.*

ABOVE LEFT *The massive Fairmont Hotel was gutted by the blaze and the original interiors lost, but both it and the Flood Mansion (pictured above) lived on.*

LEFT *The ruins of the Stanford Mansion lie beyond the incongruously manicured gardens and exterior fence.*

The New York Times.

VOL. LV...NO. 17,617. • • • • • NEW YORK, THURSDAY, APRIL 19, 1906.—TWENTY TWO PAGES.

OVER 500 DEAD, $200,000,000 LOST
· IN SAN FRANCISCO EARTHQUAKE

Nearly Half the City Is in Ruins and 50,000 Are Homeless.

WATER SUPPLY FAILS AND DYNAMITE IS USED IN VAIN

firemen and United States soldiers, who assisted them, blew down building after building. Their efforts, however, were useless, so far as checking the headway of the flames was concerned.

The shortage of water was due to the breaking of the mains of the Spring Valley Water Company at San Mateo. The water needed so badly in the city ran in a flood over San Mateo.

Burning of the Opera House.

The fire swept down the streets so rapidly that it was practically impossible to save anything in its way. It reached the Grand Opera House on Mission Street, and in a moment had burned through the roof. The Met-

was ruined, though its massive walls were not all destroyed.

A little further down Market Street, the Academy of Sciences and the Jennie Flood Building and the History Building kindled and burned like so much tinder. Sparks carried across the wide street, ignited the Phelan Building, and the army headquarters, were burned.

Still nearing the bay, the waters of which did the firemen good service along the docks, the fire took the Rialto Building, a handsome skyscraper, and converted scores of solid business blocks into smoldering piles of bricks.

Thousands Watch the Flames.

Pacific Division of the United States Army, were asked to send troops. A thousand men from the Presidio, sent by Gen. Funston, arrived downtown at 9 o'clock to patrol the streets. The Thirteenth Infantry, 1,000 strong, arrived from Angel Island a little later and went on patrol duty at once.

The soldiers were ordered to shoot down vandals caught robbing the dead and to guard with their lives the millions of dollars' worth of property placed in the streets to escape the flames.

The First California Artillery, 200 strong, two companies, was detailed to patrol duty on Ellis Street. Two more companies patrolled Broadway in the Italian section. The Ellis Street con-

ALL SAN FRA

Flames Ca
 Qu

PALACE H
 BIG

Old Civic Center DESTROYED 1906

The Gold Rush spurred growth for the first two decades of San Francisco's history. The city's seat of government moved from Portsmouth Square to a larger, newly appointed civic center at the location of Yerba Buena cemetery on Larkin Street, in 1872. In what some commentators regarded as the city's worst ever decision, the building was financed on a year-by-year basis until completion. This presented money-making opportunities to unscrupulous builders and corruptible city officials and also resulted in the structure being obsolete before completion, unable to incorporate the many advances in building technology being pioneered in other expanding U.S. cities.

Twenty-seven years in construction and costing $6 million, City Hall finally opened to great fanfare in 1899. But only seven years later the 1906 earthquake dealt it a fatal *coup de grâce* that many felt was a welcome release. The quake and the subsequent "Ham and Eggs Fire," which was generated in the Hayes district, left the building's magnificent dome perched atop a charred steel frame. This sight was described in the *San Francisco Examiner* as resembling "a huge birdcage against the morning dawn." The destruction did nothing to dispel the rumors of shoddy construction and cheap materials. The president of the Chamber of Commerce commented that the wreck was the result of "mixing bad politics with cement."

City Architect Newton J. Tharp defended the building in his report on the damage: "Contrary to popular belief, the bricks and mortar used throughout the entire structure are of the finest and the workmanship of the best. So far the most rigid inspection of the standing and fallen walls have failed to disclose any large voids or enclosed boxes, barrels or wheelbarrows that have been told in many an old tale as evidence of lax supervision and contractors' deceits."

As an indication of the waste that had gone into the first City Hall (which took 27 years to plan and construct), the new 1915 Beaux-Arts style City Hall was built for half the price of the original.

THE "HAM AND EGGS" FIRE

The fire that followed the earthquake is sometimes referred to as the "Ham and Eggs Fire." It is believed that one of the main fires broke out at a house on the south side of Hayes Street, about 70 feet east of Gough. The story goes that a woman lit her stove to cook breakfast at about 9:30 a.m. but because her chimney had been rendered defective by the earthquake, a ferocious fire broke out. The fire crossed Gough Street to the west, Franklin Street to the east and Hayes Street to the south. As there was no water available through the hydrants, the fire raged out of control. Whether it was started by this event or not, the fire that ensued lasted for two whole days until it burned itself out, leaving many more dead and a quarter million homeless. Because of the "Ham and Eggs Fire," Mayor Schmitz ordered that all cooking would take place in the street until building inspectors could inspect chimneys.

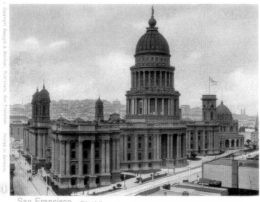

San Francisco. City Hall.

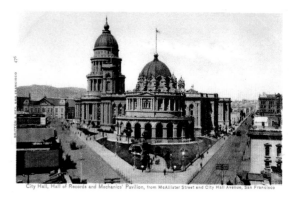

City Hall, Hall of Records and Mechanics' Pavilion, from McAllister Street and City Hall Avenue, San Francisco

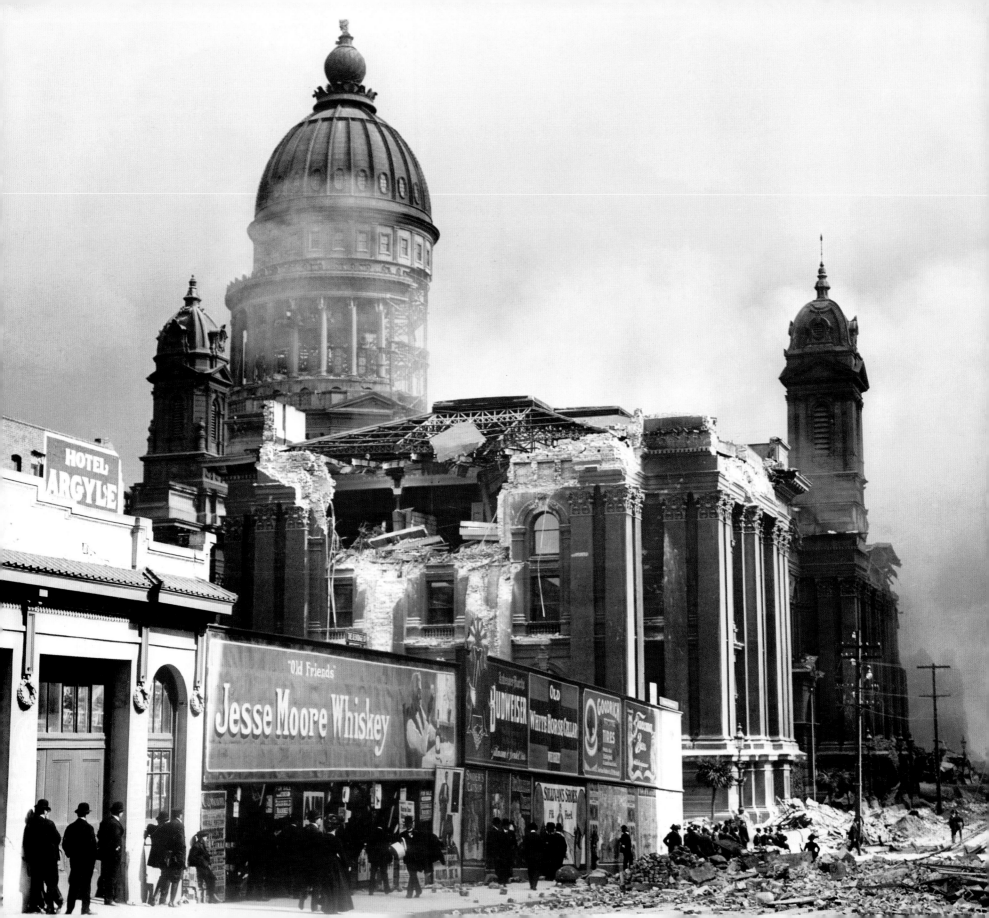

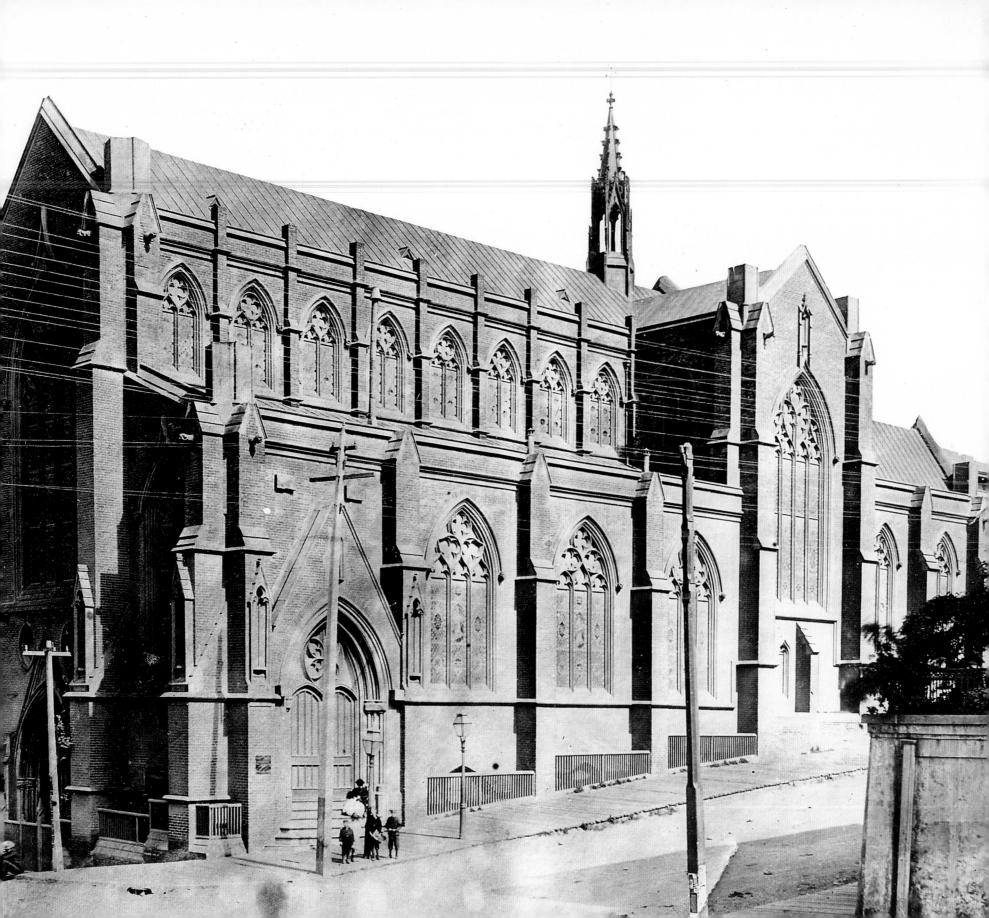

Grace Church VICTIM OF THE 1906 EARTHQUAKE

In 1848, members of the Episcopal faith living in San Francisco petitioned their Board of Missions for a minister. The board replied by sending the Reverend Jean Leonhard Henri Corneille Ver Mehr. He arrived with his family after a trip around Cape Horn and held the city's first Episcopal service on October 1, 1849.

In his book *Checkered Life In the Old and New World*, Ver Mehr described the obstacles, difficulties, trials and varied incidents of his early work. He oversaw the building of the first Grace Chapel, "where services were first held on July 20, 1850," Ver Mehr wrote. "Though plainly built it was

a good house for those days and cost $8,000." He described the chapel at Jackson and Powell streets as a "shingled-roof, clapboard-sided chapel measuring 20 x 60 feet."

The first "plainly built" chapel was replaced in 1851 by another of Ver Mehr's designs. "The church stands there yet, on the corner of Powell and Jackson streets, just as I designed it, except the spire, which is wanting," Ver Mehr remembered in 1877. By the time the 1906 earthquake struck, the expensive spire had finally been put in place.

The centennial mural inside today's Grace Cathedral depicts San Francisco firemen standing

helplessly by as flames engulf Ver Mehr's church. Sadly, historians lay the blame for this fire to a possible arsonist who had set fire to the Delmonico Restaurant in the Alcazar Theatre Building on O'Farrell Street near Stockton Street: that blaze burned into downtown and raced up Nob Hill. Firefighters attempted to make a stand at 9 p.m. along Powell Street, between Sutter and Pine, but they could not keep the fire from sweeping up the hill to Grace Church.

In 1908, construction began on the diocese's third church on Nob Hill, today's Grace Cathedral, at Taylor and California streets, three blocks from the Grace Church. The church rose up on the site of Charles and William Crocker's mansions and the infamous Spite Fence. The diocese established the third Grace church as a cathedral in 1910.

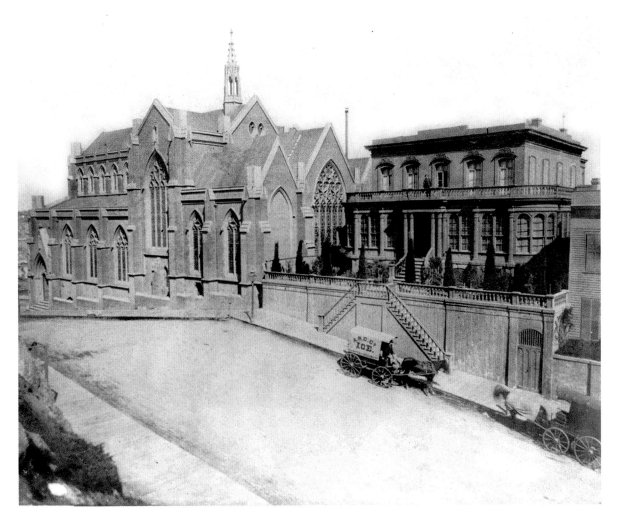

OPPOSITE PAGE AND LEFT *Ver Mehr's Grace Church of 1851 was the second church on the site, replacing a shingled-roof, clapboard-sided chapel.*

BELOW *The Crocker Mansion on Nob Hill was consumed by the Great San Francisco Earthquake and Fire of 1906 and served as the location for the rebuilt Grace Church Cathedral.*

Temple Emanu-El and the Sherith Israel Synagogue
VICTIMS OF THE 1906 EARTHQUAKE

In his book *The Jewish Community of San Francisco,* Stephen Mark Dobbs tells the story of the role that the Jews played in the city's early history. "Among the settlers around the Yerba Buena cove were men with names such as Jacobs, Meyers, Fischer and Adler," Dobbs writes. He reminds us that an important transition occurred in January 1847, when Washington Bartlett, the first American Alcalde, changed the name of the town from "Yerba Buena" to "San Francisco." Bartlett traced his lineage to a prominent Jewish Sephardic (of Spanish or North African origins) family, the Henriquez of Charleston, South Carolina.

On Yom Kippur, September 26, 1849, the first Jewish services were held in a tent that stood near the shoreline of Yerba Buena Cove at what is now 700 Montgomery Street. According to the plaque that marks the spot as State Registered Landmark No. 462, "forty pioneers of Jewish faith gathered... and participated in the first Jewish religious services in San Francisco." Sometime in 1850, the social barrier between the educated, upper-class,

Reform German Jews and the less educated, working-class, Orthodox Eastern European Jews, caused a split to form two synagogues.

Congregation Emanu-El chose to worship according to the German practices of Jews from Bavaria. Congregation Emanu-El's charter was issued in April 1851; most of the 16 members who signed the charter hailed from Bavaria. The congregation of 260 laid the cornerstone for a new synagogue at 450 Sutter Street on October 25, 1864.

"Our new Synagogue, now in course of erection on the Sutter street site, promises to be a noble structure," members of the congregation said in their chronicle. "It meets with the admiration of most everybody, and when completed the members of the Congregation Emanu-El may well feel proud of possessing such a house of worship."

On Friday evening, March 23, 1866, after more than four years of waiting, the congregation dedicated its house of worship. The building served as a house of worship until its destruction on April 18, 1906.

Members of the Congregation Sherith Israel followed the Polish traditions of Jews from Posen in Prussia. San Francisco's earthquake and fire of 1906 destroyed Sherith Israel's meeting place. After losing a second place of worship to another fire, the congregation purchased property on Stockton Street between Vallejo Street and Broadway in 1854 for $10,000. In 1870, Sherith Israel moved to an impressive, Gothic-style structure on Post and Taylor streets, where it remained for thirty-four years. In 1903, the congregation broke ground for its current synagogue at California and Webster streets.

RIGHT *Temple Emanu-El dominates the skyline in this 1864 photograph.*

FAR LEFT *Temple Emanu-El on the right and the National Guard Armory on the left photographed in 1866. In the mid-1850s the state of California called for volunteer militia companies. A company was organized in San Francisco on August 31, 1855. County Judge David McDowell presided at the election of officers of the new company, which chose the name "National Guard," and was mustered into State service under that designation. The armory at 312 Post Street was likely built around this time.*

LEFT *Members of the Congregation Sherith Israel worshipped in this synagogue on Post and Taylor streets. They broke ground for a new synagogue three years before the 1906 earthquake.*

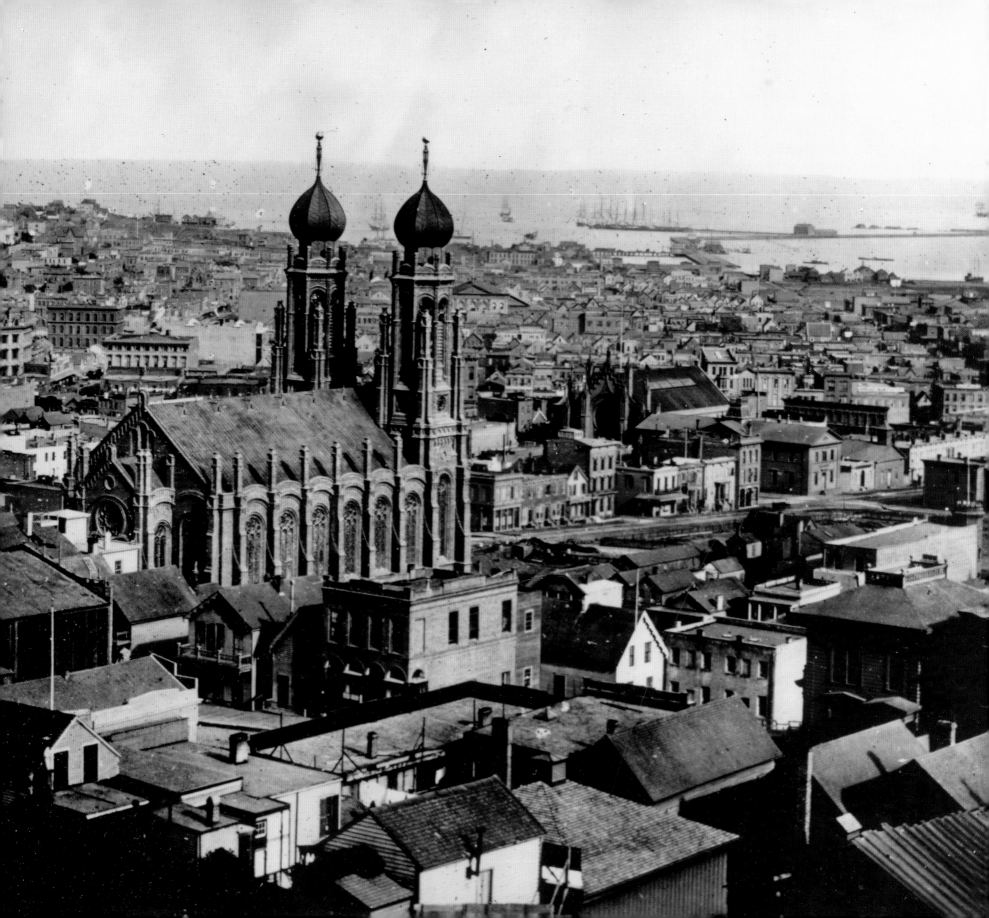

The Lick House VICTIM OF THE 1906 EARTHQUAKE

Despite his disdain for luxury, in 1862 James Lick (1796–1876) opened the opulent Lick House, a three-story hotel with a magnificent dining room copied from the Palace of Versailles. The Lick House soon became the meeting place of San Francisco's elite.

A month before the January 1848 Treaty of Guadeloupe Hidalgo delivered California to the U.S., Lick arrived in Yerba Buena with a chest full of $30,000 in pure Peruvian gold. The accomplished woodworker earned his money building pianos for the wealthy while living in South America. San Franciscans remember him as a bit of an oddity, trading the precious metal for some ridiculous sand dunes and far-flung districts of undeveloped Yerba Buena. He also had 600 pounds of chocolate he picked up from his neighbor in Lima, Peru, that sold well. He penned a letter about the chocolate sales to that neighbor, Domingo Ghirardelli, which brought the famed chocolatier to the city that made his name.

In his mid-50s, Lick gave off a poor impression. He rarely ate and appeared emaciated, wearing the same suit every day. As gold fever struck the city, Lick stayed behind, buying more land when residents-turned-miners sold their holdings for a pittance. When returning gold miners sought a place to settle down and San Francisco real estate value spiked, Lick owned much undeveloped land, including Montgomery Street, rising from the now subdivided dunes. Here James built the opulent Lick House Hotel.

The Lick House guests marveled at the attention paid to quality in this three-story, 164-room building that spanned two city blocks. Twelve double suites and six single suites boasted their own bathrooms, the remainder sharing baths. Guests could relax in the reading room, parlor or bar with billiard table, get a trim at the barber's and, of course, eat in the dining room modeled after that of Louis IV. At dinner, 400 guests could eat comfortably under a stained-glass domed ceiling some 48 feet above. The fabulous parquet floor featured more than 87,000 pieces of wood that Lick cut himself. In fact, much of the design and construction fell under Lick's watchful eye for craftsmanship. Along the walls of the dining room, Lick placed 9 x 12-foot mirrors of French plate glass and 11 panels of California landscapes by famed painter Thomas

Hill. Lick's masterful frames bordered each. During the 1865 quake, the hotel suffered damage only to the chimney, while other buildings, like City Hall, fared far worse, a testimony to Lick's engineering.

For some time, Lick maintained a single-room residence inside the hotel that also included his workbench. Later he moved to Room 127, with a view of the corner of Montgomery and Sutter streets. Even with his sudden tremendous riches, Lick still refused himself regular meals or a new suit. Instead, he largely worked on his mill, orchard and estate in the Santa Clara Valley.

Approaching 80 in 1873, he decided to change his reputation as a miser and began spending his massive fortune. Lick left $3 million to the state of California. Millions of dollars went to schools, including a new home for the California Academy of Sciences downtown. He also funded the construction of Lick Observatory atop Mount Hamilton in San Jose. After his death, a massive greenhouse he had originally intended for his private use still lay in crates.

James Lick died at the Lick House in 1876. The house was purchased by James Fair in 1889 and eventually sold by Fair's daughter to the Hunter-Dulin Company. The 1926 Hunter-Dulin Building now stands on the site of Lick House, which the 1906 earthquake and fire destroyed.

RIGHT *The Lick House boasted a dining room that could seat 400 people. Lick based the room's design on a similar room at the Palace of Versailles.*

BELOW LEFT *An exterior view of Lick House on Montgomery Street in 1866.*

BELOW *The James Lick Free Baths on Tenth Street, photographed in 1890, one of many latter-day public gifts.*

BOTTOM *The Lick Observatory on top of Mount Hamilton, San Jose.*

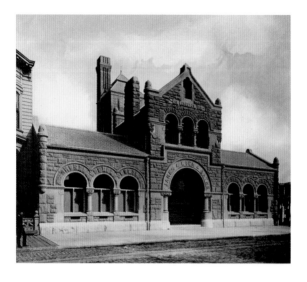

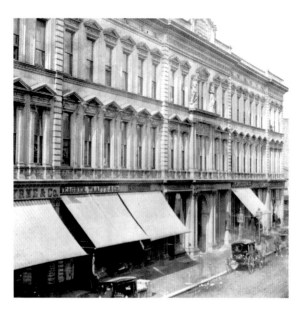

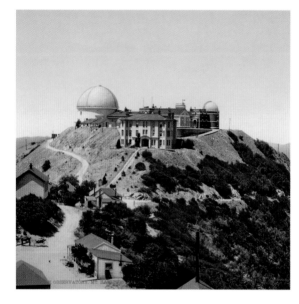

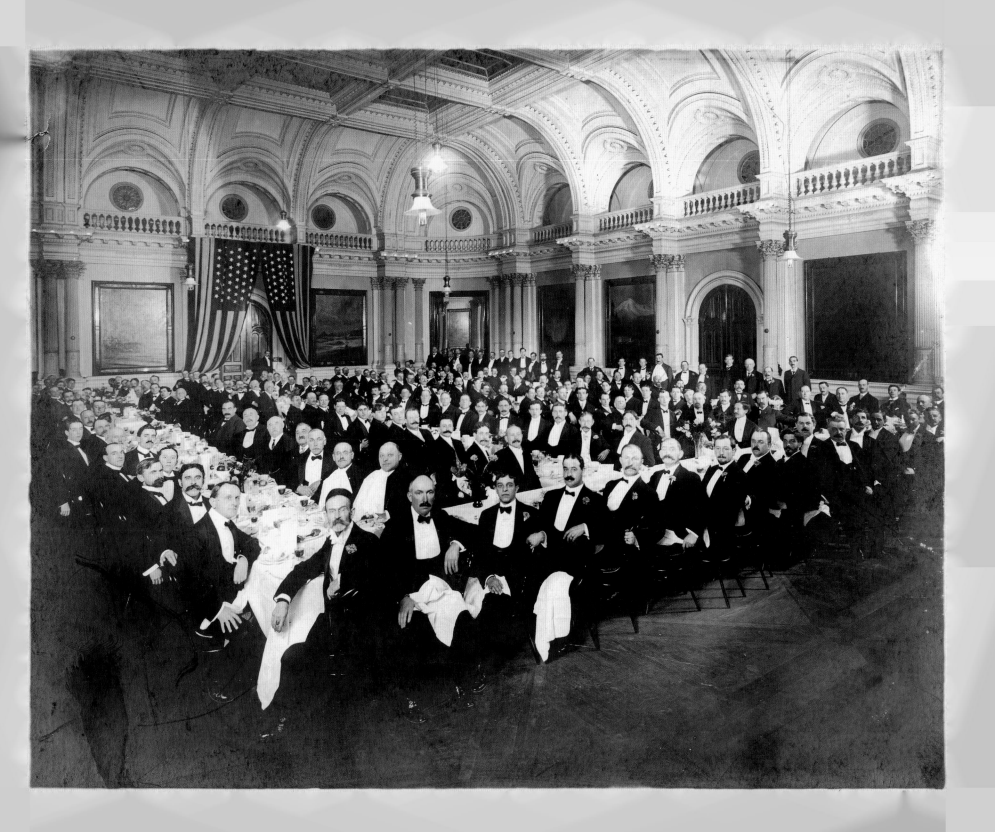

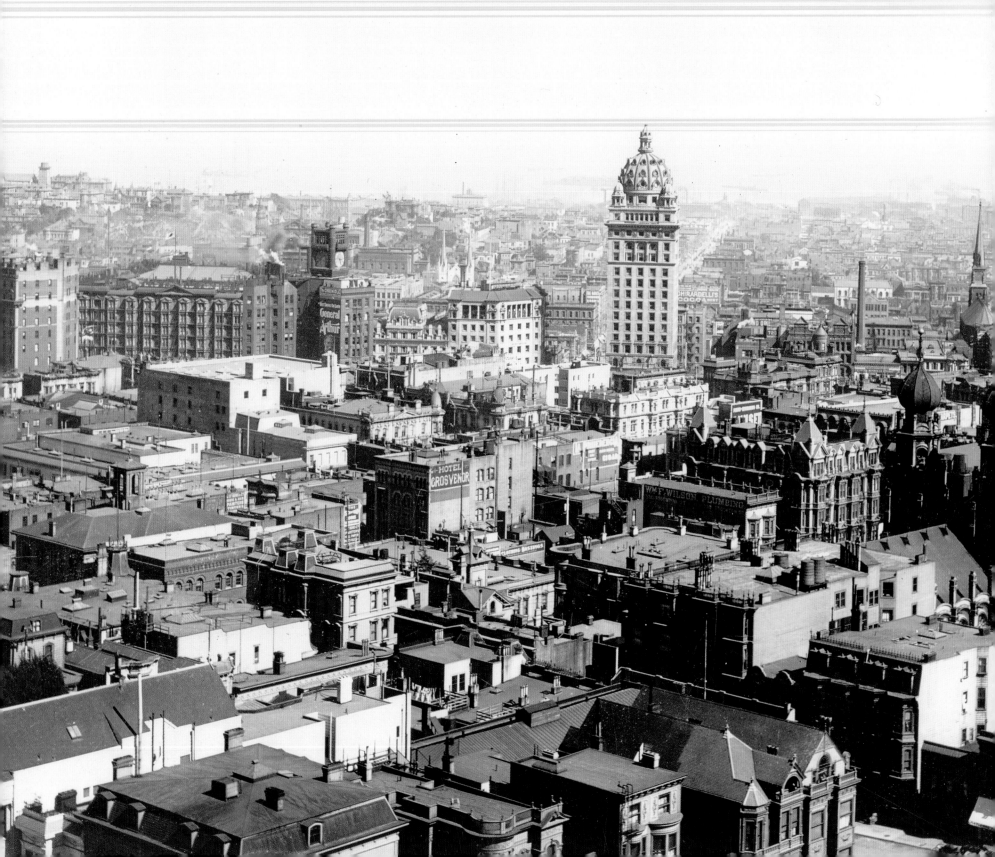

Newspaper Row PARTIALLY DESTROYED 1906

Until April 18, 1906, three buildings on Market Street once shouted, "The newspaper is king" to anyone who cared to listen. The *San Francisco Chronicle* building vied for attention with the *San Francisco Examiner,* but both were dwarfed by the *San Francisco Call* building, the tallest west of the Mississippi.

The *San Francisco Chronicle* had something to boast about, too. It had the largest circulation of the three newspapers. Not only that, but the 1889 Chronicle Building was nine years older than the Call Building and could rightly boast its status as San Francisco's first skyscraper. The de Young family had hired the prominent architectural firm of Burnham & Root to design the building with its signature clock tower. The building was completed in 1889.

The *San Francisco Examiner* was founded in 1863 as the *Democratic Press*, a pro-Confederacy,

pro-slavery newspaper. When Abraham Lincoln was assassinated in April 1865, a mob destroyed the *Democratic Press*'s offices. By June 12, 1865, the paper was reborn as the *Daily Examiner.* Fifteen years later, mining engineer and entrepreneur George Hearst bought the *Examiner*. After being elected to the U.S. Senate in 1887, he gave it to his son, William Randolph Hearst, who was then 23 years old. When William Randolph Hearst put up a new *Examiner* building on Market Street in 1898, he wanted to better both his rivals with a 26-story structure. However, while Hearst's architects were drawing up the blueprints, the city imposed a height limit of 12 stories on new construction, which thwarted his attempts to dwarf the Chronicle and Call buildings.

The *Call* began life in 1856, at 612 Commercial Street as the *Morning Call* and hired Mark Twain to

cover Nevada as a reporter in June 1863. On May 29, 1864, Twain moved to San Francisco, and for four and a half months worked as the newspaper's only full-time reporter.

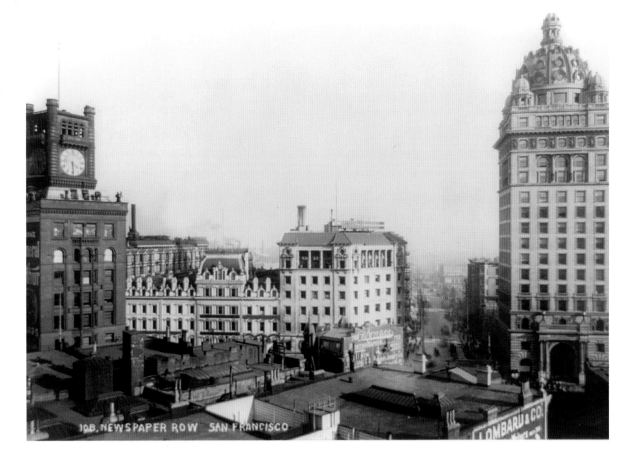

OPPOSITE PAGE *The San Francisco Call Building dominates the skyline in this photograph taken before the devastating 1906 earthquake. The Chronicle Building, with its signature clock tower, stands across Market Street. The pale Hearst Building, home to the* Examiner, *stands between the two.*

LEFT *The earthquake stopped work in all three buildings on Newspaper Row, but that didn't stop the presses. On April 19, 1906, the day after the temblor, the* Examiner, Chronicle *and* Call *brought out a joint edition, which they had printed across the bay in Oakland.*

AFTER 1906

CHRONICLE

The Chronicle Building at Kearny and Market streets did not crumble and survives today. After the 1906 earthquake, another well-respected architect, Willis Polk, restored the building for the de Youngs. Polk replaced the clock tower with office space. In 1924 the *Chronicle* left Market Street for its new digs at Fifth and Mission, across from the Old Mint building. The Market Street building was clothed in white enameled porcelain in 1962, but a 2007 renovation removed the enamel and restored the building's brick facade.

EXAMINER

The Hearst Building, home to the *San Francisco Examiner*, went up on Market Street, right across from the Call Building on Third Street. Like the Call Building, it was completed in 1898. The architect was Albert Cicero ("A.C.") Schweinfurth. The building survived the earthquake and fire but was destroyed by the Army, who dynamited it to create a firebreak in a futile attempt to save the Palace Hotel just two blocks down Market Street. In 1906 Phoebe Hearst hired the architectural firm of Kirby, Petit & Green to rebuild it. The building was completed in 1909. In 1937 the facade, entranceway and lobby were remodeled by architect Julia Morgan.

CALL

San Francisco Call owner John Spreckels wanted a tower to eclipse the de Young's ten-story Chronicle Building. He hired architects James and Merritt Reid and Charles Strobe to design and build the structure just across Market at Third Street. Strobe was a bridge builder who owned a patent on a design that the Reid brothers incorporated into the building to strengthen it. Ground was broken (actually sand was shoveled) in September 1895 and the building was completed in 1898. The Call Building burned in the 1906 fire but did not "crumble." The *Call* moved into "The Montgomery," a new building on New Montgomery Street, which the Reid brothers also designed. In 1938, architect Albert Roller refurbished the fire-damaged Call Building by removing its top floors and signature dome. The Call Building survives as an office building called the Central Tower.

The newspaper itself has had an even more eventful history. In 1913, M. H. de Young, owner of the *San Francisco Chronicle*, purchased the paper and sold it to William Randolph Hearst who brought

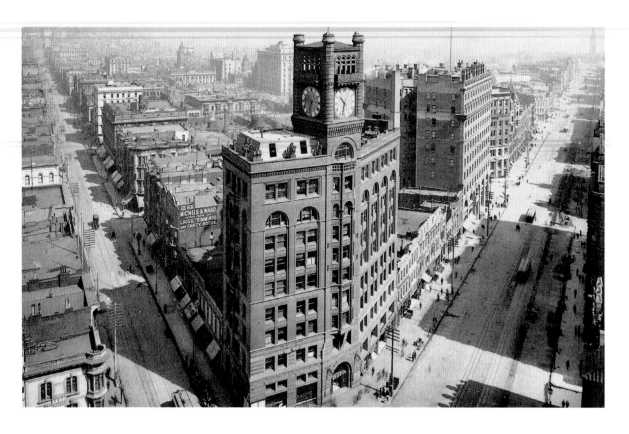

in editor Fremont Older, former editor of the *San Francisco Evening Bulletin*. Then, in December of that year, Hearst merged the *San Francisco Call* with the *Evening Post* and the papers became the *San Francisco Call & Post*.

The name changes continued. On 29 August, 1929, the newspaper was renamed yet again to the *San Francisco Call-Bulletin*, when the *San Francisco Call & Post* merged with the *San Francisco Bulletin*. In 1959, the *San Francisco Call-Bulletin* merged with Scripps-Howard's *San Francisco News* becoming the *News-Call Bulletin*. Finally, in 1965, the paper was swallowed up by the *San Francisco Examiner*.

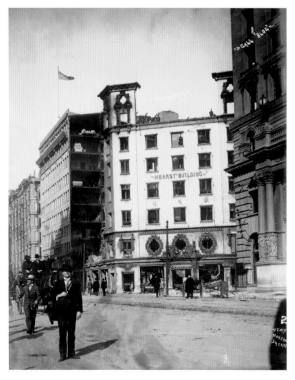

OPPOSITE PAGE *The San Francisco Call Building managed to remain intact despite being damaged in the fire that followed the 1906 earthquake. The Hearst Building, behind, did not fare so well.*

ABOVE *The Chronicle Building, one of the first steel-framed skyscrapers, survived the earthquake and fire of 1906 and still stands today.*

RIGHT *The Hearst Building, home to the* San Francisco Examiner, *just about survived the earthquake but it was detonated to provide a firebreak to save other buildings.*

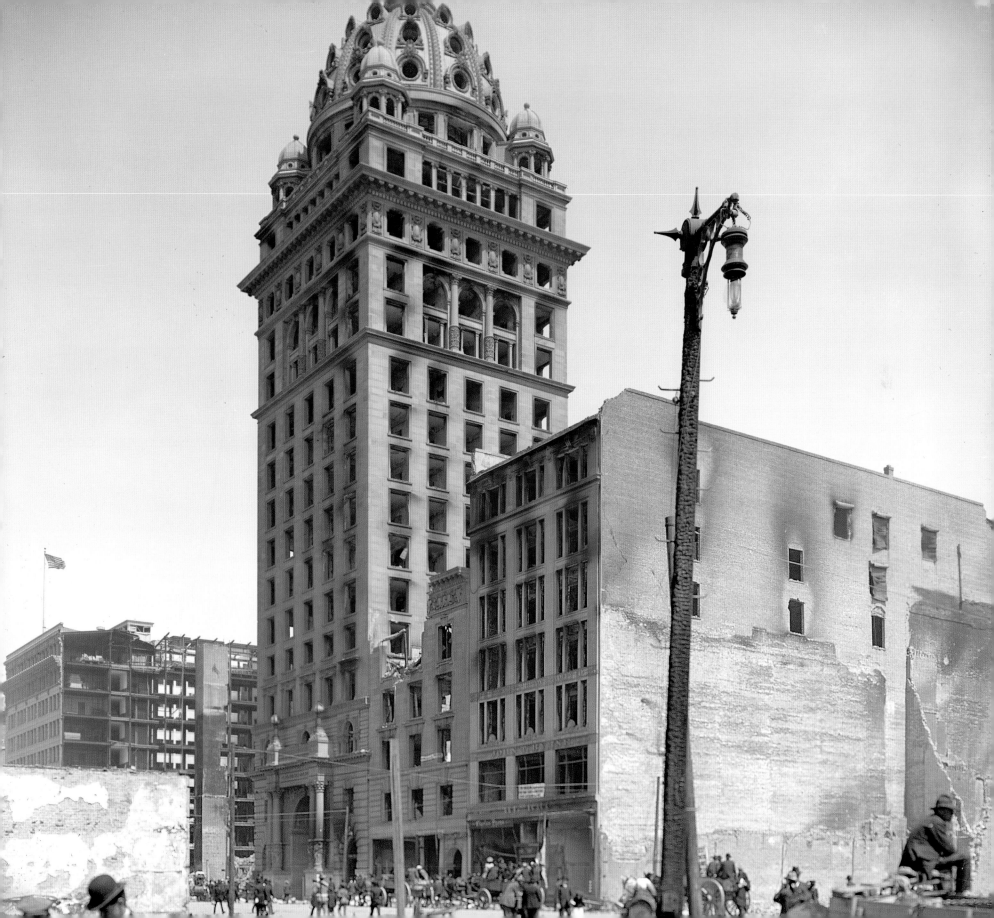

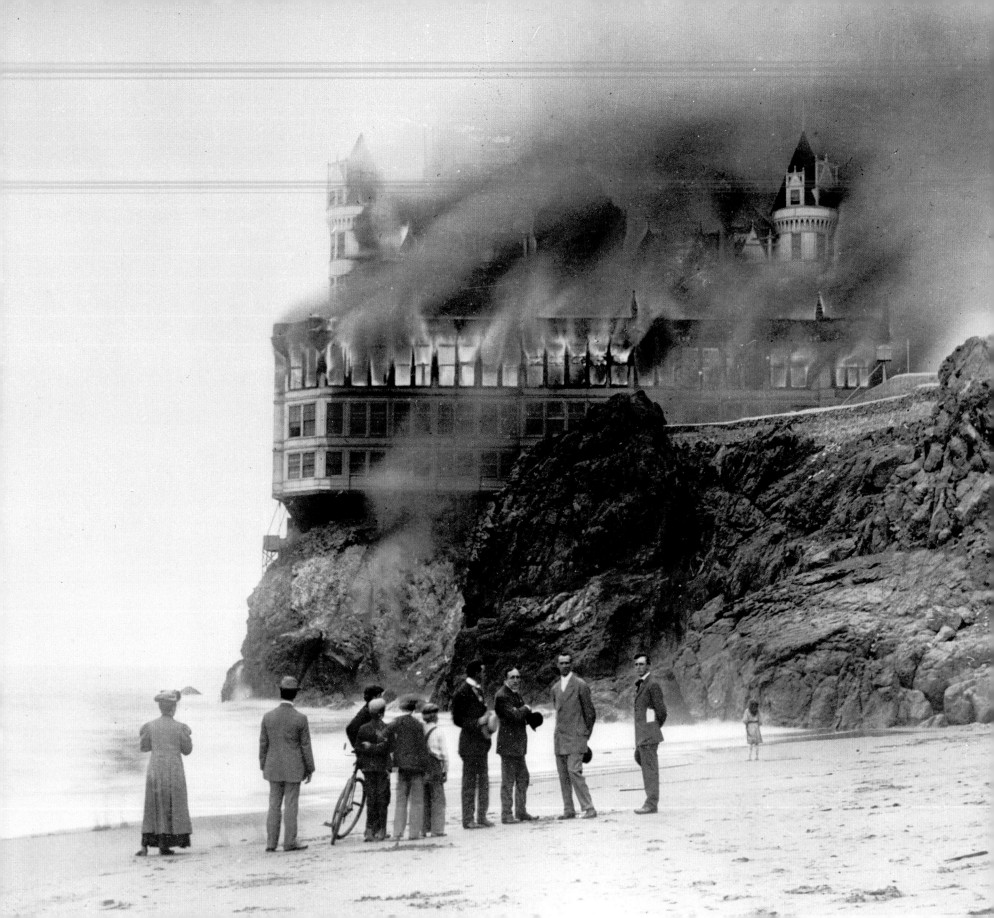

Cliff House BURNED 1907

In 1863, the same year the Boys in Blue claimed victory after Pickett's Charge at Gettysburg, California State Senator John Buckley financed real estate speculator C. C. Butler's vision to build the first Cliff House, a modest restaurant with a balcony overlooking Seal Rocks that would cater to San Francisco's wealthiest residents. Butler leased it to manager Captain Junius Foster and regardless of exorbitant pricing of both hiring transportation across the dunes and the food and drink upon arrival, business boomed. Foster's 1868 expansion of both the building and the promenade attracted larger crowds. Increasingly the clientele turned out to be corrupt politicians influencing their constituents, and Barbary Coast rowdies out for a good time.

Soon the place was synonymous with drunken debauchery, scandal and noise. Once the city's most influential neighbor moved into the heights above the Cliff House, the party ended. Adolph Sutro, disturbed from his sleep one too many times, purchased the building in 1883, installing his own man as manager. Sutro's efforts restored the Cliff House to its former appeal, bringing families, tourists and quality food and service back to the location. In 1887, the Cliff House almost met its end. The *Parallel*, a schooner heavily loaded with black powder and dynamite caps, plus a full complement of kerosene, ran aground below the north wing of the house.

Timely rescue efforts by locals—including Sutro himself—to save the crew proved unnecessary, as they had abandoned ship long before impact. With just two men standing guard on the cliffs above, at about midnight the dynamite caps somehow set off the black powder and the resultant explosion could be heard in San Jose. The watchmen were blown backward, every window and room in the Cliff House was damaged or destroyed, and even Sutro's mansion suffered significant damage.

The explosion obliterated the north wing of the Cliff House, but the bar was swiftly swept out so spectators coming to see the results of the explosion would have something to drink. An unremarkable kitchen fire destroyed the rest of the house on Christmas Day 1894. Sutro, in his typical overdone way, rebuilt the Cliff House into a magnificent eight-story, towered French chateau-style palace that opened in 1896.

Entering on the ground floor, one could visit the bar, dining room or sitting room. The second floor offered visitors 20 different lunchrooms to eat in, a gem exhibit and an art gallery. The third floor presented a photo gallery and viewing parlors with panoramic views, a pale comparison to those from the tower five stories higher.

Dancers and performers filled the ballroom. And true to his populist nature, Sutro offered all this for little more than a nickel. He also established a nickel streetcar line to compete with the Southern Pacific's exorbitant fares in hopes that both his Cliff House and the Sutro Baths would be low-cost entertainments for working-class as well as upper-class residents. Holding out for the common man, Sutro delayed the opening of Sutro Baths until the Southern Pacific lowered its rates to deliver passengers to his attractions. Then he ran against a railroad man for mayor and won. In a spectacular fire in 1907, the Cliff House burned to the ground in less than one hour. Newspaper accounts from the time suggested that the fire may have been related to renovations taking place after Sutro's daughter leased the house to restaurateur John Tait and his seven partners.

Tait rebuilt the Cliff House in 1909 and it has continued the tradition of offering fine food and a beautiful view off and on until today. Over the years, the place has played host to a number of American presidents, including Ulysses S. Grant, William McKinley and Theodore Roosevelt.

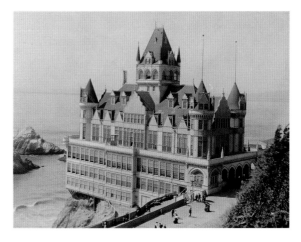

OPPOSITE PAGE *A spectacular fire destroyed the second Cliff House in September 1907.*

TOP RIGHT *The first Cliff House, seen here in 1865, was a modest restaurant with a commanding view of the Pacific Ocean from its balcony. It was opened in 1863, extended in 1868 and destroyed by fire on Christmas Day 1894.*

MIDDLE RIGHT *The second Cliff House was far more ambitious than its predecessor and successor. Adolph Sutro's magnificent 1896 building stood eight stories tall until it burned to the ground in 1907.*

BOTTOM RIGHT *The modern-day Cliff House followed Sutro's Victorian-era masterpiece in 1909.*

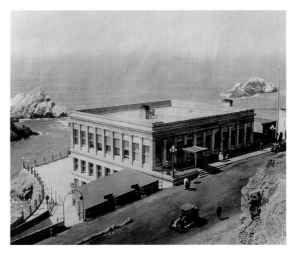

South Park Neighborhood REDEVELOPED 1907

When Londoner George Gordon arrived in San Francisco in 1851 he set himself up as a lumber dealer and used his product to build some of the city's wharves. He set up "Vulcan," one of the city's first iron foundries and built a row of fireproof iron buildings on Front Street. He later opened another successful enterprise refining sugar. He used his wealth to build his county estate, Mayfield Grange, which railroad baron Leland Stanford later purchased and is now the site of today's Stanford University. He also used his wealth to purchase real estate in San Francisco.

Gordon came up with a sales tool in the form of an eight-page brochure he called "Prospectus of South Park." Here he outlined a plan to lay out what he called "ornamental grounds and building lots on the plan of London Squares, Ovals or Crescents." He planned to develop homes for 58 families around the park, with a windmill at its center to provide water for the homes. To suit his purpose, Gordon purchased 12 acres on the southwest side of Rincon Hill.

On August 21, 1854, he began offering lots for sale in the *Alta California* newspaper. The following January he used the *Alta* to announce a "Great Sale of thirty-two building lots." In the same issue he noted that seventeen mansions had already been built around the 550-foot oval garden, which the newspaper described as "tastefully laid out." The park in the center was closed to all but the residents and their servants.

Prominent San Franciscans called South Park home. These included businessmen like Robert B. Woodward, creator of Woodward's Gardens; David Douty Colton, lawyer to the Central Pacific Railroad's "Big Four"; and Lloyd Tevis, who later became president of Wells Fargo Bank. Politicians—like William McKendree Gwin, one of California's first United States senators; Judge Hall McAllister, for whom McAllister Street is named; and Governor John Downey's secretary, George Wallace—also lived on South Park.

However, encroaching industrialization, which began at nearby Steamboat Point, drove the wealthy away. In 1869 the bottom fell out of Gordon's project when the "Second Street Cut" encouraged industrialization to creep too close to South Park's oval for its prominent residents to bear. South Park denizens literally took to the hills, building homes on nearby Rincon Hill and, as Colton would do, on Nob Hill.

By 1877 the elite were gone. The September 1877 edition of the *San Francisco Real Estate Circular* called South Park "a relic of bygone days." Alfred Schumate points to Gregory Yale's house as an example. In his book *South Park and Rincon Park*, Schumate describes how Yale sold his home to James Phelan, who "tore down Yale's home and erected a large-frame apartment house."

The city took the park under its aegis in 1897, established it as a public park and removed the locks on its gates. "In 1906 the earthquake and fire removed the neighborhood," writes Jeanne Alexander of the Neighborhood Parks Council. Nine years later the Great Earthquake and Fire struck, destroying homes and driving residents away. After the temblor and fire, South Park was rebuilt into what Alexander calls "a motley collection of warehouses, machine shops, sleazy hotels and honky-tonks." Light manufacturing, nightclubs and commercial establishments stood where the elite once called home.

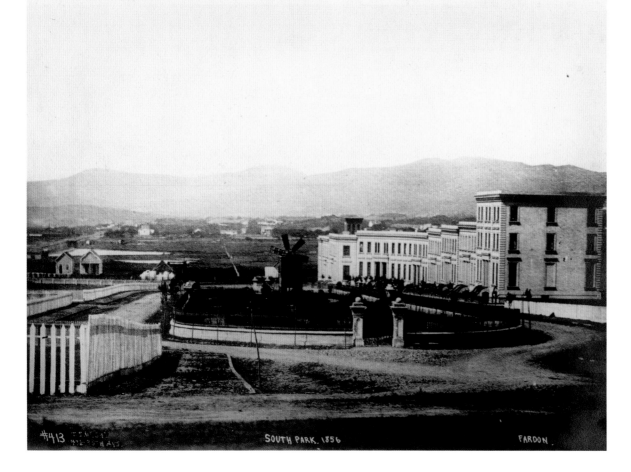

RIGHT *The wealthy residents of South Park could climb aboard this horse car line that traveled through town to North Beach.*

LEFT *George Gordon built South Park for the rich who wanted to escape from the sights, sounds and smells of downtown San Francisco. The oval park within the confines of South Park was off limits to all but the families who lived there—and, of course, their nannies.*

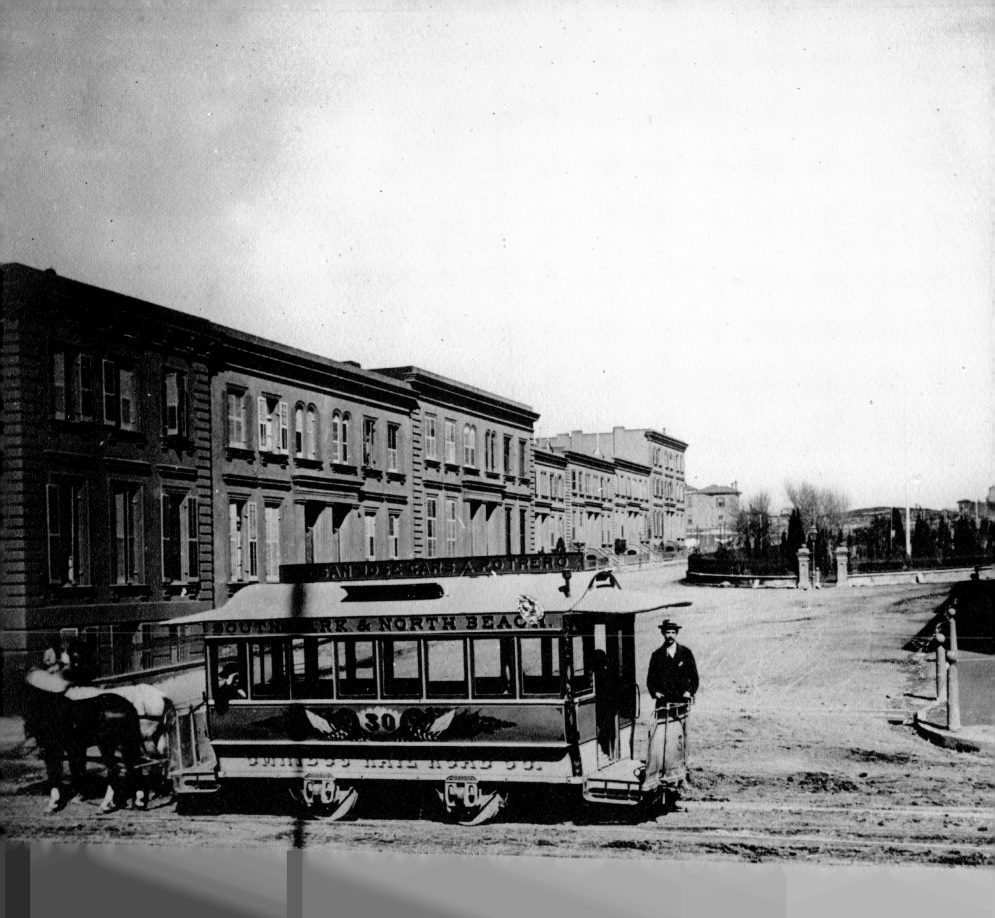

San Francisco Wharves REPLACED BY SEAWALL 1912

In the 1850s, an assortment of 12 wharves jutted out into San Francisco Bay between Union and Market streets. Law's Wharf, Buckelew's Wharf and Cunningham Wharf stood on Battery Street at the foot of Union and Green streets. The Vallejo Street, Broadway and Pacific Street wharves, (pictured opposite), were gathered around Clarke's Point, the small peninsula named for W. E. Clarke, that defined the northwest border of Yerba Buena Cove. Seven more wharves crowded the shore southeast to the Market Street wharf.

In May 1, 1851, the California legislature had passed the Second Water Lot Bill, which gave San Francisco the right to build wharves into the bay, and thus beyond the city limits. Francis Salmon built the Broadway Wharf, while M. R. Roberts and Joseph R. West received the contract for the building of Pacific Street Wharf.

The Vallejo Street Wharf began life as the hulk of the beached steamer *James K. Polk* at Clark's Point, where the bluff was leveled. Mr. O'Brien (his first name is lost to us) received the contract to build the wharf at Vallejo Street.

The Pacific Mail's steamships tied up at the Broadway Wharf. Ferries that served Oakland and Sacramento and Marysville berthed at the Pacific Street Wharf, which earned a reputation as the "gateway" to the Barbary Coast.

In the 1860s, San Francisco's waterfront had become a tangled hodgepodge of wharves and piers. California's Board of State Harbor Commissioners approved a plan to replace the disorganized jumble with a seawall. Construction began in the late 1860s, but the arrival of the transcontinental railroad across the bay in 1869 cut cargo traffic at the port in half, and lost revenue put a stop to work on the seawall. In 1881, the commissioners decided to begin the work on the seawall in earnest and by 1912 the task was complete. The seawall took the shoreline three to four blocks into the bay. Pier 9 now stands near the site of the Vallejo Street, Pacific Street and Broadway wharves, albeit three blocks away.

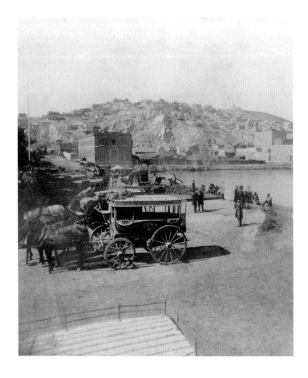

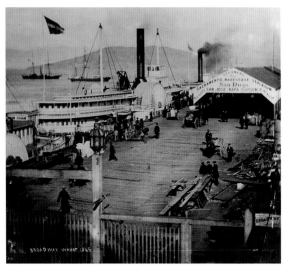

MEIGGS' WHARF

One wharf of particular notice stretched out into the bay from the foot of Taylor Street and took its name from its owner, Henry Meiggs, one of the biggest hustlers in 1850s San Francisco. When he arrived in 1850 all vessels entering the Golden Gate anchored in Yerba Buena Cove at the foot of what was then Washington, Commercial and Jackson streets. Wharves were extended into the bay and residents generally recognized that locality as the city's only shipping point. Henry Meiggs had other ideas. He built a road around the base of Telegraph Hill to Clark's Point. He ran out a wharf 2,000 feet long from the foot of Powell Street (pictured below), hoping to encourage ship owners to make use of his facilities for their warehouses. He told them that his dock was closer to the Golden Gate, and its inducements superior to the old anchorage. He plunged heavily into debt trying to swing this big scheme. Later stories claim that Meiggs repaid all his debts, as much as one million dollars. Meiggs' Wharf became the landing for the ferry to Sausalito until a seawall enclosed it in 1881. Today, Fisherman's Wharf, a widely popular tourist destination, is located on the former site of Meiggs' Wharf.

OPPOSITE PAGE *The Vallejo Street, Broadway and Pacific Street wharves lined up shoulder-to-shoulder from left to right on the San Francisco waterfront. These wharves stood near Clarke's Point that defined the northwestern edge of Yerba Buena Cove. Today this spot lies beneath the city's streets.*

ABOVE *Broadway Wharf in 1865. All ferries sailed from here until the late 1870s when they moved to the foot of Market Street.*

TOP *A view of carts waiting at Vallejo Wharf around 1865 with Telegraph Hill in the background.*

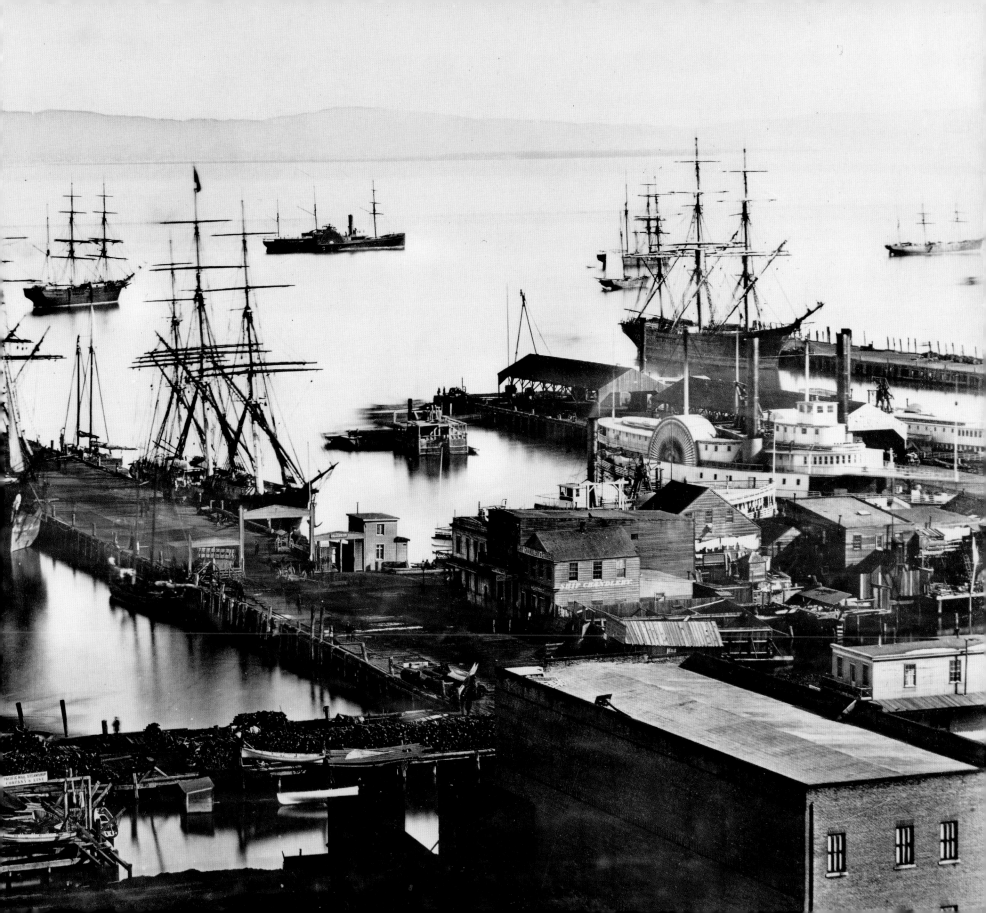

Barbary Coast OUTLAWED 1914

The storied neighborhood of the Barbary Coast, the seedy underbelly of San Francisco, was known coast to coast for its debauchery and vice. Unspeakable things happened in venues in this neighborhood: from getting "Shanghaied" to escorting "dancing girls" to the opium dens. The Barbary Coast began life with Sydney-Town at its nucleus. Sydney-Town, named for Australian immigrants known as Sydney Ducks, centered on Broadway and Pacific Street.

The Australians did not bring prostitution and vice to the area; trouble was already brewing when the immigrants from Down Under arrived. The neighborhood acquired its moniker sometime around 1860, borrowed from the Barbary Coast of North Africa where Arab pirates were active.

Colonel Albert S. Evans gave a first-hand description of the Barbary Coast in his 1871 book, *A la California: Sketch of Life in the Golden State*. He wrote that, "Every city on earth has its special sink of vice, crime and degradation, its running ulcer or moral cancer, which it would fain hide from the gaze of mankind. London has its St. Giles, New York its Five Points." Evans's list of contents relating to the Barbary Coast included subjects such as "The Thieves and Rounders of San Francisco, How they Live and where they Lodge; The Dance-Cellars; Opium Dens and Thieves' Ordinaries of the Barbary Coast and How the San Francisco Police treat Old Offenders, etc., etc."

Evans wrote that San Franciscans will "point triumphantly to the Barbary Coast, strewn from end to end with the wrecks of humanity, and challenge you to match it anywhere outside of the lake of fire and brimstone." He invited his readers on a daylight stroll through the area bounded by Montgomery, Stockton, Washington and Broadway streets. "You will have but a faint idea, a very inadequate conception, of the real character of the locality," he told his readers.

Evans described the "few red-faced, frowzy females" he encountered during the day, "glancing from their seats just inside the doorways of bars stocked with well-drugged liquors." Evans discovered that "every second building has a saloon." These dens of iniquity boasted names such as the Roaring Gimlet, the Bull's Run, the Cock of the Walk and the Star of the Union. For the most part, Evans found that the "dirty shops, saloons and basements have a thriftless, tumble-down, hopeless and half-deserted appearance. Such is the Barbary Coast by daylight." But Evans warned, "by gaslight or moonlight it is quite another thing... At night jay-hawkers, short-card sharps, rounders and pickpockets join with prostitutes and their assistants as the Barbary Coast comes alive as victims dare stroll in."

The 1906 earthquake devastated the area and four years later the city launched a vice campaign. The 1914 Red Light Abatement Act helped spell the end of barbarous practices. The act, passed by the California legislature and signed by Governor Hiram Johnson in 1913, was intended to curtail or eliminate prostitution; it became law on November 3, 1914.

Hal Mohr's 1915 film *The Last Night of The Barbary Coast* crystalized the nation's distaste for the area. City officials later claimed that the last brothel on San Francisco's Barbary Coast closed its doors in 1917.

RIGHT *Women await their "customers" at one of the larger establishments along the Barbary Coast.*

BELOW LEFT *The Midway, Bear, and Hippodrome were popular venues for entertainment along the Barbary Coast. Gambling and prostitution went hand in hand with the gold rush economy of the 1850s, but the vice outlived the gold.*

BELOW *The California Midwinter Exposition of 1894 had its more exotic exhibits and Parisian belles were to the fore, including "the Belle of Midway" Belle Bara.*

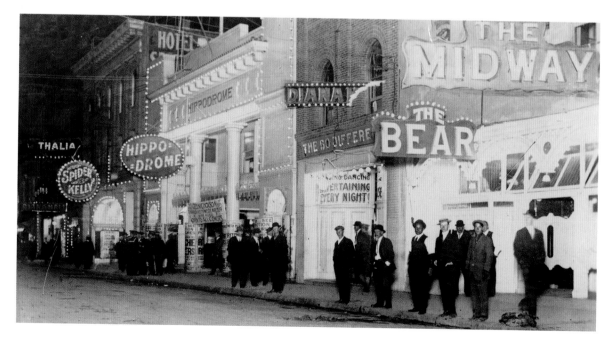

1915 Panama-Pacific Exposition DISMANTLED 1915

In 1911, San Franciscans could think of no better way to express their recovery from the devastating 1906 earthquake than to host a world's fair. San Francisco was overjoyed when President Howard Taft announced that the city had won out over its primary rival, New Orleans, to host the Panama-Pacific International Exposition, which ran from February 20 to December 4, 1915. It took more than three years to build the venue for the exposition, which celebrated the completion of the Panama Canal and remembered the 400th anniversary of a discovery made by explorer Vasco Núñez de Balboa on September 25, 1513. (Balboa called his discovery the "South Sea," which explorer Ferdinand Magellan later renamed the Pacific Ocean.)

Some wanted to build the exposition at Golden Gate Park, but the mud flats at the northern end of the city won out. The 645-acre fair was located between Van Ness Avenue, the Presidio, Chestnut Street and San Francisco Bay. The *San Francisco Chronicle* called the exposition "a magical city of domes and pastel-colored buildings that lasted for only a few months, like a dream." Palaces, courts, state and foreign buildings dotted the landscape— most built with a temporary plaster-like material, designed to only last the duration of the fair. At 43 stories the Tower of Jewels with some 100,000 panes of colored glass dominated the make-believe landscape; each pane individually hung to move in the wind and reflect the light.

Alexander Graham Bell kicked off the festivities by making the first-ever transcontinental telephone call to the fairgrounds before the fair opened. Visitors to the exposition marveled to learn that a cross-country telephone call was made every day

the fair was open. Fairgoers could ogle a full-scale model of the Panama Canal that covered five acres. They could ride around the model on a moving platform, listening to information over a telephone receiver. Visitors were also able to listen to the first-ever ukulele performances in the United States—which would eventually lead to the ukulele craze that hit the country during the Roaring '20s.

Automobile maker Henry Ford visited the fair, where the Palace of Transportation housed an actual Ford assembly line. Fairgoers watched in utter amazement every afternoon as the line turned out one car every ten minutes for three hours, except, of course, on Sunday. The line turned out some 4,400 cars over the duration of the exposition.

Inventor Thomas Edison visited the exposition to show off a storage battery that he had created. He was photographed with other notables standing next to the Liberty Bell, which had made a cross-country pilgrimage from Philadelphia.

General Electric entertained fairgoers with its "Scintillator," a battery of searchlights on a barge on San Francisco Bay that beamed 48 lights in seven colors out across San Francisco's fog banks. No fog? No problem: a steam locomotive generated artificial fog.

The Palace of Fine Arts is all that remains to remind us of the exposition. Built to house the work of living artists, famed architect Bernard Maybeck's creation was considered by many too beautiful to destroy. Like the other buildings at the exposition, Maybeck's palace was not built to last. In 1964 it came down and restoration work began. Some forty years later, the palace got a second facelift, which workers completed on January 14, 2011.

RIGHT *The Tower of Jewels lights up the night sky at the Panama-Pacific Exposition. The tower stood as the tallest building at the fair and sparkled with thousands of twinkling, free-hanging jewels. The sky beyond is lit with spotlights from the "Scintillator," a barge that cruised around San Francisco Bay and provided a light show above the fairgrounds.*

BELOW *A bird's-eye view of the 1915 exposition site.*

BOTTOM *This panoramic view shows the breadth of the Panama-Pacific Exposition, which covered 645 acres. At night, crowds would be guided toward the site by illuminated arches put up by businesses along Fillmore Street.*

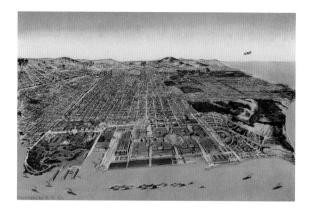

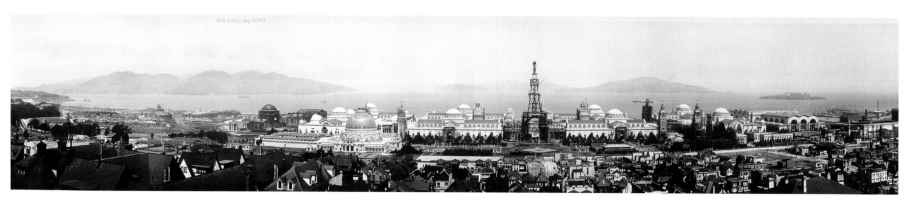

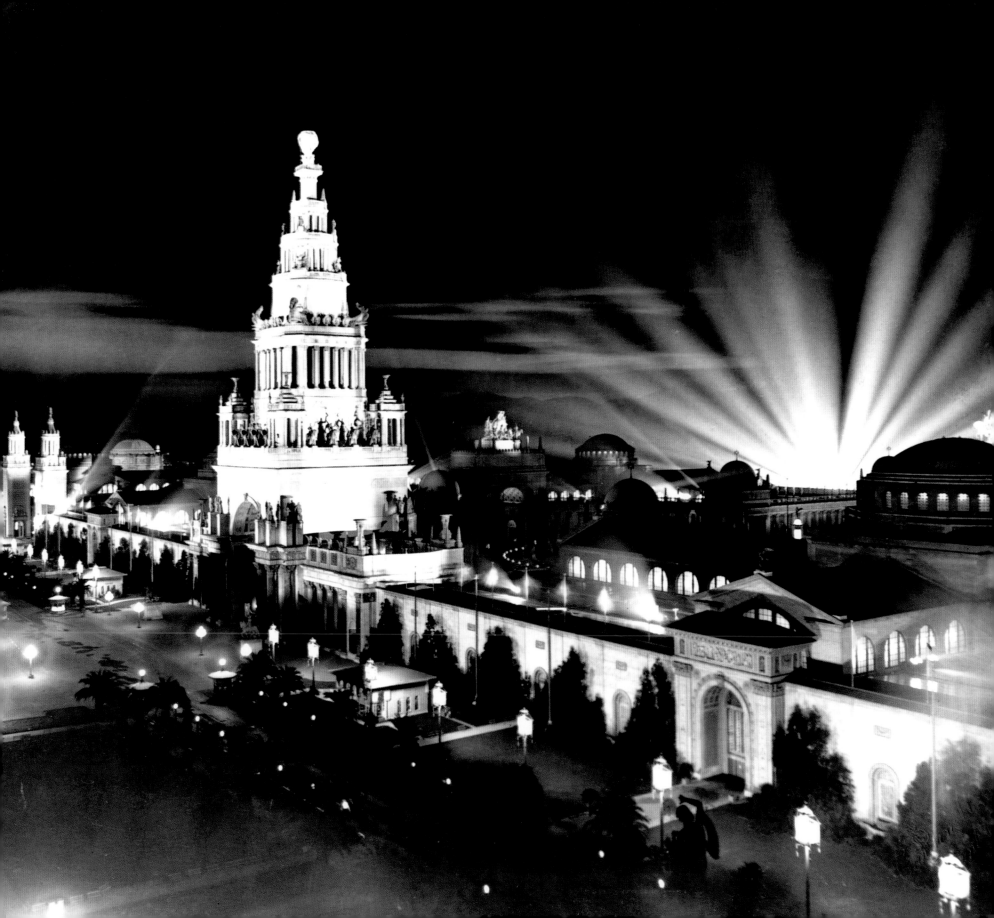

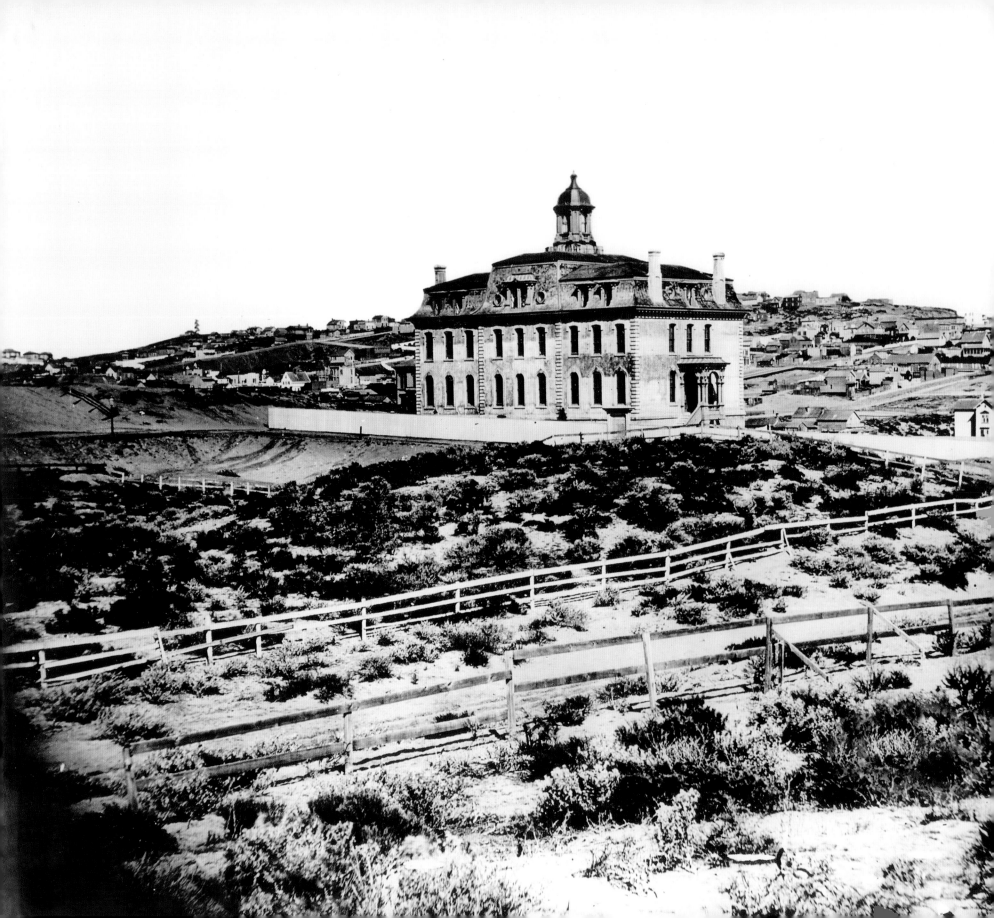

Ladies' Protection and Relief Society Building RAZED 1919

The Ladies' Protection and Relief Society was established on August 4, 1853. The society first met in a home in a small building on the east side of Franklin Street between today's Geary Boulevard and Post Street. The building provided a home for friendless or destitute girls between the ages of two and fourteen and boys in that same sad situation between the ages of two and ten. The orphans remained here until the society could find permanent homes for them. Over time the society needed more space. The ladies raised some $23,000, and broke ground on October 1, 1863, for a commodious new building that opened its doors on April 20, 1864.

The society was part of a network of social welfare services that charitable institutions provided. These services allowed state and city political leaders to avoid expanding San Francisco's public welfare system, which consisted of the city hospital, the jail, an almshouse and a juvenile hall. Support for private charities also allowed citizens to maintain control over social welfare spending. Essentially conservative in the area of gender politics, citizens preferred to keep social welfare work in the hands of white, middle-class church women who—unlike (male) politicians—they saw as innately pure and altruistic, and therefore immune to the greed and corruption that plagued urban politics.

Contemporaneous reports describe some of the children the society helped in its early days. Someone brought Susie Jones, a half orphan, abandoned by her father to the society. Police Officer Forner brought to the society's office 11-year-old Lena Dorf. Lena had escaped from her uncle August Kreiger and taken refuge with a neighbor. The child told the neighbor that her uncle brought her from Germany. She also claimed that since her arrival she had been frequently kept at work from early morning until midnight. She said that she had been cruelly punished for the most trivial offenses.

A 17-year-old girl, identified only as L. F., came to the society's office to say that she had escaped from her mother, a disreputable woman, who was about to take her to an inland town to consign her to "a fate worse than death," as she had done with an elder sister. The society temporarily placed L. F. in their Franklin Street home. When an inquiry proved the truth of her statement she was placed with a "worthy family."

The 1906 earthquake spelled the beginning of the end of the society's building. "The historic old structure at Geary and Franklin, used as the home of the Ladies' Protection and Relief Society, had stood the assaults of the elements since 1864, but was a wreck within 10 seconds of the giant shock," the *San Francisco Chronicle* reported on May 1, 1906. "The windows were reduced to atoms, doors wrenched from their hinges, portions of the side walls fell and the roof of the annex, containing the offices, reposed on the sidewalk below."

In 1919, because of the earthquake damage and age of the building, the society decided to sell the property and build a new orphanage. The State of California purchased the property and razed the 1864 structure. The society recovered from its loss and in 1925 constructed a Julia Morgan-designed building on a lot on Laguna Street, between Bay and Francisco streets, that was part of the 1915 Panama-Pacific International Exposition.

OPPOSITE AND LEFT *The sandy and barren nature of the ground around the Ladies' Relief Society orphanage on Franklin Street is clear to see in these photos from 1866. The building was rendered unusable within seconds of the 1906 earthquake and was finally razed in 1919.*

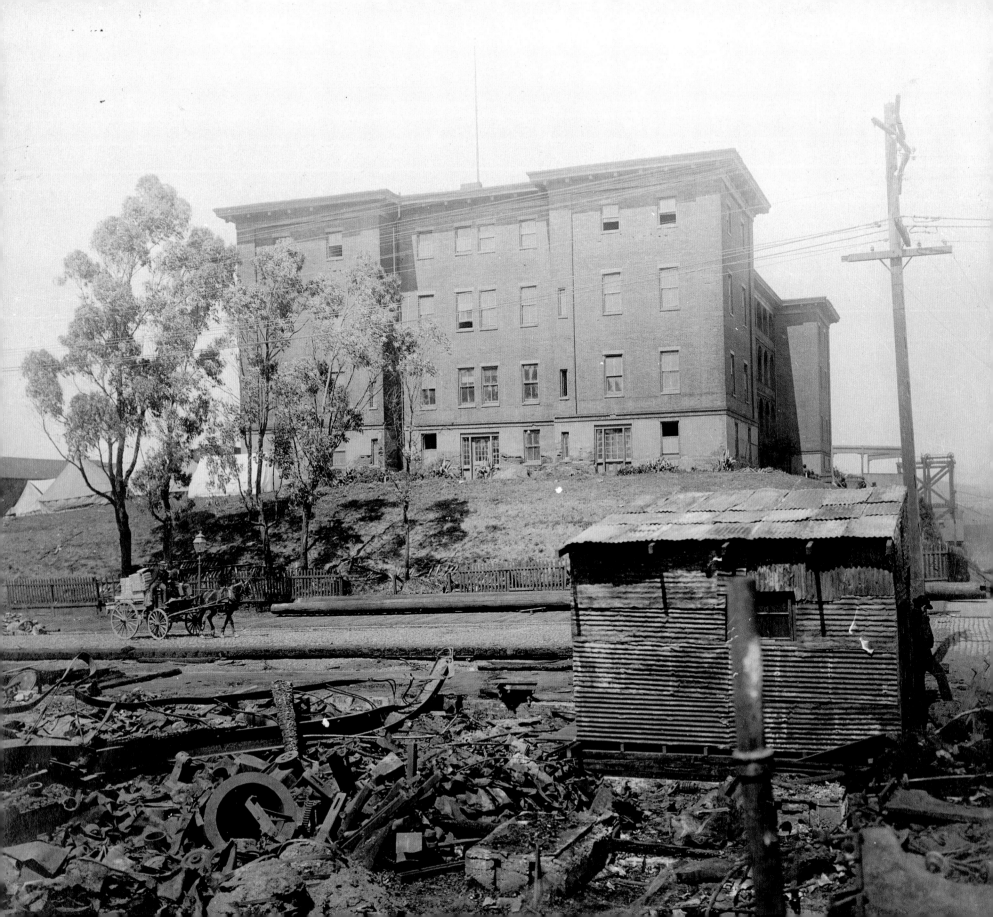

Rincon Hill Hospitals CRUMBLED 1906; RAZED 1923

The area bounded by Third, Spear, Folsom and Bryant streets roughly defines Rincon Hill, with the shoreline some 300 feet to the east. The hill's climate, views and topography made the spot a particularly attractive residential area for well-to-do merchants and professionals. Mansions, carriage houses and stables dominated the hill during the 1850s and 1860s: home to, among others, sea captains and shipping merchants and their families. The shoreline below the hill supported a burgeoning maritime industry with its wharves, shopping districts, ship chandleries and industrial development.

By 1870, a pair of hospitals became part of the Rincon Hill skyline. The first, the "Sailor's Home," stood on the tip of Rincon Point on the north side of Harrison Street between Main and Spear streets facing the bay. The hospital was built after the California Legislature requested help with dealing with the crush of sailors that arrived during the Gold Rush. These men, many suffering from the cholera and yellow fever epidemics, were also in need of basic health care. The federal government financed the building in 1852 as the United States Marine Hospital, to tend to the medical needs of merchant seaman free of charge. The hospital had an average of 150 patients, with daily admissions amounting to

six patients and deaths averaging four per month.

The 1868 San Francisco Earthquake damaged the building to such an extent that the government moved the hospital to the Presidio near Mountain Lake. In the 1870s it became a place for the "indigent or sick," and by 1900, Captain Jack Shickell recalled, "The old Sailor's Home stood on Rincon Hill, but was run by the City and no longer for the exclusive use of seamen." The 1919 Sanborn Maps indicate that the former Sailor's Home successively became a Cooperative Employment Bureau, a wood yard, and again a home for the poor. It was demolished in 1923.

The second hospital on Rincon Hill traces its history to the 1854 arrival of six Sisters of Mercy from Ireland. Less than a week after their arrival in San Francisco, the Sisters rented a house in the 600 block of Vallejo Street and began visiting the sick at both the Marine Hospital on Rincon Hill and the County Hospital on Stockton Street. They won praise for cleaning up the hospital after a series of scandals over poor care and nursing of patients suffering from cholera and smallpox. The Sisters of Mercy stayed in San Francisco and continued to provide hospital care in a setting that eventually became St. Mary's Hospital.

At the County Hospital, in an environment managed by the lowest bidder, they found conditions deplorable. The situation went from very bad to unbearable when cholera broke out in 1855. When the epidemic passed, the county presented the Sisters with the County Hospital contract. The nuns purchased the hospital and rented it to the city. After months of repeated default of payment by the county, they withdrew from the whole scheme in 1857 and mounted a fresh sign over the building's entrance: "St. Mary's Hospital."

The facility moved to a new building on Rincon Hill in 1861 and then to Sutter Street in 1906, after the fire that came on the heels of the earthquake destroyed the building.

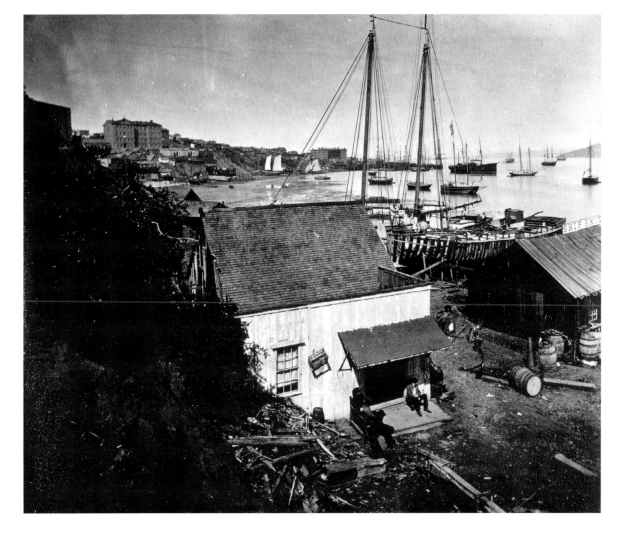

OPPOSITE PAGE *The federal government built the Marine Hospital to care for sick sailors. It was damaged by the 1868 earthquake and continued in various guises helping the poor, sick and homeless. It is shown here in 1906, after surviving the earthquake and fire. It was razed in 1923.*

LEFT *St. Mary's Hospital moved to this South Beach location near Rincon Hill in 1861.*

The Parrott Building RAZED 1926

John Parrott was born in Tennessee in 1811. He grew up in a wilderness frontier but still managed to get a good education. His older brother William distinguished himself in the War of 1812 and developed a promising career in government. William moved to Mazatlan, Mexico. John followed in his brother's footsteps and began serving as United States Consul to Mazatlan in 1837. He resigned the post in 1850 and moved to San Francisco, where he opened Parrott & Company, a bank with a reputation for conservative practices.

In 1852 he financed the construction of the three-story Parrott Building at Montgomery and California streets. The structure, built with Chinese granite and first erected in Hong Kong, held special significance to the Chinese community. When the building was taken down in Hong Kong, workers carefully deconstructed it piece by piece,

identifying each granite block with Chinese characters to show the exact position each stone should take in Parrott's San Francisco location. Before work began, however, the Chinese workers claimed that Parrott had picked an unlucky site for the building. Parrott apparently refused the workmen's demands to have the site "exorcised" before work could begin. (Other sources claim that the Chinese workers went on strike—San Francisco's first—for higher wages. According to this story, Parrott gave in to the workers' demands and paid them more money.)

To lend some credence to the site's supposed lack of luck, three years later, two of California's largest banks—Adams & Company, and Page, Bacon & Company, tenants in the "Parrott Block," as the owner dubbed the building—perished in the Panic of 1855. Wells Fargo weathered the panic,

acquired the building and invited the Chinese to purify the site. Thus cleansed, the Parrott Block became home to Wells Fargo, which, the bank says, became "the bank of the Chinese." Wells Fargo would go on to acquire the two failed banks.

Parrott & Company also survived the Panic of 1855 and went on to flourish. In 1853, John married Abby Eastman Maher in Mobile, Alabama. The couple lived on Rincon Hill; they had six daughters and one son. Their daughter, Abby Josephine, affectionately known as "Daisy," married Captain A. H. Payson, the director of the Spring Valley Water Company, now the San Francisco Water Department. Payson had been an Army engineer and taught at West Point for a few years until 1877 when he was transferred to San Francisco. His work included overseeing construction of lighthouses with the Lighthouse, Rivers and Harbors Department.

Between 1860 and 1875, John acquired all of Rancho Llano Seco in Butte County. In 1870, while he was still acquiring, the rancho people said that John was the richest man in San Francisco, with assets totaling some $4 million. Even William Ralston, the West's most-renowned financial genius, could only claim a mere $1.5 million at the time. (Incidentally, Parrott is credited with foiling Ralston's plans to extend Montgomery Street to China Basin from downtown.)

The Parrott Block's luck persisted; the 1906 earthquake did little damage to the building. John died, aged 74, in 1884 at his palatial home in San Mateo County. San Francisco Savings Union, Parrott's company, opened its doors again for business as things settled down after the temblor. His wife Abby died in 1917 at age 89.

In 1926 the Parrott Block's luck eventually gave out and it was demolished to make way for the Financial Center Building, which stands on the site today—home to the Omni San Francisco Hotel.

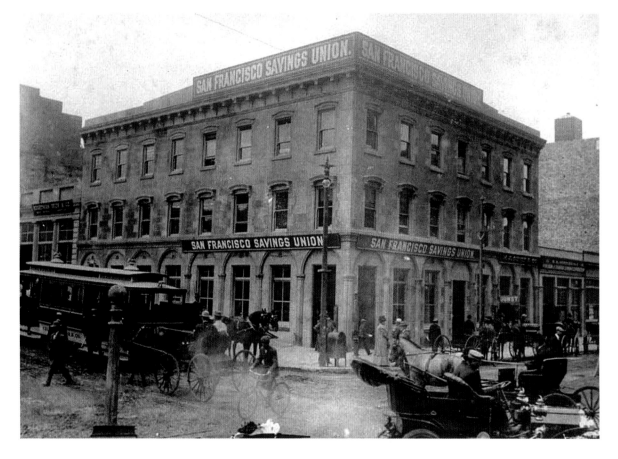

RIGHT *A Chinese man walks across the street from the Parrott Block. The granite for the building was quarried in China and first erected in Hong Kong before being shipped to San Francisco. Stories persist that Chinese workers constructing the Parrott Block thought it an unlucky site for the building.*

LEFT *The Parrott Block—billed as the first stone building in the city—survived the 1906 earthquake.*

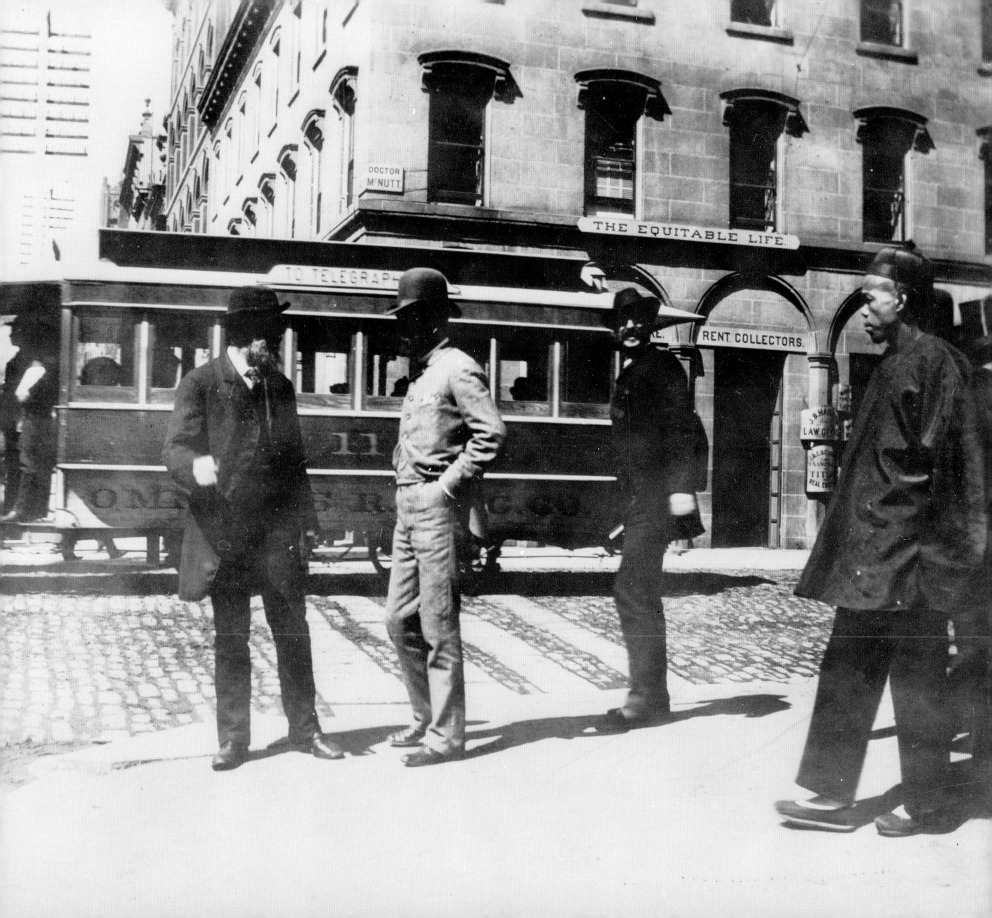

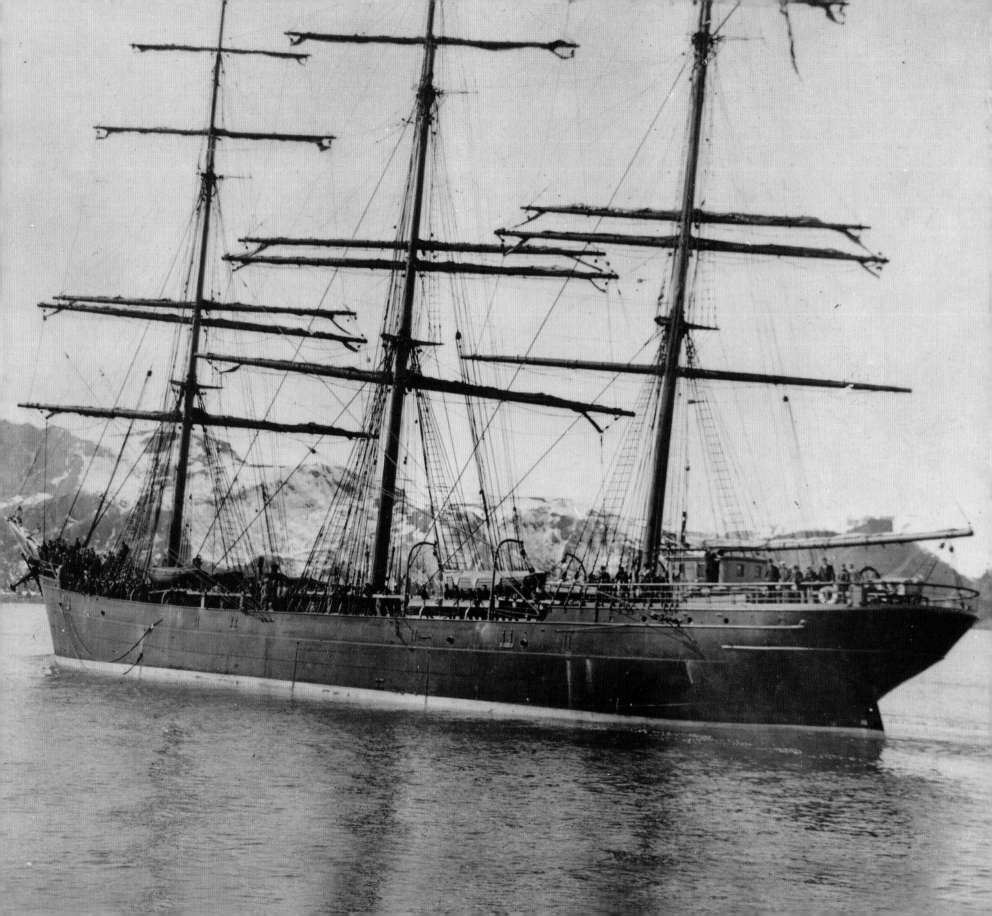

Alaska Packers' Star Fleet REPLACED 1930

The Alaska Packers' Association formed in 1891, as a consortium of Alaska salmon fishing operations that had outdone themselves. Granted, American exploitation of Alaska salmon was fairly new, but the fishermen canned so much salmon that the local market couldn't buy it all. The association, then the largest fishing operation on the Pacific, formed with its headquarters in San Francisco and began seeking ways to regulate itself and better market its product.

The company docked most of its fleet—with its ships stuffed with unsold cans of salmon—across San Francisco Bay in Alameda for the winter. Keeping the salmon naturally refrigerated below water, the company had time to sell it off before the next summer. Not until the 1920s did the Federal government begin regulating the fishing industry, and the packers didn't see it as overproduction, but instead, a lack of consumer demand.

The association successfully sold off the excess and, after some minor changes, reincorporated with Henry Frederick Fortmann as its president. Fortmann led the company for the next three decades. For the 1900 World's Fair in St. Louis, the packers produced a fully illustrated, 62-page cookbook of recipes for canned salmon. In the introduction, the "largest canning company in the world" speaks to the scientific proof of canned salmon's nutritious benefits and adaptability to any meal or environment.

Around the turn of the twentieth century, the company took on a naming convention that gave rise to the packers' illustrious Star Fleet. Beginning with the 1901 *Star of India*, ships were added to the fleet steadily, including the 1905 *Star of England*, 1907 *Star of France* and 1909 *Star of Iceland*. After 1910, the naming convention extended to the last four letters as well, as each name ended in "land," as in the *Star of Scotland*, *Star of Lapland*, *Star of Greenland*, *Star of Zealand*, *Star of Poland* and *Star of Falkland*, to name a few.

By 1916, the association merged with the California Packing Corporation ("Calpak"), adding Hawaiian pineapple and other canned fruits and vegetables to its repertoire. Calpak began its history in Oakland in 1886, where it distributed coffee for Hotel Del Monte in Monterey. After the 1906 quake, they built the largest cannery in the world at San Francisco's Fisherman's Wharf to provide for a city whose food production lay in ruins. By 1916 the combined companies took on the identity of its most popular brand and became Del Monte Foods, with the Del Monte shield logo a mainstay in American cupboards after 1909.

The Star Fleet remained in use until 1930, some of the last commercial tall-masted sailing ships in operation, when they were replaced with steam-driven ships. Of the 14 ships in operation as of 1927, only two survive. The *Star of Alaska*, now back to its original name *Balclutha*, today lies docked at San Francisco's Hyde Street Pier; the other survivor, the *Star of India* is docked in San Diego's harbor.

During World War II, the company remained in operation but saw many Alaska canneries shuttered. During the war, the fleet's base of operations moved to Seattle. Over the following 30 years, salmon production declined steadily and Del Monte sold its salmon canning assets, the former Alaska Packers' Association, to ConAgra Foods of Nebraska and Trident Seafoods in Seattle. Del Monte Foods remains headquartered in San Francisco, while today a new consortium of fishermen and canneries based in Seattle has taken the name Alaska Packers' Association.

OPPOSITE PAGE *The* Balclutha, *built in Scotland in 1886, was renamed* Star of Alaska *while it served the Alaska Packers as a cannery ship. She is photographed here in the early 1900s in Chignik Bay, Alaska.*

BELOW LEFT *The* Star of Alaska *under sail at sea. This view looks beyond the standard compass and binnacle in the foreground.*

BELOW *Today,* Balclutha *is one of the star attractions at the Hyde Street Pier. It is part of the Maritime Museum's varied fleet of vessels.*

BOTTOM *The* Star of Alaska *getting her poop deck extended at the United Engineering Works in Alameda in 1911.*

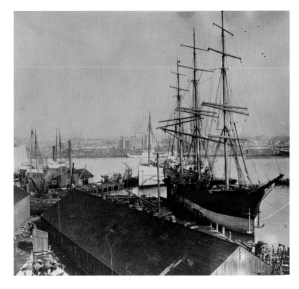

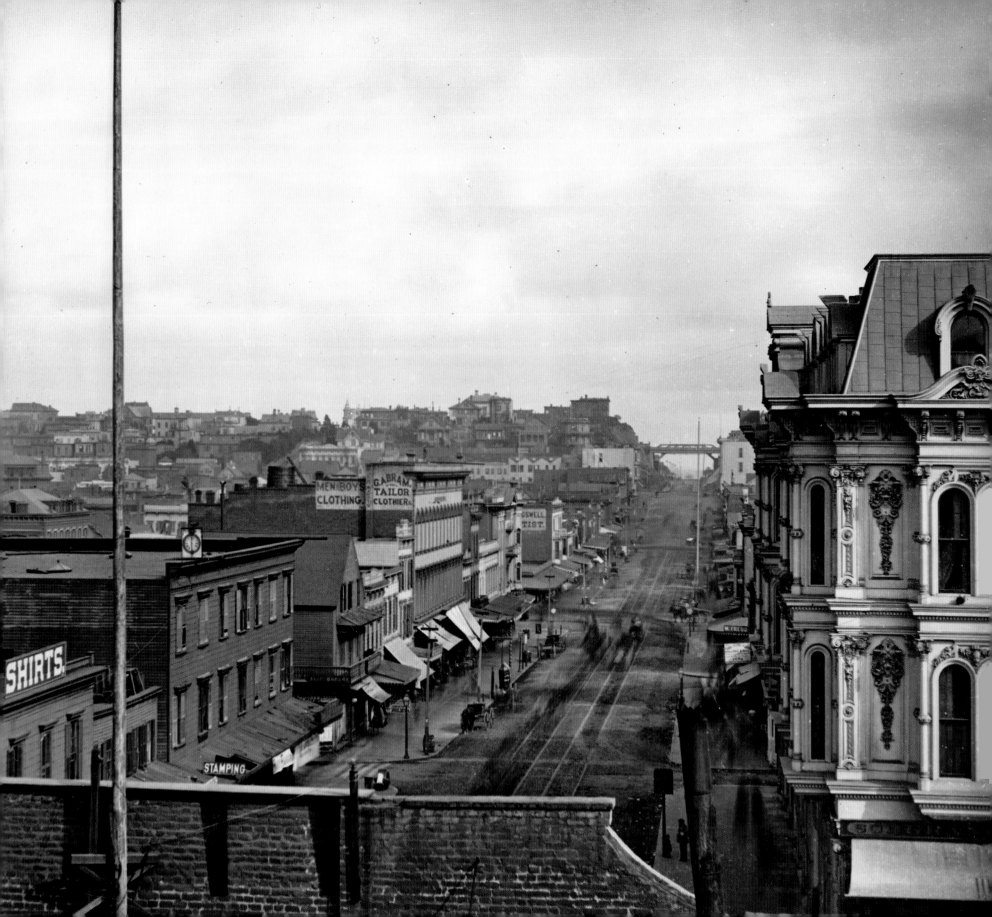

Rincon Hill GRADED AWAY 1936

When approaching the town of Yerba Buena in the 1840s, sailors could discern two distinct landing areas: Yerba Buena Cove, with Telegraph Hill, marking the northern extent and Rincon Hill the southern. Rincon comes from the Spanish *rinconada*, which means a projection extending into the sea, plains or forming a corner of land. Certainly Rincon Hill did just that, projecting outward to form a clear landmark until the harbor was filled.

While not as tall as Telegraph, Rincon raised some 120 feet above the waterline, offering commanding views of the approach to the harbor. Settlers around 1850 described the hill as being covered with dense scrub and live oak, where deer could be hunted on the south side. At the foot of the hill sat Happy Valley, along Mission Street from First to Third streets. Sheltered from cutting ocean winds and blessed with a fresh water spring, Happy Valley began as a tent city of miners gearing up for the trek to the foothills. As the city's population became larger and more permanent, Rincon Hill grew to be the most prestigious residential neighborhood in San Francisco.

In the 1860s, local papers described Rincon Hill as "unquestionably the most elegant part of the city," which boasted the 40-room mansion of Peter Donahue, the homes of John Parrott and Senator Milton Latham. Rincon Hill also attracted some of San Francisco's literary elite, with Bret Harte, Robert Louis Stevenson and Jack London all passing time here.

The arrival of the Pacific Mail to the docks below Rincon Hill spelled the beginning of the end of the area's opulence. Warehouses went up to store the mail, and city engineers, determined to provide a graded access route to Mission Bay's harbor south of Rincon Hill, led to the 1869 Second Street Cut. The slice through the hill left some homeowners stranded on rocky outcroppings and devalued all the others. When Rincon Hill resident Thomas Selby became mayor that year, he lamented the blow to himself and his neighbors, "Elegant homes have been destroyed under the plea of commercial necessity… the cut through Rincon Hill is a public outrage."

The advent of cable cars in the 1870s, allowed the residential trend to shift to new mansions on the taller hills north of Market Street, especially Nob Hill. One by one, the wealthy and powerful left Rincon for other hills. An estimated 83 well-heeled families left in 1879; by 1889 37 remained; a decade later just 12 residences, now surrounded with industry, held out against the tide of falling real estate value. The 1906 San Francisco earthquake and the resulting fire destroyed the remaining Rincon Hill mansions.

The area was rebuilt as an industrial and maritime district, benefiting from its proximity to the Port of San Francisco and the Bay Bridge, completed in 1936. The top of the hill became the anchorage for the western end of the Bay Bridge, which significantly reduced the hill's profile.

ROBERT LOUIS STEVENSON

Banker Peder Sather lived atop Rincon Hill in the 1850s. Sather's home stood at Second and Harrison streets but the family abandoned the place when the Second Street Cut ruined the neighborhood. Charles Stoddard moved in and hosted, among other writers, Robert Louis Stevenson. Stevenson had arrived in San Francisco in August 1879, and lived at 608 Bush Street. He was in town waiting for Fanny Osborne's divorce to become final. Stoddard later related that Stevenson "used to come to that eyrie on Rincon Hill to chat and to dream; he called it 'the most San Francisco-ey' part of San Francisco." Stoddard's *South Sea Idylls*, published in 1873, would inspire Stevenson's own travel to the South Seas.

OPPOSITE PAGE *This photograph shows Rincon Hill with the cut that was made to facilitate horse-drawn traffic. The gradient made it difficult for teamsters to coax their horses over the hill to the industry along the distant shoreline.*

ABOVE LEFT *The view on Harrison Street, Rincon Hill, in 1866.*

LEFT *Cables from the Bay Bridge sweep downward to meet what is left of Rincon Hill. In 1933, President Franklin D. Roosevelt hit a telegraph key in Washington, D. C. and set off the charges that blew the top off the hill and officially began the bridge's construction.*

Lurline Baths CLOSED 1936

Dating to 1860, San Francisco's Olympic Club is considered America's oldest athletic club. Known for its extensive golf courses, Olympic-quality swimming pool and 5,000-strong membership today, the founding membership numbered just 23. Initial facilities were small, limiting membership and building exclusivity. The club's membership often included some of the city's most influential men and most accomplished athletes. Stanford and Crocker—two of the "Big Four" who built the Central Pacific Railroad—joined the club, as did news mogul William Randolph Hearst and the 1892 World Heavyweight Boxing Champion, "Gentleman Jim" Corbett.

John D. Spreckels came to San Francisco in the late 1880s, already a wealthy man. Having worked for a time with his father, Claus, in the sugar business, John used the knowledge he had garnered to build his own shipping business, carrying his father's sugar to market. Soon John was wealthy in his own right. He married Lillie Siebein in 1887 and the couple traveled to Hawaii for a time and then settled in San Francisco, sailing into the harbor on their yacht, *Lurline*. Spreckels maintained several investments in San Diego concurrent with adventures in San Francisco. He owned railroads, newspapers (like the *San Francisco Call*), theaters and office buildings, mostly in the San Diego area.

John may have been attempting to solidify his membership in the Olympic Club when he and several businessmen founded the Olympic Salt Water Company in 1892. The company's purported mission was "to supply the people of San Francisco pure ocean water for bathing purposes." During this time the Bay waters had become quite polluted making many of the downtown bathhouses regret their choice of having intake pipes in the Bay. Olympic Salt Water Company offered new hope to these operations, but first things first, Spreckels wanted to supply the Olympic Club with fresh "clean" salt water for he (and the other members) to use at their brand new swimming facilities.

The Olympic Salt Water Company constructed an intake pipe 600 feet into the ocean, a pump capable of moving three million gallons per day located just across the highway and then 3.75 miles of pipe running beneath Geary Boulevard. In the Laurel Heights neighborhood, the 16-foot pipe emptied into a reservoir which then used gravity to deliver the product to the various customers. Lurline Pier at Ocean Beach protected the intake pipe and was located between Anza and Balboa streets above the park. Other than the Olympic Club pools just a few small customers signed up. So Spreckels and company created their own best customer. Built at the intersection of Bush and Larkin streets in 1894, the Lurline Baths used Olympic Salt Water Company water exclusively. The facility featured a water slide, providing the action for one of Thomas Edison's pioneering movies. In 1897, the Wizard of Menlo Park (as Edison was dubbed) captured 20 seconds of action in Lurline Baths, forever memorializing the place.

Salt-water delivery proved somewhat unpopular. Residents eyeing the extra expense, street cleaners and fire departments all turned down the company's offers of "fresh" seawater. Spreckels gave up on San Francisco after 1906, moving his family to San Diego, but the company kept pumping. The Olympic Salt Water Company folded in 1936, taking the baths with it, but Lurline Pier remained standing until 1966.

LURLINE OCEAN WATER BATHS
BUSH AND LARKIN STREETS
SAN FRANCISCO

ABOVE *The Lurline Baths were opened in 1894 at Bush and Larkin streets "to supply the people of San Francisco pure ocean water for bathing purposes." The baths survived until the Great Depression, closing in 1936.*

RIGHT *The Lurline Baths' pipeline and pier extend into the Pacific Ocean from a point halfway between Balboa and Anza streets. The pier, which protected the pipeline, was known as the Olympic Pier and the Lurline Pier, because it served both the Olympic Club and the Lurline Baths. The pier was demolished in 1967. Sutro's grand Cliff House dominates this 1903 view.*

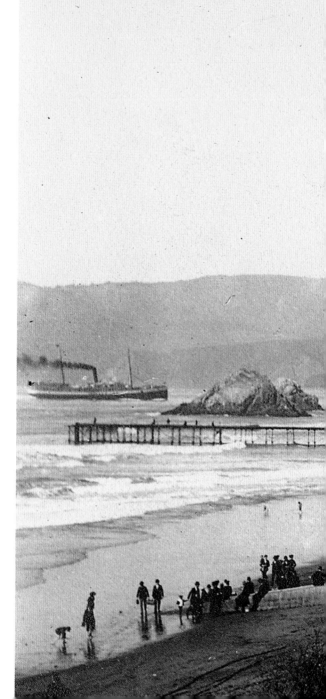

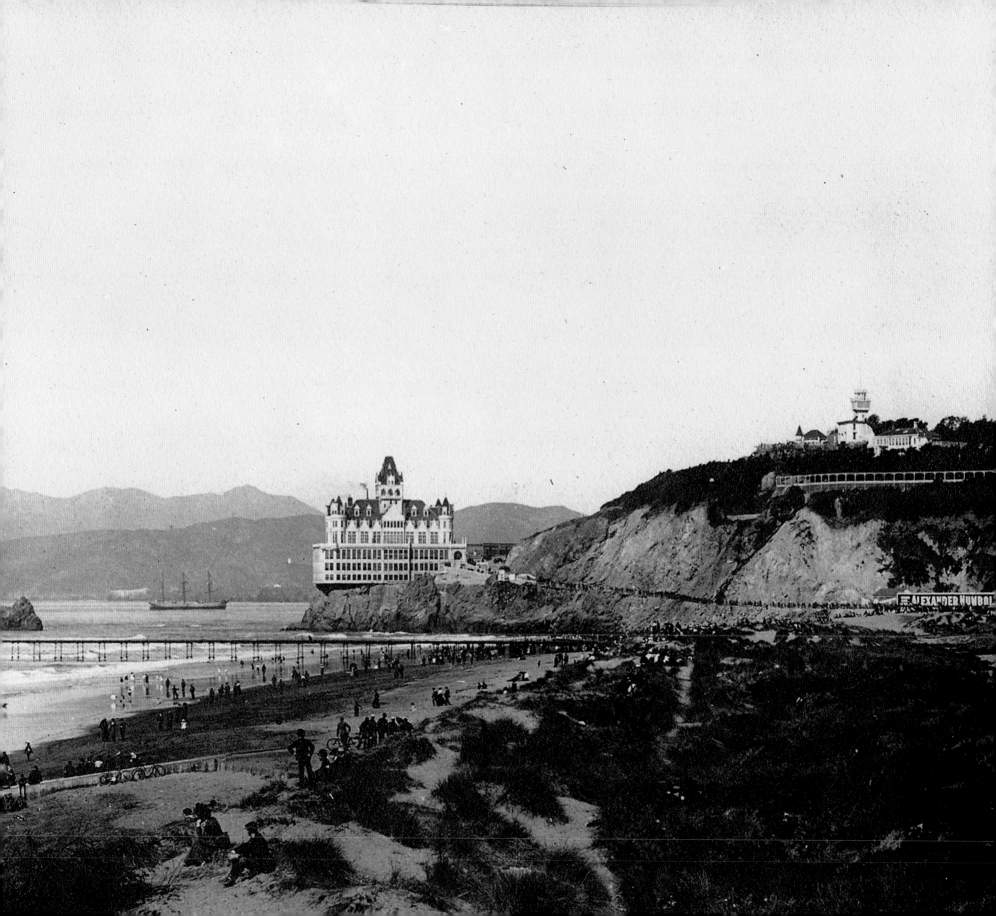

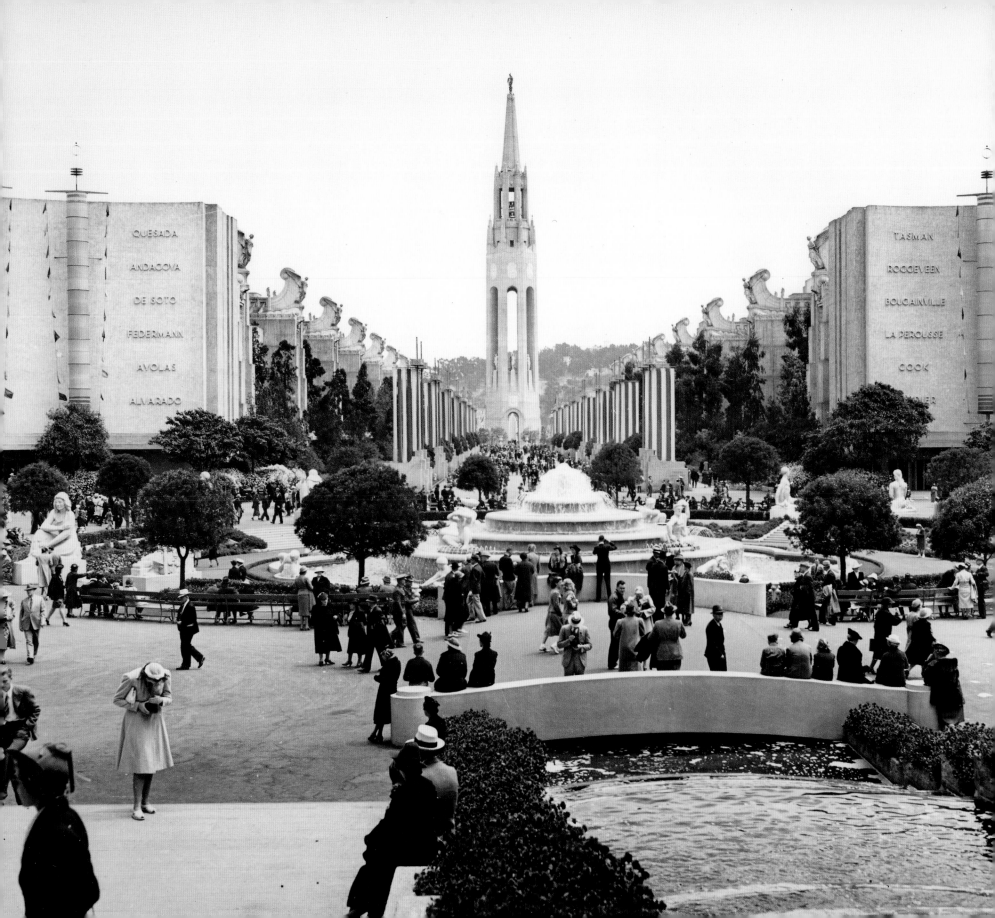

1939 World's Fair on Treasure Island ENDED 1940

Begun as a Depression-era WPA project, Treasure Island took form from Bay mud hauled up from the mouth of the Sacramento River Delta. The place got its name from the potential for gold deposits in its soil. The plan for the 1.5-acre site involved San Francisco's first airport and the upcoming Golden Gate International Exposition and World's Fair of 1939. Ostensibly to celebrate the opening of the Bay Bridge in 1936 and the Golden Gate Bridge in 1937, the event inspired the 49-mile drive around the city, ending at Treasure Island, and special passenger rail lines from Chicago and other places around the nation. Indeed, from February through October 1939, San Francisco benefited from visitors all over the world taking in the bounty of Pacific-oriented nations on the newly created Treasure Island.

The 80-foot statue of Pacifica symbolized unity among Pacific nations just prior to a massive war with Japan. The 400-foot Tower of the Sun rivaled with the towers of the Bay Bridge and Golden Gate Bridge, while multicolored searchlights probed the night sky. Palaces featured exhibits on a wide range of human achievement: mines, metals and machinery; electricity and communication; food and beverage; agriculture; and home and garden.

Between each palace, fairgoers traversed such romantic places as the Court of Flowers, the Court of Reflections, the Portals of the Pacific—with its giant Elephant towers bathed in red light—the Court of the Seven Seas, the Court of the Sun, the Court of Pacifica or the Gayway, a court of amusements. Opulent gardens shone under the California sun, an attempt to out-do the rival

World's Fair held in New York.

A single view of the Treasure Garden took in thousands of blooming tulips. Ford Motor Company, Ghirardelli Chocolate, National Cash Register, and Pacific Gas & Electric among others built promotional structures just for the event. Everything had been decorated using indirect neon black lighting, luminescent paint and other illusions. This caused the improvised city to glow at night, with the color of some surfaces changing constantly. In contrast, by day the fair buildings stood bedecked in mellow earthy colors termed "Chromatherapy," which aimed to soothe fairgoers. Loud primary colors were reserved for advertising signs. A 74 x 22-foot mural by Diego Rivera titled "Pacific Unity" graced the scene. The mural is now located at San Francisco City College.

Organizers petitioned for an extension and managed to keep the fair open for another stint from May through September 1940. Once the fair closed, Pan American Airways' flying boats—the "China Clippers" that provided air mail and passenger service around the Pacific Rim—were set to move their operations to the Federal land. Instead, events in 1941 changed the nation's focus. The Navy recognized the strategic convenience of Treasure Island, and traded a much larger site in South San Francisco—Mills Field—in exchange for retaining the use of the Treasure Island acreage for a new naval base.

For half a century, Treasure Island, once the site of celebration, joy and culture, served as a place of war until the 1993 Base Realignment and Closure program ended Treasure Island's service. Since the Navy ceased operations in 1997, the place has slowly been turning back to private use.

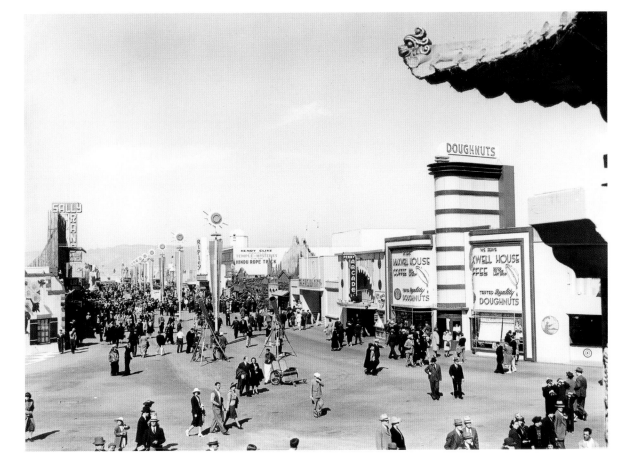

OPPOSITE PAGE *View of the Court of the Moon with the Tower of the Sun in the background. These courts were part of what promoters called "a luminous city, replete with towers, fountains, sculpture, trees, flowers, and magnificent palaces."*

LEFT *Pedestrians stroll along the Gayway, the entertainment zone of the 1939 Golden Gate International Exposition. Along with the more educational exhibits there were sensational elements, such as Sally Rand's Nude Ranch (a play on the phrase "dude ranch"). Rand's fan-dancing burlesque show was given a large hall located opposite a Hindu temple and Ripley's Believe It Or Not!*

San Francisco Cemeteries MOVED TO COLMA 1940s

Some 27 different facilities served San Francisco's deceased residents at one time or another. The Mission Dolores cemetery appeared first in the late 1770s. At the summit of Russian Hill, some 40 graves made by Russian explorers were found. The nascent town of Yerba Buena buried its dead as of 1826 near the coast at Telegraph Hill Cemetery bounded by today's Broadway, Green, Sansome and Battery streets.

When Yerba Buena Cemetery (on the site of today's main library near City Hall) opened in 1850, city residents consolidated cemeteries. All pre-Gold Rush era burials—including those at Russian Hill and Telegraph Hill cemeteries, North Beach Cemetery on Powell near Filbert and Greenwich, and the Bush Street and First Street cemeteries—were moved to the Yerba Buena Cemetery. Green Oak Cemetery advertised in the local paper about their plots at Market, Mission, Seventh and Eighth streets, but like the early burials at Yerba Buena Cemetery, these were moved west to Golden Gate Cemetery around 1870. A few burials took place near the U.S. Marine Hospital (for merchant mariners) on Rincon Hill after it opened in 1853 around Harrison, Main and Spear streets.

In 1854, on a large piece of property in Laurel Heights, the first of the "Big Four" cemeteries opened: the Lone Mountain Cemetery, between California, Parker, Geary and Presidio. The Catholic Calvary Cemetery opened next in 1860, bordered by Geary and Turk streets, and St. Joseph's and Masonic avenues. Completing the Big Four were the 1864 Masonic Cemetery (at Turk, Fulton and Parker streets and Masonic Avenue) and the 1865 Oddfellows Cemetery (at Geary, Turk, Parker and Arguello).

A Greek Cemetery stood at the intersection of Stanyan Street and Golden Gate Avenue near the Oddfellows facility and the Chinese Cemetery stood alongside Lone Mountain. Lone Mountain was renamed Laurel Hill Cemetery in 1867. Green Oak Cemetery advertised in the local paper about plots in its cemetery bounded by Market, Mission, Seventh and Eighth streets, but like the early burials at Yerba Buena Cemetery, bodies in the Green Oak Cemetery were moved to the Golden Gate Cemetery around 1870.

For Jewish residents, Nevai (Home of Peace) cemetery appeared at Dolores, Church, 18th and 19th streets, with Gibbath Olom Cemetery (Hills of Eternity) appearing just across the street in 1861. The new facilities replaced the 1850 Hebrew Cemetery in Pacific Heights between Broadway, Vallejo, Franklin and Gough streets. The Gibbath Olom location between Dolores, Church, 19th and 20th streets later became Dolores Park.

In 1875, the Presidio opened its U.S. Marine Hospital Cemetery just above the Lake Street entrance that remained functional until 1932. General William T. Sherman created the Presidio's other graveyard, the San Francisco National Cemetery, in 1884 as a resting place for army veterans. In 1900 city supervisors outlawed the creation of new graveyards. In 1912, the supervisors aimed to evict the city's deceased residents. For the next 30 years or so, cemeteries regularly closed up shop and moved down the peninsula to a community created just for them: Lawndale, later renamed Colma (perhaps the only U.S. city where the dead outnumber the living).

Before reaching Colma, some bodies might have been moved as many as four times—so much for eternal rest. While hundreds of thousands of bodily remains made the trek to Colma, thousands more failed to find their way. Undisturbed burials were found during renovations at the main library (Yerba Buena Cemetery) and at the Lincoln Park Golf Course (Golden Gate Cemetery), where renovations uncovered bodies wearing nineteenth-century Levi's.

Just two cemeteries remain: that adjoining Mission Dolores, and the Presidio's National Cemetery, where notable veterans may still be interred. Openings for ashen remains can also be found at Grace Cathedral's columbarium and the San Francisco Columbarium (a part of the former Oddfellows Cemetery).

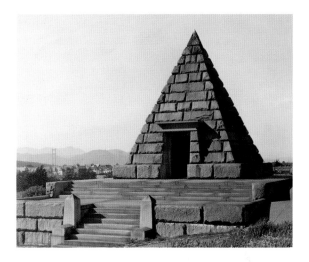

OPPOSITE PAGE Calvary Cemetery, photographed from the air in 1939, demonstrates exactly the kind of pressure San Francisco's cemeteries were under as the city expanded.

TOP A pyramid tomb in Laurel Hill Cemetery photographed in the 1940s, just prior to its demise.

ABOVE Laurel Hill was originally named Lone Mountain Cemetery. By the 1940s it was clear that it was failing to be maintained.

LEFT An earth mover drives past the tomb of William S. Clark in 1946 as Laurel Hill is converted to housing land. Clark was a San Francisco pioneer who built the first wharf in the city, thus reducing the cost of goods.

Mission Bay FILLED IN DURING THE 1940s

The two villages on Mission Bay were the largest and most commonly settled sites in San Francisco. Using pointed staffs, the natives pried mussels from the mud in the summer dry season or low tide, and scooped up smelt with nets, or snared birds when the tide came in and the water was high. When the Spanish settled the mission, they chose to join the native population on the shores of the creek at Mission Bay.

Later, Provisional Military Governor Stephen Watts Kearney, a key figure in California's fate during and after the Mexican War, held the first auction of water lots in Mission Bay in 1847. Four years later, ownership of all swamp and tidelands were transferred to the state of California through a Federal order.

Legislators from San Francisco dominated the state government and temporarily transferred the tidelands to the city, which they could use for the next 100 years, to add to the treasury. By the 1860s, new owners were taking possession, building long piers to their water lot, or sinking derelict watercraft to indicate they intended to fill it. Some erected log frameworks to catch the fill, but for many investors—land rich and cash poor—the task of converting to buildable land and then actually building was nigh impossible. As amendments were made to the landscape, like removing a 100-foot hill that impeded Market Street's progress, rail cars along temporary lines dumped the fill where ordered.

Long Bridge ended the Bay's use by water traffic. The 1867 construction provided trackage for a horse car line. A refreshment station, open day and night, served the passengers halfway across the bridge. Today Fourth Street and the north-south part of Third Street follow the path of Long Bridge. This horse car line fed the growth of the city southward, opening up prime industrial and residential real estate. Mission Bay sat in the center of it all. In the way, choked off from the Bay, with the increasingly foul Mission Creek pouring into it, the place reeked.

When real estate capitalists cut through Rincon Hill, the apparent payoff was the filling of Mission Bay. The city would have received 200 blocks of new city property said one idealist. But sadly, the bay remained a disgrace, giving the Division Street neighborhood the moniker "Dumpville" in the 1890s as everyone dumped their trash there.

The bay remained in this state well into the twentieth century, and slowly the water lots filled. The completion of Pier 50 after World War II filled in the last. Today, Mission Creek has been somewhat rehabilitated with wetlands restored to an urban park, while Mission Bay is now a biotech campus for UCSF and housing developments.

BELOW LEFT *Looking south along Mission Bay in 1864. The Citizens Gas Works and the Long Bridge in the distance are already encroaching on the bay.*

BELOW *This 1867 view looking southeast shows that the Long Bridge, built three years earlier, had already begun the encroachment process in Mission Bay.*

RIGHT *The 1864 Long Bridge enclosed two-thirds of Mission Bay and ended its function as a waterway. The bridge itself would become the new waterfront.*

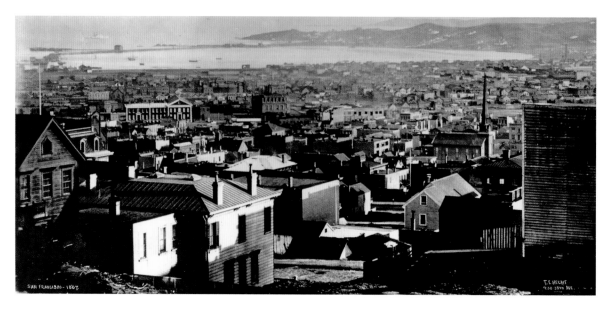

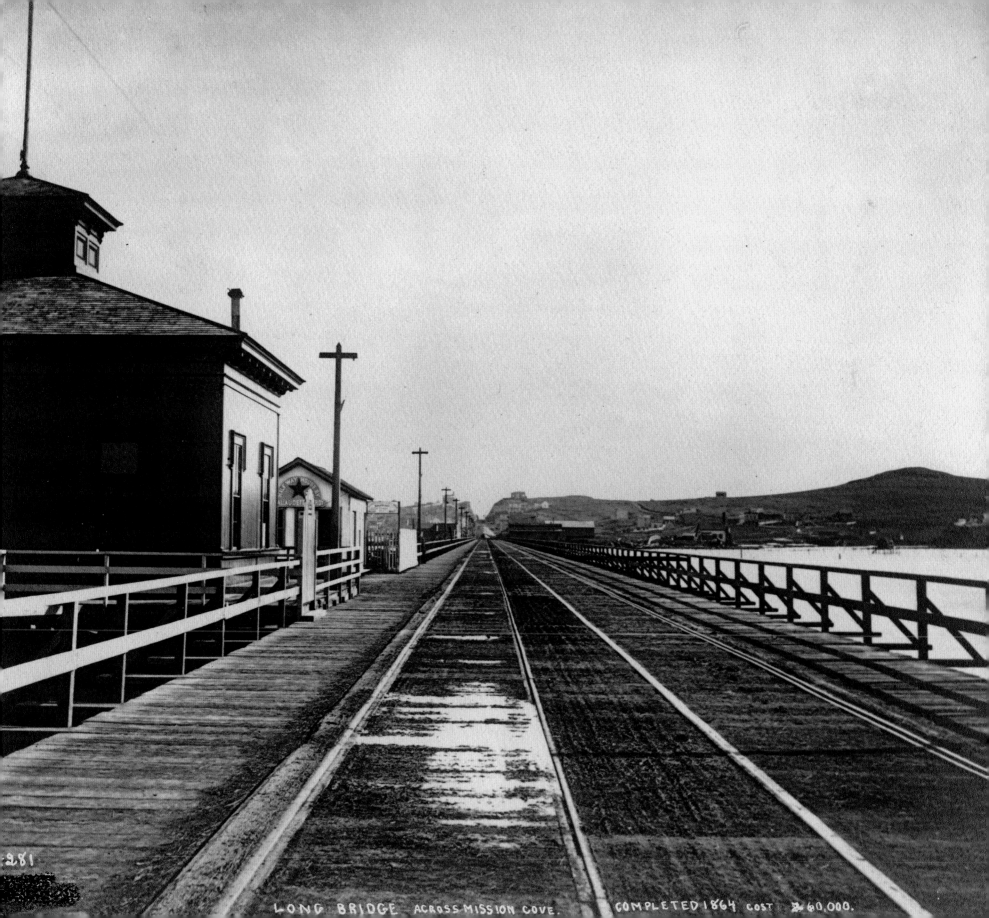

LONG BRIDGE ACROSS MISSION COVE. COMPLETED 1864 COST $60,000.

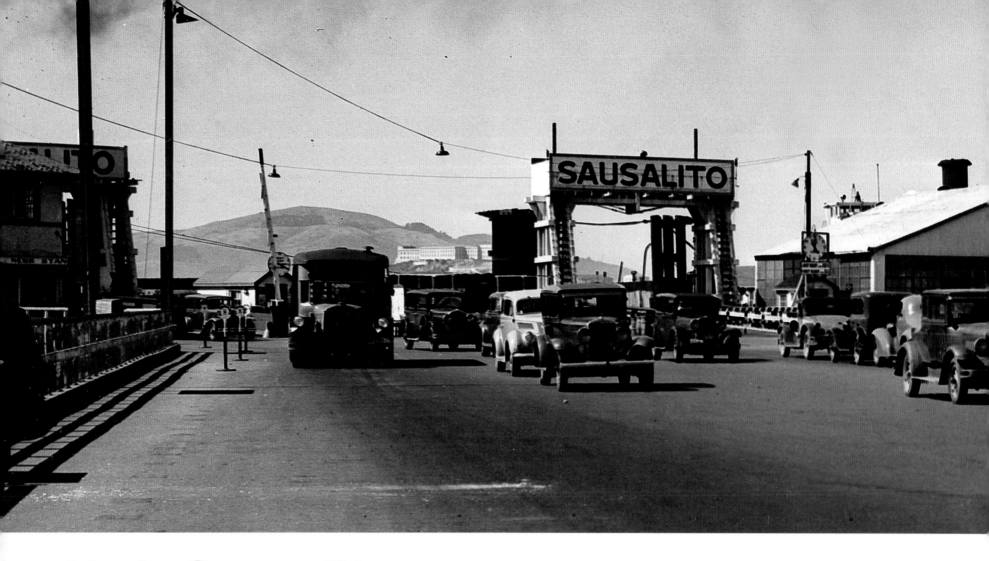

Hyde Street Pier SERVICE ENDED 1941

Before the Bay Bridge opened in 1936 and cars started flowing across the Golden Gate Bridge the following year, the Hyde Street Pier served commuters as the principal automobile ferry terminal connecting Sausalito in Marin County and Berkeley in the East Bay with San Francisco. Golden Gate Ferries, a subsidiary of the Southern Pacific Railroad, operated the ferries from the Hyde Street Pier, which the federal government had designated a part of U.S. routes 101 and 40.

Hyde Street Pier was built in 1922 and service lasted until 1941. On April 18, 1961, the State Division of Beaches and Parks and the San Francisco Port Authority signed a lease that would transform the Hyde Street Pier into a replica of an old-time wharf.

The San Francisco Maritime Museum Association oversaw the project that reshaped the old working Hyde Street Pier into a museum displaying historic vessels. The Maritime Museum had originally been housed in the 1939 Streamline Moderne Bathhouse Building erected as a Works Progress Administration (WPA) project, putting San Franciscans back to work during the Depression. The bathhouse, reminiscent of an Ocean Liner, had served as a temporary housing location for men shipping out to the various battlefields of World War II prior to welcoming the museum.

Five ships—the 1886 square-rigger *Balclutha*; the 1890 steam ferryboat *Eureka*; the 1891 scow schooner *Alma*; the 1895 schooner C.A. *Thayer*;

and the 1915 steam schooner *Wapama*—arrived at the pier in October 1963. (All but the *Wapama* remain at the pier; she is now docked in Richmond, California.) In 1978 the pier joined the National Park Service when it became part of the Golden Gate National Recreational Area. The pier was rededicated as the San Francisco Maritime National Historical Park on June 27, 1988.

Today, visitors to the Hyde Street Pier can enjoy activities including school group overnights, boatbuilding and woodworking classes.

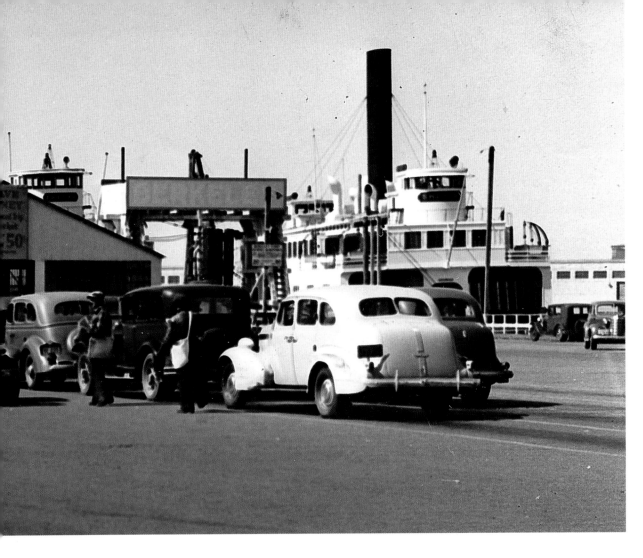

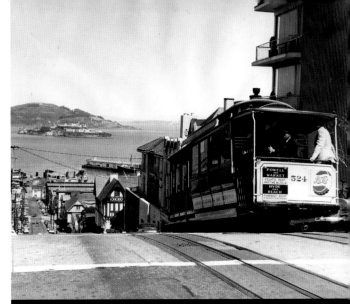

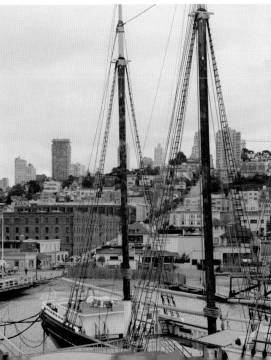

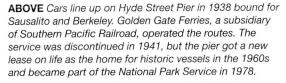
ABOVE *Cars line up on Hyde Street Pier in 1938 bound for Sausalito and Berkeley. Golden Gate Ferries, a subsidiary of Southern Pacific Railroad, operated the routes. The service was discontinued in 1941, but the pier got a new lease on life as the home for historic vessels in the 1960s and became part of the National Park Service in 1978.*

RIGHT *A view of Hyde Street from amidst the historic ships collection in 1988. In the foreground is the lumber schooner C. A. Thayer.*

HYDE STREET CABLE CAR

The Hyde Street Cable Car line dates back to 1890 when the California Street Cable Railroad or "Cal Cable" opened the O'Farrell, Jones and Hyde line. Only the Hyde Street line remains in operation today, carrying passengers from Powell and Market streets to the Hyde Street Pier, effectively connecting some of the city's most desirable shopping locations with the tourist locations at Fisherman's Wharf.

Few remember Hyde Street's namesake, George Hyde, whose name was then transferred to the Pier and the Cable Car. Hyde, a Pennsylvania lawyer and judge, served his country as a clerk under Commodore Stockton during the Mexican War.

Following the conflict, military governor Richard Mason appointed Hyde the alcalde (mayor) of San Francisco. Hyde organized elections for the city's first council and built a home house "far out of town" near the intersection of today's Market, Montgomery and Post streets. Hyde drew much attention with this, the most opulent home and grounds yet built in the city.

As the Gold Rush began, downtown sprung up all around Hyde's house. His term was fraught with complaints of nepotism and that he redrew city boundaries to benefit his friends' land sales. Such practices galvanized locals to elect their next mayor rather than have one appointed by a military governor.

Ferry Services DISCONTINUED 1941

The earliest residents of the San Francisco Bay area relied on water routes for both supplies and personal transport. Ferry service began as early as 1850 to connect San Francisco to the nascent East Bay city of Oakland. As a perfect complement to the railroad, ferries served railroad terminals sticking way out into the Bay on stone foundation piers called moles.

The San Francisco & Oakland, and San Francisco & Alameda railroads were the first companies to provide this service on San Francisco Bay as part of the first transcontinental railroad. This combination across the region later gave the vast majority of Bay Area residents a commute of less than 45 minutes to the big city. Competition for passengers was fierce—the nickel ferry won out over the dime ferry.

Culture formed around ferry travel with people receiving their daily news, catching up with friends and perhaps having a bite to eat together. Bankers and businessmen read the newspaper they bought onboard while the bootblack shined their shoes. Riders could get a cup of coffee or even a whole meal on some trips. In the 1920s, one Alameda to San Francisco ferry started a Commuters' Golf Tournament, a tradition that continues to today. Certain celebrations took place onboard annually, like Straw Hat Day at the end of summer, when all the riders tossed their hat in the Bay, or Bootblack Day when the most respectable and wealthy commuter was made to shine the bootblack's

shoes. Eventually, at the height of the ferry era, no fewer than 24 ferry companies plied the bay, each with a dozen or so crossings per day.

From San Francisco, ferries traveled to Tiburon and Sausalito in Marin County using the Hyde Street Pier, and to Vallejo and Berkeley in the East Bay. Other lines also existed: the San Rafael and Richmond ferry or the Six-Minute Ferry across the Carquinez Strait, for example.

Between 1900 and 1910 some ten million passengers went through the Ferry Building. Trolleys would leave here every 20 seconds for various parts of the city. In 1903, Francis Marion "Borax" Smith turned his mining fortune into a streetcar empire, buying up most of the street railway lines in the East Bay under his Key System. The new Key System ferries provided competition to the big rail companies but commuters' patience with conglomerates was waning.

On February 28, 1941, the *Eureka* was the last ferry to leave the Hyde Street Pier with paying passengers. The pier finally stopped operating after the demise of the Northwestern Pacific Railroad's ferry terminal in Sausalito (where the Hyde Street ferries carried passengers).

The completion of the Oakland-San Francisco Bay Bridge in 1936 and the Golden Gate Bridge in 1937 brought in a new wave of rail and automobile users, which, for a time, put an end to all ferry services. They returned, however, in 1968 (with the Red and White Fleet service from Tiburon to San Francisco) and then in earnest in 1970 when the Golden Gate Ferry service began carrying passengers from San Francisco to Sausalito.

OPPOSITE PAGE *Serving San Francisco from 1890 to the late 1950s, the wooden ferry* Eureka *was at one time the biggest and fastest double-ended passenger ferry boat in the world.*

LEFT *Ferry-shaped wharves await their vessels at the foot of Market Street. The "57" in the photograph refers to the Heinz Company, which claimed it had "57 varieties of pure food products."*

TOP Eureka *was originally built to hold a capacity of 3,500 passengers, but her lower deck was converted to hold 120 automobiles, reducing passenger numbers to 2,300.*

RIGHT *Originally powered by a coal-fired walking beam engine, built by the Fulton Iron Works in San Francisco, the* Eureka *was converted to oil in 1905.*

EUREKA

The side-wheel paddle steamboat ferry *Eureka* was built in 1890 and started life as the *Ukiah* on the San Francisco to Tiburon run. As a passenger ferry, she could carry 2,300 passengers along with 120 automobiles. Reconfigured several times in her career, her glory years were between 1922 and 1941 on the Sausalito commuter run. She made the most popular commuter journeys—the 7:30 from Sausalito and the 5:15 from San Francisco. During this time the upper deck included a magazine stand, and a restaurant that served full meals. As the *Ukiah* in World War I she hauled munition-filled rail cars, after which a complete refit was required and she was rechristened the *Eureka*. In World War II she was used as troop transport, before resuming ferry duties from Oakland. She retired to the Hyde Street maritime museum in 1958.

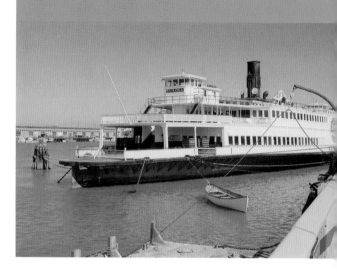

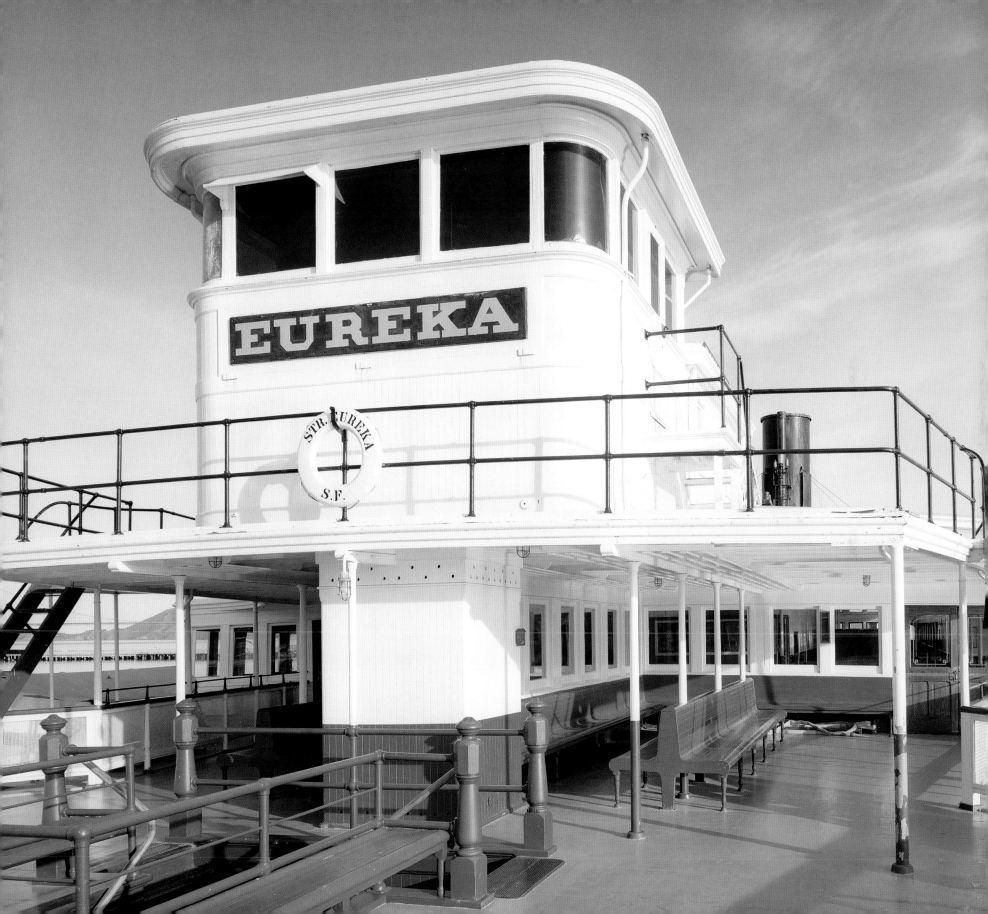

Sunset Limited Forty-Niner Train REPLACED 1941

The story of San Francisco's full-scale railroading centers on the Southern Pacific (SP). Founded in 1865 by Timothy Phelps and a group of local businessmen who quickly cashed out to the "Big Four" railroad barons, the company merged with the formidable Central Pacific (CP). While the initial board's goal was connecting San Francisco to San Diego, under Leland Stanford, Collis P. Huntington, Charles Crocker and Mark Hopkins, the railroad took a different turn. Through service to Los Angeles was established by 1876. Just five years later, SP connected to the Texas & Pacific's tracks heading westward in Hudspeth County, Texas, to complete the nation's second transcontinental route.

The Sunset Limited was the SP's premier train on the southern transcontinental route from 1894. It ran the San Francisco route via Los Angeles along the coastline. Around 1900, *The Octopus: A California Story*, a Frank Norris novel, scandalized SP in a story inspired by railroad men's ruthless eviction tactics during a land dispute. Critics saw SP's tentacles everywhere: from *Sunset* magazine's promotional glitz, to its complete absorption of CP, to key seats in the state legislature.

Not to be left out of the San Francisco rebirth celebration, SP carried a very special passenger to the Panama-Pacific International Expo: Philadelphia's Liberty Bell aboard the "Exposition Line – 1915." During the fair, attendees could take the Expo Line and tour the region's natural wonders in sleeper cars, or take the Bell's return trip, again stopping at every town possible along the way. After 1930, the Sunset Limited would never again have direct access to New Orleans via San Francisco, thereby ending transcontinental service. The train also lost its Pullman sleeping cars that same year.

A streamliner train, the Union Pacific Forty-Niner was a special train just for the Golden Gate Exposition. The Forty-Niner made its first run in 1939 in Wyoming. It ran five times a month between Chicago and the Golden Gate Exposition in San Francisco and stopped running in 1941.

By 1957, all of SP's steam engines had been replaced with diesel. Increasing property values at the tip of the San Francisco peninsula progressively squeezed out industrial operations during the 1960s and 70s. Without freight to carry, the rails pulled out of the city by the bay, leaving CalTrans and BART trains to the business of delivering passengers. One lonely freight line that linked the piers to the railroad, the State Belt Railroad, stayed viable until 1993 when it was discontinued.

OPPOSITE PAGE *The Union Pacific Streamliner Forty-Niner was a heavyweight, all-Pullman affair that ran between Chicago and San Francisco. The locomotives wore UP's prewar streamliner colors of Armour Yellow, Leaf Brown and Scarlet. She made her last run in 1941.*

ABOVE *An early 1920s Southern Pacific Sunset Limited, with rear observation platform, photographed circa 1923.*

RIGHT *Southern Pacific was keen to sell the glamour of California beaches and California girls.*

California BEACHES

SOUTHERN PACIFIC

EARTHQUAKE RELIEF

In 1906, SP took its opportunity to shine. In one of the greatest evacuation efforts in history—rivaling that of Dunkirk in World War II—SP took more than half the city's population away from the raging flames. Ferries and trains combined were said to have taken 300,000 of the 410,000 population, while the Navy accounted for another 20 to 30,000 evacuees from Fort Mason. The commercial value of the evacuation was said to exceed $400,000. The railroad company ran some 1,400 trains with more than 20,000 cars throughout its Bay Area system free of charge to those traveling from San Francisco to points like Santa Rosa, Vallejo, Oakland, San Jose or Sacramento. The offer began 45 minutes after the quake and lasted the next five days. The value of the donated supplies carried was an estimated $500,000. Following the disaster, SP's publicity department aggressively wrote its own history of the relief efforts, playing up the fact that the fire caused more damage than the quake itself, and encouraging people to return and rebuild.

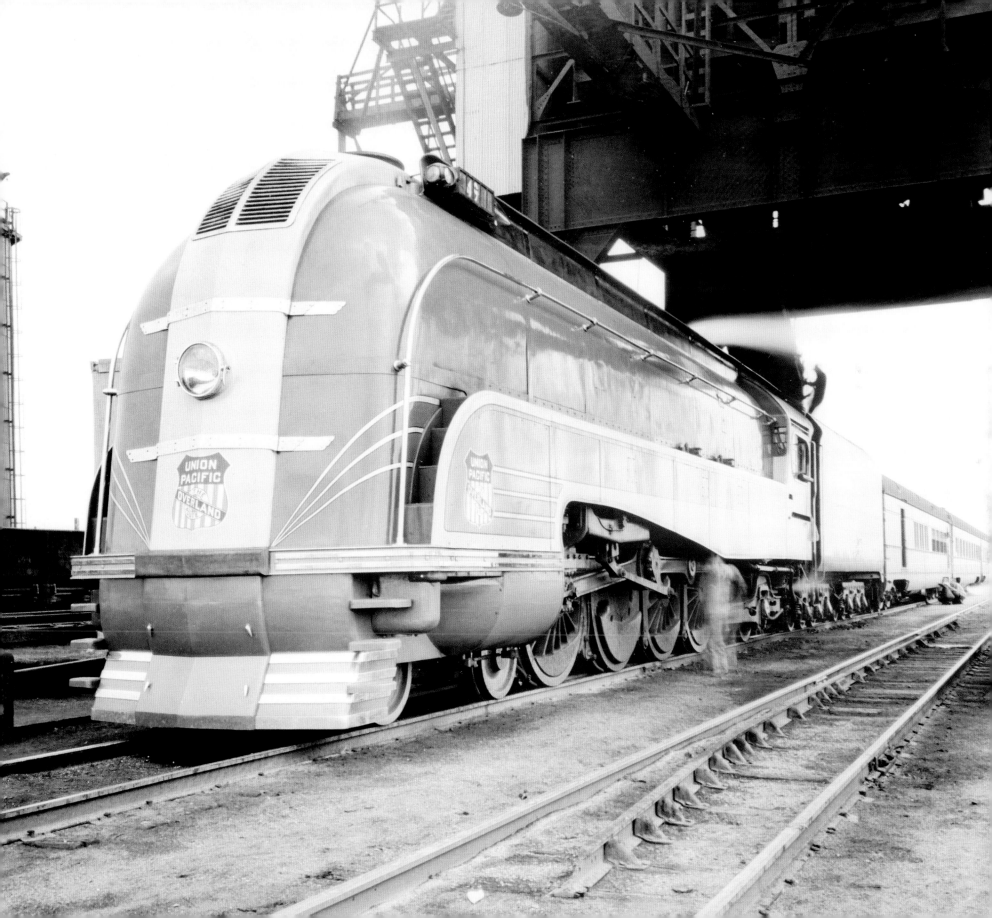

Fillmore Arches SCRAPPED 1943

Safely beyond the 1906 fire line at Van Ness Avenue, the relatively new working-class neighborhoods along Fillmore Street and in the Western Addition survived. Many displaced San Franciscans couldn't buy into the new high-class high rises appearing downtown. Instead, the Fillmore offered an affordable option. Fillmore Street and the surrounding blocks served as the temporary home of several newspapers and department stores, even City Hall, until new facilities were completed in 1909.

To celebrate the regeneration of the Fillmore neighborhood, merchants pooled their efforts in an attempt to maintain their commercial edge as the rest of the city returned to compete with them. The idea came about to decorate their street with fanciful arches that also helped illuminate their street at night. With so much of the city a dark wasteland, the Fillmore couldn't be missed.

As one of their earliest acts, the Fillmore merchants erected an arch in 1907. Festooned with scores of bulbs, the arch lit up the street like daytime whenever the merchants desired. For the construction of the arches they approached a San Francisco mechanical engineering company, John Hendy's Ironworks.

The decorative streetlamps often seen in old pictures of San Francisco's Chinatown were also Hendy productions. As the Fillmore Street commercial district expanded, 14 arches in all were ordered from Hendy for each intersection along Fillmore, from Fulton to Sacramento streets.

Fillmore then earned the reputation as the most illuminated street in the country when the Panama-Pacific Exposition brought several million people right down the street and into the fair at the Marina.

As a part of the "war effort" folks in the Fillmore donated the beloved arches, removing them in 1943. The arches may well have gone full circle back to a place like Hendy's Ironworks. The arches were very bright and without any means of turning them down during a "dim out" the merchants decided the prudent idea was to remove them and supply the scrap iron to the war department.

RIGHT *Arches like this one at Fillmore and Fulton streets lit up the way to the 1915 Panama-Pacific International Exposition.*

LEFT *Removal of the arches was begun on June 5, 1943, by the Fillmore Merchants & Improvement Association, who spent $1,500 in a patriotic move to aid the steel salvage campaign. Workers are shown here taking down the arch at McAllister and Fillmore streets.*

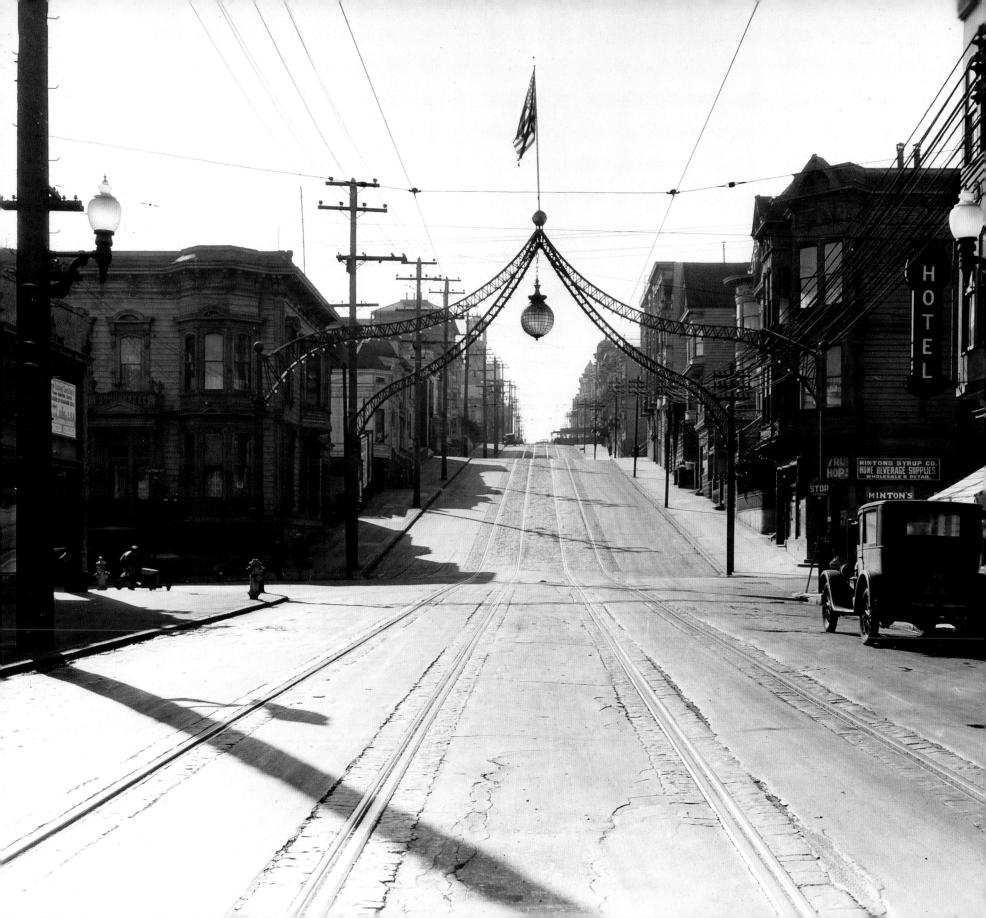

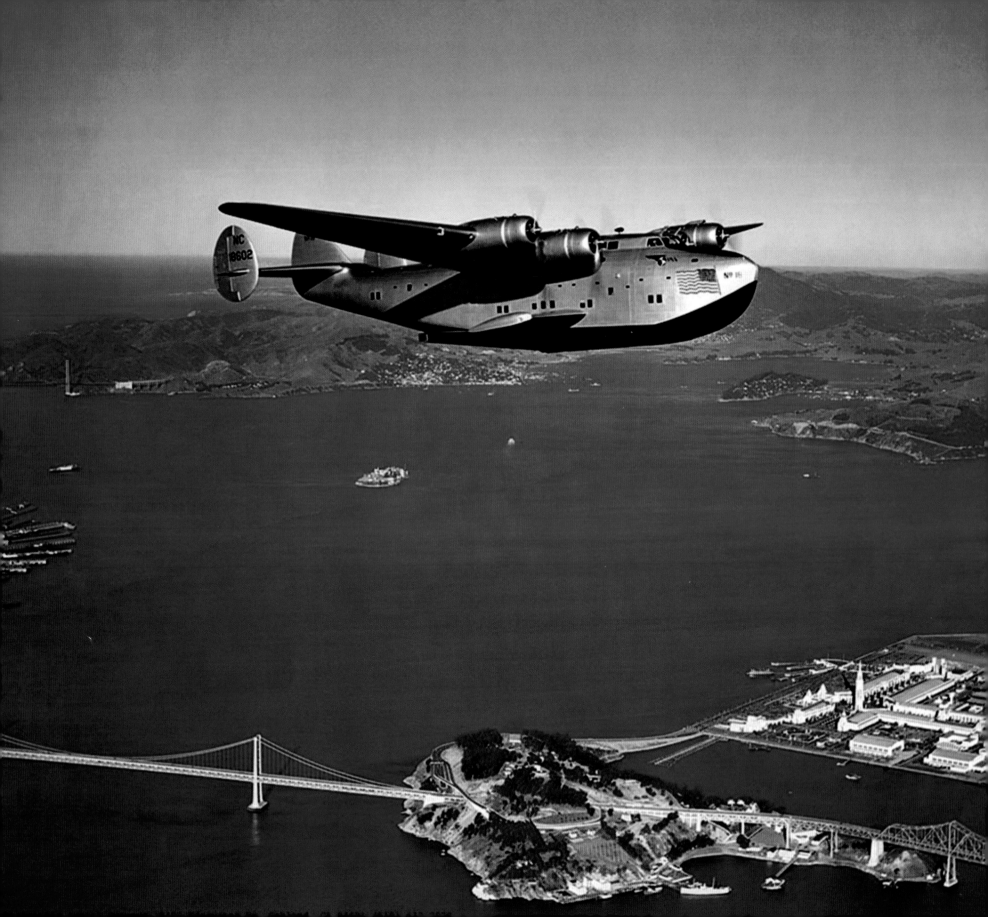

The China Clipper CEASED SERVICE 1945

The first airline to deliver airmail across the Pacific was Pan American World Airways, commonly known as Pan Am. Utilizing the specially commissioned Martin M-130 Clipper Seaplane for its initial flights, Pan Am purchased three Martin craft, dubbed the China Clipper, the Hawaiian Clipper and the Philippine Clipper. Most Americans referred to all three as China Clippers.

The classic Martins were referred to as "flying boats" in the vernacular, but the Martin Company itself called them Martin Ocean Transports. Once the company began using the cutting-edge Boeing B-314s—giant long-range seaplanes—the average American still referred to them as China Clippers. On November 22, 1935, the first trans-Pacific airmail delivery took off from Alameda (across the Bay from San Francisco), where Pan Am based its operations before moving to Treasure Island. Alameda's airport offered easy access to the water that often provided the best take-off and landing runway for the seaplanes.

The China Clipper delivered some 111,000 letters to places like Midway and Wake islands, Hawaii, Guam and the Philippines on that inaugural flight. The crew stayed overnight at each stop, spending a total of 59 hours and 48 minutes in the air over six days. Reappearing in San Francisco after its 8,000-mile flight, the China Clipper had cut a full month off the same trip by steamer.

Pan Am inaugurated passenger service in October 1936. The Hawaii Clipper and the Philippine Clipper made the historic first deliveries of transoceanic commercial passengers from California to the Philippines and to Hong Kong respectively. For passengers the trip cost $950 one way or $1,170 round trip; roughly the equivalent of $14,653 or $26,376 in today's money. Following the introduction of passenger services, U.S. President Franklin D. Roosevelt presented Pan Am with the annual Collier Award—among the highest honors in American aviation—for "establishment of the transpacific airline and the successful execution of extended overwater navigation and the regular operations thereof." The planes were also the inspiration for the 1936 film *China Clipper* starring Humphrey Bogart and Pat O'Brien.

The Hawaiian Clipper disappeared without trace while flying to Manila in 1938. One of the passengers was Chinese War Relief President Wah Sun Choy, who was carrying the $3 million ($45 million in today's money) that his group had raised to support the Chinese government in their war against the Japanese. Skeptics postulate that Japanese officers may have performed history's first hijacking to get Choy's money, but no evidence exists to prove this theory. Aviation experts were dumbfounded. The plane was equipped with safety features that should have prevented a wholesale sinking: four watertight bulkheads, rubber inflatable boats, kites for emergency radio broadcast and a stash of balloons to send up a signal. Pan Am stocked each clipper with a shotgun and some fishing tackle in case of being stranded, plus enough food to feed 15 people for a month. The mystery surrounding the disappearance of the Hawaiian Clipper and all of its passengers and crew remains unsolved.

The Philippine Clipper crashed in the mountains outside Ukiah, California, in 1943 due to a pilot error, killing all 19 people aboard, including 10 high-ranking Navy officials.

The China Clipper, the first of Pan Am's clippers, remained in service the longest, until January 8, 1945, when it was destroyed in a crash in Port of Spain, Trinidad. Sixteen passengers and nine crew members died in that crash. Pan Am was the principal U.S. international air carrier from the late 1920s until its collapse on December 4, 1991.

OPPOSITE PAGE *A Boeing B-314 seaplane pictured above San Francisco Bay in 1940. Boeing had a long history in producing seaplanes and the B-314 was brought into service alongside the original Martin flying boat. The plane, which could carry more passengers than the Martin, was also used on the route from Los Angeles to San Francisco.*

ABOVE *The original China Clipper was the Martin M-130 flying boat, which the company built to a specific brief from Pan American.*

LEFT *A poster advertising Pan American's services.*

BELOW *The Clipper arrives in Singapore, April 1941, just months before the Japanese would overwhelm the island in World War II.*

Angel Island DECOMMISSIONED 1946

Now a place for peaceful recreation, for almost a century Angel Island had served as a military base and for a time San Francisco's answer to Ellis Island. The largest island in San Francisco Bay, Angel Island started its military career with statehood in 1850. Following the tense days of the Mexican War, the Presidio lay in ruins and a single gun at Black Point overlooked the bay.

The new American stewards drew up an elaborate plan of defense and built Fort Point, artillery batteries at Alcatraz and other improvements. Angel Island's batteries were planned but never built. War pushed the plans back to the forefront in 1861 when Confederate-leaning San Franciscans vocalized a plan to seize Fort Point and all the shipping through the Golden Gate.

The idea galvanized public concern over the relative defenselessness of the bay from Confederate attacks, possibly staunching the flow of gold into the American economy. Alcatraz became a major fortress supporting some 100 guns while Angel Island waited until 1863 for its second-line defensive batteries. On September 21, some 56 men of Company B, Third Artillery, began construction of Camp Reynolds, named for Major General John Reynolds who fell to a sniper bullet while commanding the First Corps at Gettysburg just that July. Artillery engineers swept the island of its civilian squatters and built temporary emplacements at Point Knox and Point Stuart, while contractors built barracks and officers' quarters. The men spent their first winter in tents. The first of the island's three hospitals went up in 1864 along with surgeons' and stewards' quarters. By 1864, the island had 13 guns with 7,400 pounds of powder and 2,600 rounds ready.

Another battery at Point Blunt proved difficult to access. Alcatraz's men could better reach it by water, and it lay under their jurisdiction until the parapet collapsed in 1866. Separate barracks and officer's quarters at Point Blunt became a sub-post to Camp Reynolds. After the war, the island became a recruitment station and headquarters for units fighting the Sioux, Apache, Modoc and other tribes.

Units based there could be split up and assigned to any number of duties from Sitka, Alaska, to the Mexican Border. The army's prestige, number and pay declined. Desertion and drinking became increasingly common along with complaints of "deadly" monotony, which might explain why a camp chapel was built in 1876.

San Franciscans complained that Civil War-era emplacements were crumbling in the 1880s. In response, four mine-control points were built in San Francisco Bay, one on the south side of Angel Island. By 1898, Angel Island could claim three, permanent, state-of-the-art Endicott batteries just in time for the Spanish-American War. Thousands of men passed through Camp Reynolds on their way to win the Philippines and then put down their insurrection. In 1899 a detention camp went up to serve men suffering tropical diseases and, after the war in 1901, a discharge camp was built for the 127,000 returning troops.

In 1900, the army renamed the post Fort McDowell, after the Civil War general and lifetime military man Irvin McDowell. Immensely popular in San Francisco, McDowell proved a master administrator after failing miserably while in command at the First Battle of Bull Run. In 1910 a major building program took place using prison labor from Alcatraz that included all new quarters, mess hall, hospital and guard house along with the Immigration Service's new processing station, the so-called "Ellis Island of the West."

Fort McDowell's most significant role included processing hundreds of thousands of men for both world wars, including POWs, until it was decommissioned in 1946. A Nike Missile base stood poised to strike until it too became obsolete in 1962. The following year the entire island became a California State Park.

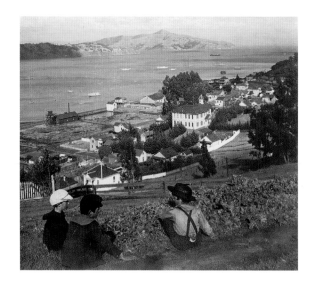

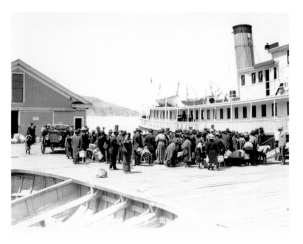

OPPOSITE PAGE *The Immigration Headquarters on Angel Island photographed in 1928.*

TOP RIGHT *Three boys enjoy the view from Angel Island in this 1901 photograph. Nine years later it would become the Ellis Island of the West. In the face of the Chinese Exclusion Act of 1882, immigrants from China faced a much tougher task of gaining entry.*

MIDDLE RIGHT *Immigrants wait on the quay with bags and possessions in 1920, ready to be shipped across to the mainland.*

BOTTOM RIGHT *This photograph from January 1957 shows that a coastal defense Nike missile site found a home on Angel Island. These sites were built during the 1950s in rings around major urban and industrial areas.*

Forts Funston and Cronkhite DECOMMISSIONED 1946; 1974

Fort Funston

Army engineers planned to arm the Lake of Mercy as far back as 1890. Laguna de la Merced (Lake Merced) and the Pacific Ocean create a narrow strip of raised sand dunes forming an ideal location to build gun batteries. In December 1900, the army attained some 45 acres from the Spring Valley Water Company but no building took place until World War I pressed the need. Construction began in February 1917 with a temporary emplacement for four 12-inch mortars named Battery Howe. Another temporary emplacement, Battery Bruff, mounted two 5-inch rapid-fire guns.

At the beginning of 1919, the Coast Artillery Corps took possession of what was now named Fort Funston after Major General Frederick Funston, the commanding officer of the Presidio, in 1906. Funston's men patrolled the streets to prevent looting, maintain order and assist the needy during the aftermath of the quake disaster. Funston then distinguished himself during the Philippine Insurrection against American occupation following the Spanish American War.

The men assigned to the batteries in 1919 lived in tents while building wooden frame barracks houses and storehouses. Not much of the construction was considered permanent, as the main facilities were north at the Presidio. After just six months, Battery Bruff's guns were already outclassed, but Battery Howe remained in operation through World War II. During the war, the base expanded with a new era of temporary construction, to a total of 86 buildings or so, some of which still stand on the east side of the road. Funston now claimed two additional batteries and two 2-inch anti-aircraft guns. By 1946 the Army declared the facility obsolete and a portion of the base was transferred to the city of San Francisco.

The Army did, however, retain the batteries where the California National Guard kept watch over the skies, with four 90-mm anti-aircraft guns in service by 1957. Some 71 acres became a Nike Missile base. With controls atop Mount San Bruno in San Mateo county, 12 launchers and three magazines held 30 MIM-14B Nike Hercules multi-stage missiles. Inactivated in 1963, today the launch area is a parking lot.

Fort Cronkhite

At Fort Cronkhite in Marin County (built beginning in 1937) barracks, mess hall and gun emplacements are preserved recalling memories of men who waited for an enemy who never came. The place was named for General Adelbert Cronkhite, commander of the 8th Corps during World War I in 1938. At one time, the largest guns available in the U.S. Army: giant 16-inch guns were positioned here in long-range defense of San Francisco. Along with positions at the Presidio and Fort Barry nearby, these guns' 26-mile range were intended to keep fleets outside the Golden Gate. There were four of them, in pairs at Cronkhite, along with three 3-inch anti-aircraft guns.

While Funston took priority, facilities were rapidly completed to serve after the bombing of Pearl Harbor. By July 1941, Battery E of the 6th Coast Artillery took command. After World War II, the garrison was removed, but the site continued serving military purposes until 1974 when Nike Missile Site SF-88 was decommissioned. The temporary buildings at Cronkhite are considered significant examples of wartime architecture that once proliferated throughout the Bay Area. Today they are maintained by the park service.

OPPOSITE PAGE *Panama mounts, like the one shown here, were gun mounts that the U.S. Army developed in Panama during the 1920s for fixed coastal artillery positions. These mounts were widely used during the buildup to and during World War II. This one is at Fort Funston's Battery Bluff. Through erosion of the cliffs over time, many eventually fell into the sea.*

BELOW *Workmen are shown dismantling one of the huge 16-inch coastal guns at Fort Funston that had guarded the Golden Gate from enemy forces on November 24, 1948.*

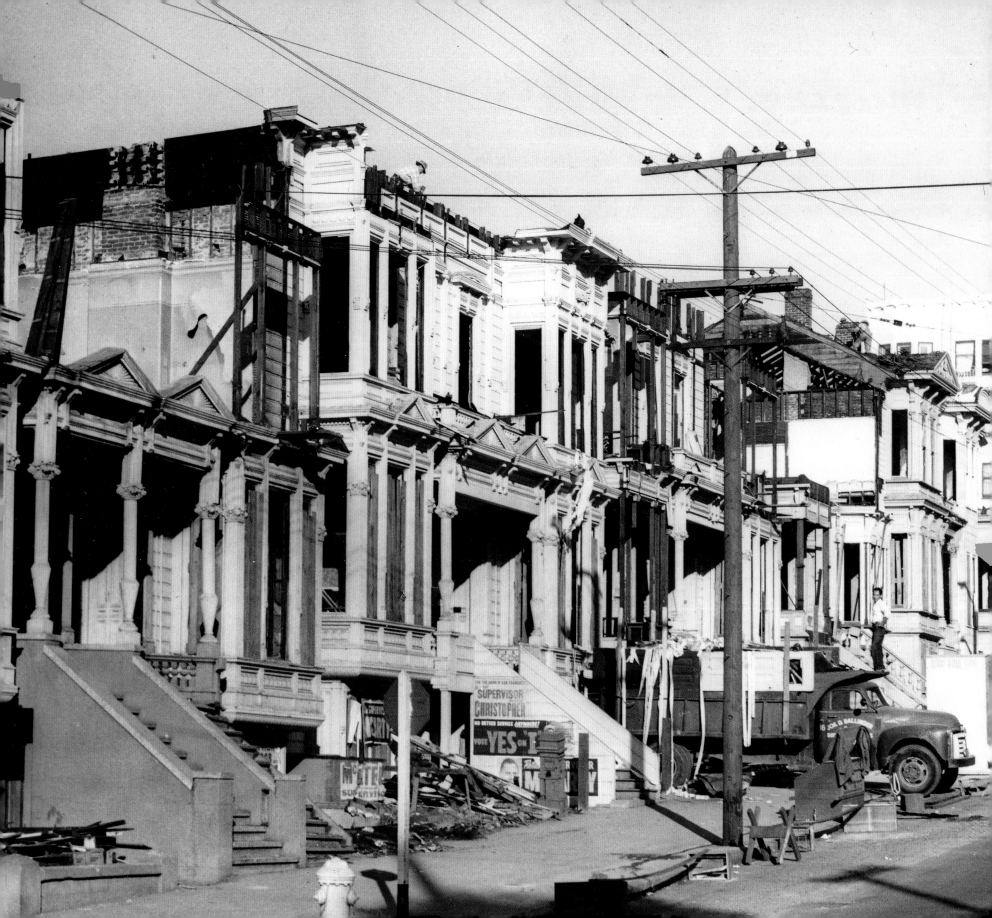

The Fillmore Neighborhood RAZED 1948

President Millard Fillmore's eponymous street stretches for over two miles, from the Marina Green to Duboce Avenue. The street has a special place in San Francisco's lore. After the 1906 earthquake, the road's Japanese community moved out to the nearby Western Addition, establishing Nihonmachi (Japanese town), now known as Japantown, centered on the intersection of Post and Laguna streets. In 1907, the notorious politician Abe "Boss" Ruef was jailed in a private home on Fillmore Street after a massive corruption scandal. In 1915, the street's handsome arches, which graced many of its intersections, became the gateway to the Panama-Pacific International Exposition. Ironically, the aviation pioneer, Lincoln Beachey, died at the foot of Fillmore Street when his plane crashed into San Francisco Bay during a demonstration flight at the exposition.

In 1948, city officials declared the Fillmore district—by then an ethnically diverse but largely African-American neighborhood—to be "blighted" under the California Redevelopment Act of 1945.

Over the next few decades, and with the help of eminent domain and Federal funding, the city forced 4,729 businesses to close, pushed some 2,500 households out of the neighborhood, and demolished 883 Victorian-era homes.

Many say that the Fillmore (as the neighborhood is known) was not blighted, but the center of a vibrant, African-American commercial district, providing goods and services, gainful employment, and upward mobility for thousands. What went wrong? Several things, according to writer Carl Close, who says that the urban planners of the day got it wrong. "If it wasn't broken (and in the eyes of many of the Fillmore's residents and shopkeepers at the time, it wasn't)," Close wrote. "It didn't need fixing."

Close compared those attempting to "fix" the Fillmore after they destroyed it to someone trying to unscramble an omelet. "Powerful politicians, bureaucrats, and contractors who profited from 'redevelopment' had different short-term interests than those displaced by the program," he said.

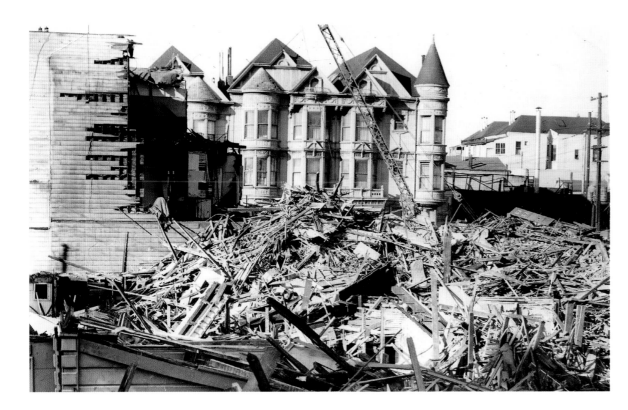

OPPOSITE PAGE *A row of Victorian-era homes waits its turn for the wrecking ball in the Western Addition.*

LEFT *An entire block of Victorian-era homes is wrecked to make room for 608 public housing units. This demolition work is in the block bounded by Turk, Eddy, Laguna and Buchanan streets.*

Shoot-the-Chutes DEMOLISHED 1950

Once Gold Rush San Francisco settled into a more sedate, residential population, people began seeking more family-oriented venues for recreation. Pioneering amusement park operator Paul Boyton created a sensation at the 1893 Chicago World's Fair when he opened the first Shoot-the-Chutes ride there. The 350-foot dive in a flat bottom boat into a pool of water delighted thousands. Soon after, he created a permanent version for New York's Coney Island.

Boyton sold the rights to the ride, and the first in San Francisco appeared on Haight Street in 1895 between Cole and Clayton. Railroad attorney Charles Ackerman developed the facility that soon included other rides, a 3,000-seat theater and a penny arcade.

The site was so popular at 10 cents per adult and five cents per child, that Ackerman expanded to a new location on Fulton Street between 10th and 11th streets by 1902. The new park added a Ferris Wheel and a zoo. As of 1906, the Fulton Street location fell into disrepair and Charles Ackerman passed away, leaving his son, Irving, to open Coney Island Park on Fillmore in 1907.

The Chutes were adapted to the location which soon came to be known as the Fillmore Chutes, along with its zoo, aquarium, dance pavilion, and motion picture and vaudeville theater. The place burned in 1911, never to reopen. Shooters would need to wait another decade (see sidebar) for the city's next Chutes ride to open at the beach.

Ocean Beach's natural attractions invited entrepreneurs to serve families on weekend outings. Starting with the Cliff House in 1863, attractions multiplied, managed by independent concessionaires. By 1884 a steam railroad serviced Ocean Beach where a dance pavilion and gravity railroad (the area's first amusement ride) had already been built. In 1896, Adolph Sutro added his magnificent bathhouse, attracting thousands more annually. By the Roaring Twenties, the stretch of rides, shooting galleries, games and eateries that stretched south along the ocean from the Cliff House took on its own identity. But after World War II these resorts lost their attraction. Shoot-the-Chutes met the wrecker in 1950, the Sutro Baths closed in 1954 and the Big Dipper fell in 1955.

OPPOSITE PAGE *First introduced at the Chicago World's Fair of 1893, "Chutes," soon started to appear throughout Europe and the U.S. This one opened at 10th and Fulton streets along with a 50-foot-long waterslide, a scenic railway, a 4,000-seat Vaudeville Theater, a zoo, an ice-skating rink, a dance hall, a merry-go-round, a shooting gallery, a miniature bowling alley, a penny arcade and a photograph gallery. It was so successful it expanded to a new site on Fulton Street in 1902.*

ABOVE LEFT *Once the "outside lands," where few would venture, the beach along the Pacific Ocean became a destination of choice when the Chutes at the Beach beckoned San Franciscans. It was the fourth incarnation of the Chutes ride in the city and survived until 1950.*

LEFT *The Chutes at Fillmore and Eddy streets burned on May 29, 1911 in a fire that started in a restaurant flue. In the foreground is one of the famous Fillmore arches.*

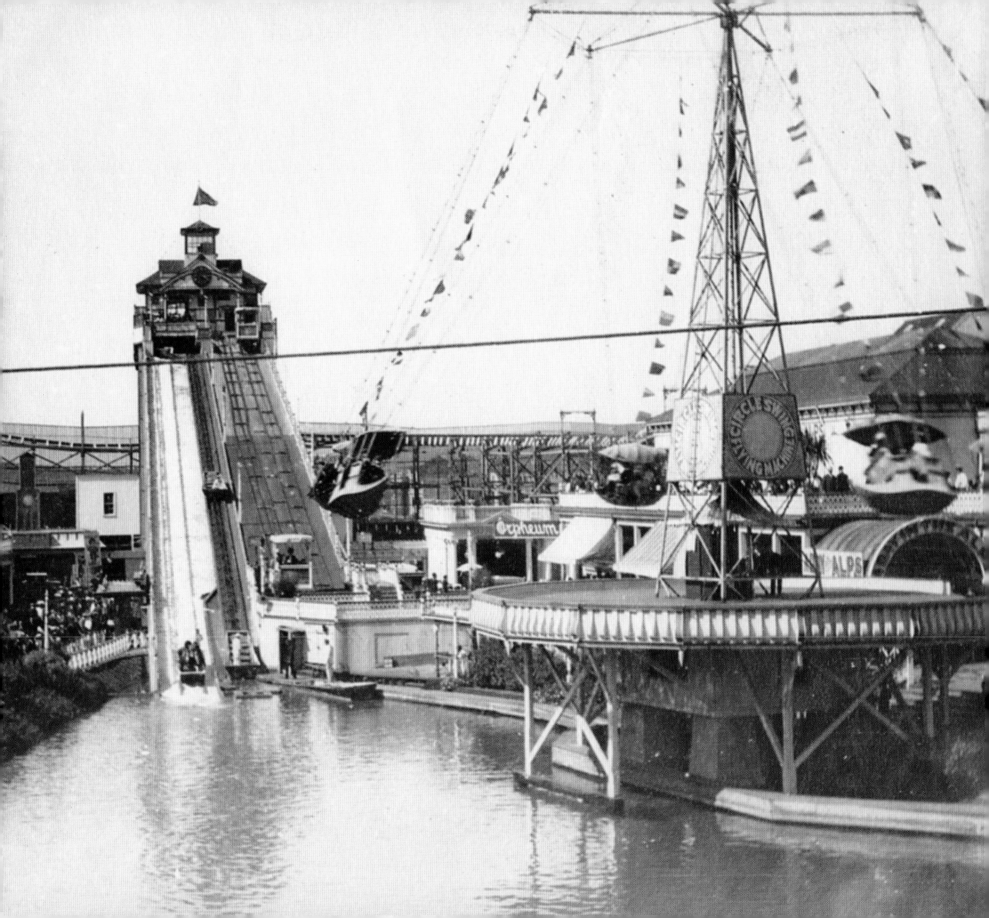

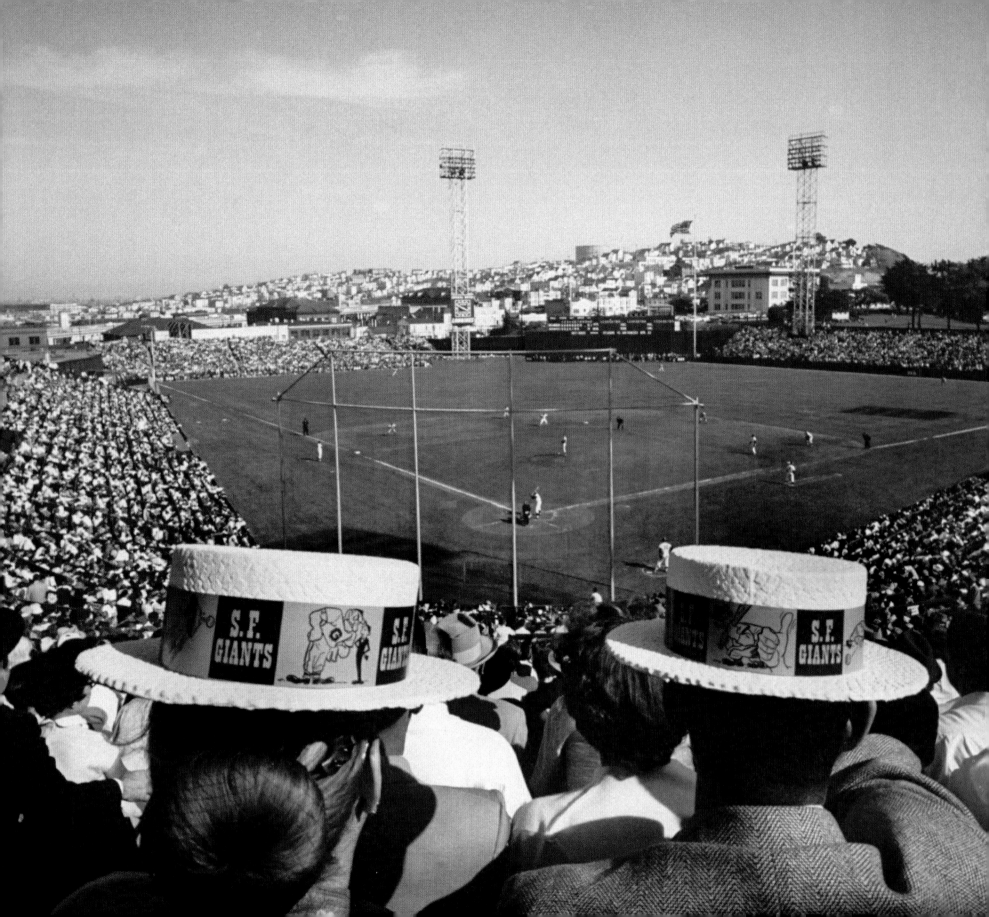

Seals Stadium DEMOLISHED 1959

Seals Stadium, home to the San Francisco Seals and, for a time, the San Francisco Mission Reds, opened on April 7, 1931 at 16th and Bryant streets. "Doc" Staub, the president of the Seals, invested $600,000 in the 16,000-seat stadium. Stories circulated about unemployed workers hopping onto the running boards of Staub's automobile, hoping for an honest day's work and the $3 that came with it. The Reds left town in 1938; the Seals played in the stadium until 1957.

In 1948, the Seals set a season record for attendance for a minor league team that stood for 40 years with some 670,000 fans in the seats. Such attendance records inspired struggling East Coast teams to move west. For example, in 1953 the Boston Braves moved to Milwaukee. Two years later, the Philadelphia Athletics became the Kansas City Athletics. In 1957, the Brooklyn Dodgers decided to come west. They opened the 1958 season as the Los Angeles Dodgers. That same year, the Major League Baseball's New York Giants pulled up stakes and became the San Francisco Giants.

The San Francisco Giants pushed the long-standing popular rivalry between the Seals and the Oakland Oaks into the background as a new Dodger-Giant rivalry formed almost overnight. The first Giants game played at Seals Stadium was on April 15, 1958. The Giants beat the Dodgers 8-0. Among the new San Francisco teammates was pioneer black baseball player Willie Mays. The "Say-Hey" Kid, as he came to be known, earned nearly every hitting honor in baseball. The Seals said goodbye to the Bay Area, departing for Phoenix the same year the Giants arrived. They played ball as the Giants' minor league affiliate until the 1998 expansion created the Arizona Diamondbacks. The D-backs took over the Seals affiliation and renamed them the Tucson Sidewinders. The Fresno Grizzlies are today's Giants' minor league affiliate.

Just two Major League seasons were played at Seals Stadium before the stadium met the wrecking ball in November 1959. In 1960, the Giants began their 40-year stint playing ball at Candlestick Park. In 2000, the team moved to the more urban AT&T Park. The Seals Stadium site is now the Potrero Center shopping mall. A plaque on the sidewalk at 16th and Bryant streets is all that remains today.

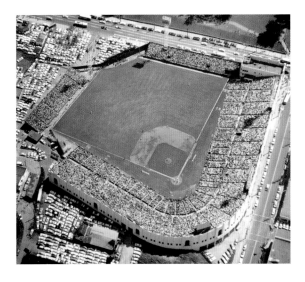

OPPOSITE PAGE *Seals Stadium, ready for the first day of the 1958 season with the San Francisco Giants taking on the Los Angeles Dodgers on April 15. The Giants beat the Dodgers 8-0.*

ABOVE LEFT *Here's proof: a capacity crowd of 23,448 fans saw the Giants win first time out.*

LEFT *Ground is about to be broken for Seals Stadium at 16th and Bryant streets in this 1930 photograph. H. J. Brunnier designed the $1.5-million single-deck cement structure. The stadium had a public address system and lights for night games. It was also home to the Mission Reds, who played here until 1938.*

WHERE HAVE YOU GONE, JOE DIMAGGIO?

Prior to 1953, playing as a San Francisco Seal was a fairly lucrative job. No major league teams existed west of St. Louis and players in the Pacific Coast League (PCL) were at times paid higher salaries than major leaguers. Many players got their start with the Seals and moved on to Major League stardom, perhaps the most notable being Joe DiMaggio. DiMaggio's brothers Dom and Vince were also Seals players, but it was Joe's 1933 61-game hitting streak that caught fans afire. It wasn't until Oakland Oaks pitcher Ed Walsh, Jr. no-hit the Seals on July 26 that Joe's streak ended. From Seattle to San Diego the PCL teams drew impressive attendance totals, driving the Seals to expand the stadium in 1946 to 18,500 for big post-war crowds.

Montgomery Block DEMOLISHED 1959

The Gold Rush brought treasure seekers from the world over to Yerba Buena, a quiet town of just 40 modest homes. Within a year, a built environment that could house maybe 400 people suddenly had 150,000 residents attempting to scratch out an existence on the sandy peninsula. Soon, expansive neighborhoods of wooden housing appeared along the shoreline expanding outward and up the hills. Sections regularly burned to the ground—no less than half a dozen fires took place in just the three years from 1849 to 1851, restoring segments of the population to their former predicament.

California's first military secretary of state, Henry W. Halleck, felt he could raise confidence in San Francisco real estate if he built a fireproof building. No ordinary bureaucrat, Halleck virtually invented military professionalism when he penned *Elements of Military Art and Science* at the age of 31. The reward for his research was a military-sponsored tour of Europe's defensive works. After the Mexican War broke out, he was assigned to California to build defensive structures, and while in the Golden State, Halleck speculated on various real estate

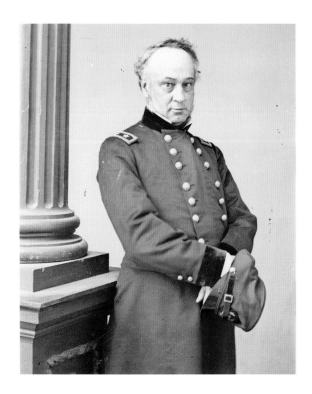

and business opportunities. Among the first would be the fireproof Montgomery Block to which he'd apply some of his military engineering experience. At $3 million the project was immense. To prepare the foundation, Chinese laborers sunk a raft of redwood logs in the muck along Montgomery Street's adjoining shoreline and used planks from the decks of abandoned ships nearby to create solid ground for the new building. The four-story, one-block building came out looking something like a fortress after more than a year of painstaking construction. It was greeted with local ridicule: San Franciscans called it "Halleck's Folly."

While the place was officially given the name "Washington Block," complete with George Washington's bust out front, locals immediately nicknamed it the Montgomery Block—after all, it stood at Montgomery and California streets. The largest building west of the Mississippi when opened in 1853, it rapidly filled up with professionals: lawyers, scientists and engineers, willing to pay a premium price of $1,000 per month for the all-stone and iron building.

Halleck himself held a law office in the building until the Civil War broke out, during which President Lincoln appointed him General in Chief of all the U.S. Armies. One of Halleck's neighbors in the block, James King-of-William, penned a particularly unfavorable editorial against City Supervisor James Casey in 1856. After William revealed the supervisor's criminal past in his *Daily Evening Bulletin*, Casey shot him dead, right outside the Montgomery Block. William was dragged inside, where he died six days later. The event led to the convening of the second Vigilance Committee that quickly tried, convicted and hung Casey.

Other famous names associated with the building include Mark Twain, who, while staying at the block and writing for a local newspaper, befriended a firefighter named Tom Sawyer, and A. P. Giannini, who founded the Bank of Italy (later Bank of America).

The twentieth century saw the building take a new nickname, "the Monkey Block," referring to the colorful Bohemian artist-types that kept showing up there like Jack London, Lotta Crabtree and Robert Louis Stevenson. By the 1930s rent in the aging structure dropped to just $5 a month and some 75 artists began to call it home. The building was demolished, under protest, in 1959 and for a time

became a parking lot. The Transamerica Pyramid skyscraper was completed on the site in 1972. The only reminder is a plaque in the lobby that commemorates California Landmark #80, Site of the Montgomery Block.

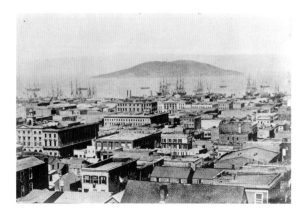

RIGHT *The Montgomery Block survived the 1906 earthquake and fire, but could not survive the wrecking ball. Photographed in 1940, it came down in 1959 to make room for the Transamerica Pyramid.*

TOP *The murder of James King-of-William was one of the most notorious incidents in San Francisco history. It is shown here in* Frank Leslie's Illustrated Newspaper.

ABOVE *The Montgomery Block is at the center of this 1860s photo of downtown San Francisco.*

LEFT *Henry Halleck—"Old Brains" of later Civil War fame—financed the building of the Montgomery Block in 1852. He is memorialized by a statue in Golden Gate Park.*

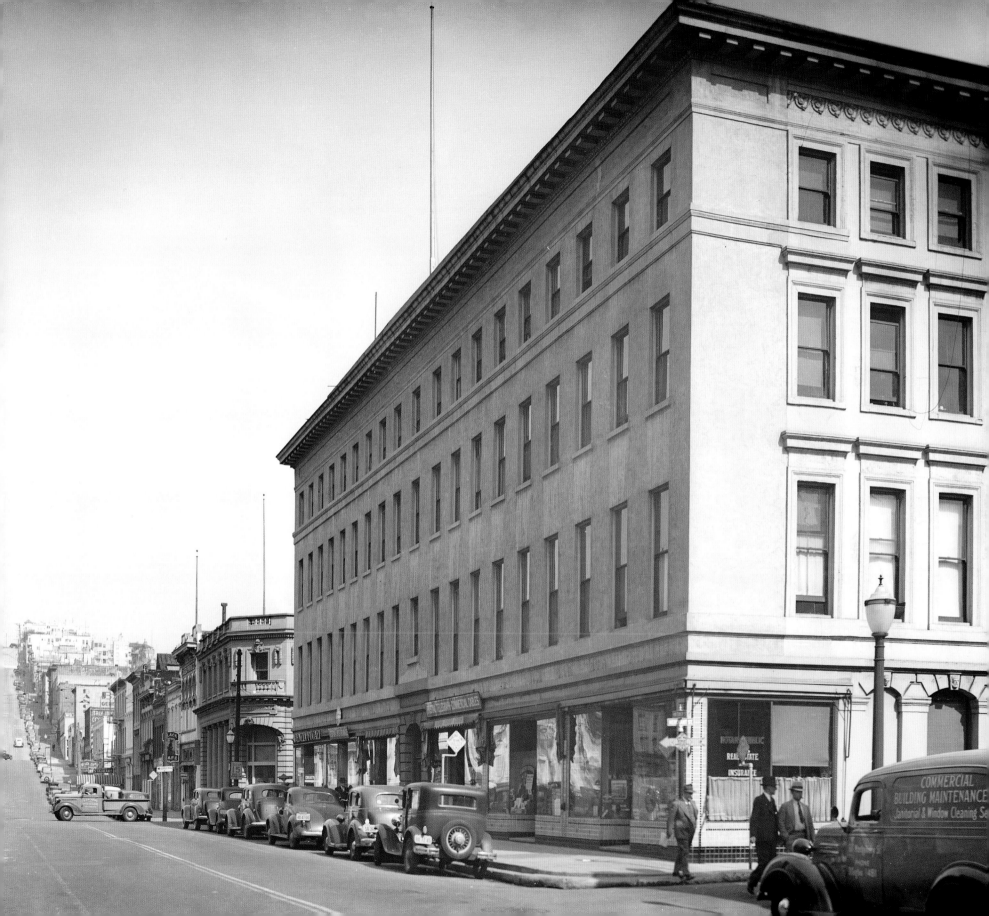

Beatniks MOVED ON 1960s

The original "Beat Generation" consisted of a circle of friends around author Jack Kerouac. He coined the phrase mostly to describe writers and friends his age that he had met at Columbia University in New York, including Allen Ginsberg and William S. Burroughs.

These friends experimented with eastern religion, anti-materialism, sexuality and drugs, and created the sense of their own underground subculture. *San Francisco Chronicle* columnist Herb Caen coined the phrase "beatnik" as a reference to the beat poets' communist leanings and outside-of-society status. Caen and the *Chronicle* helped characterize the Beats as beret-wearing, goateed men spouting nonsense poetry and playing bongos with free-spirited women dancing in leotards nearby.

A certain Neal Cassady lured Kerouac, Ginsberg and several New York friends to San Francisco by the mid-1950s. Cassady, who employed what became the Beat poets' characteristic jazz-influenced spontaneous verbosity, was Kerouac's travelling partner who inspired *On the Road*.

The Beats arrived during the San Francisco Renaissance encouraged through the late-1940s success of the local New American poets and other artists. Kenneth Rexroth, the first New American poet ushered in the next generation of San Francisco poetry, introducing the group that included Beat luminaries Gary Snyder, Michael McClure and Phil Whelan.

Lawrence Ferlinghetti, owner of the City Lights bookstore in North Beach, nurtured the Beat movement. Ginsberg's "Howl" first appeared in Ferlinghetti's City Lights Pocket Poet Series No. 4 in 1956. However, on publication, it faced ridicule and an obscenity trial from the less "hip" elements of society, which served instead to launch the poem into the national spotlight and make Ginsberg one of America's most famous poets. Ginsberg's trial liberalized America's views on literature; in fact, Ginsberg gave his generation credit for liberating the world from censorship in a list of the Beats' contributions he published in 1982. Also on his list was the evolution of rock and roll into a true art form, as both the Beatles and Bob Dylan spoke of the Beat writers as major influences.

They were among the first to oppose the military-industrial machine and call for the decriminalization of marijuana and other drugs.

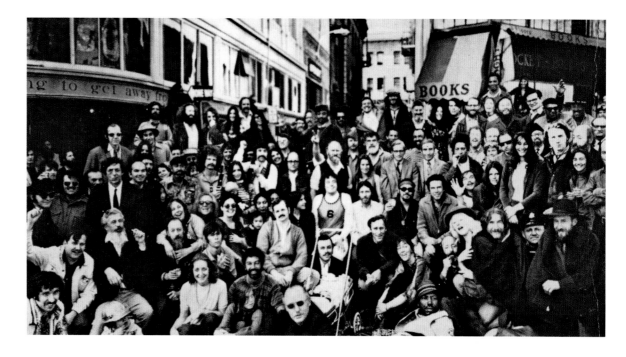

By 1960, elements of the expanding Beat movement were incorporated into the younger hippie counterculture that soon took the national spotlight.

The few men in the Beat Generation who stood up and challenged authority passed the torch to a new generation of men, who in turn stood up and challenged authority next. Ginsberg continued publishing well into his old age. When Ginsberg and Burroughs died, poetically in April and August 1997, the central pillars of the Beats vanished, but some of the inner circle live on today.

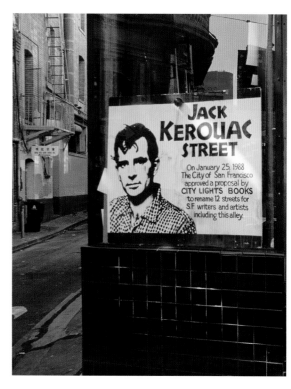

OPPOSITE PAGE *Leading lights of the Beat Generation (from left to right): Bob Donlin, Neal Cassady, Allen Ginsberg, Robert LaVigne and Lawrence Ferlinghetti.*

ABOVE *A group gathers outside the City Lights bookstore. Founder Lawrence Ferlinghetti put Allen Ginsberg's poem "Howl" on his bookshelves. The district attorney declared the poem "obscene" and hauled Ferlinghetti into court for selling it. That decision was overruled on October 3, 1957.*

RIGHT *Fittingly, the alley next to City Lights has been renamed Jack Kerouac Street in honor of the writer.*

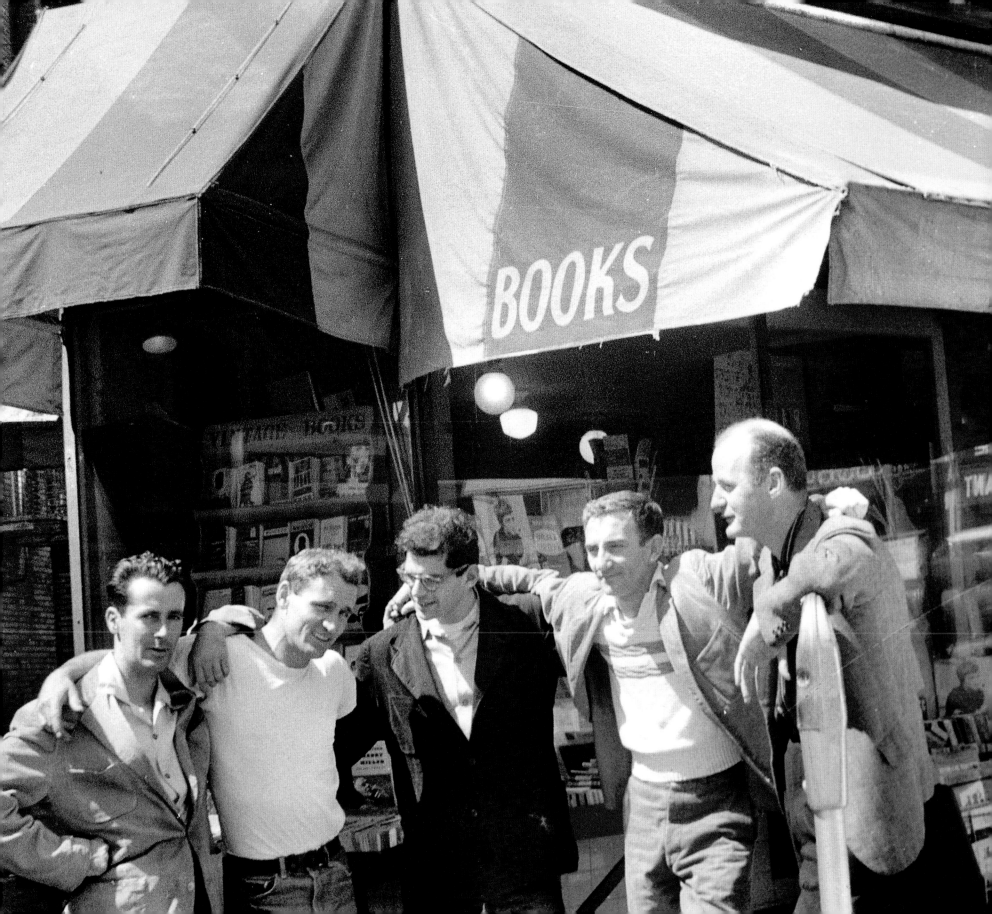

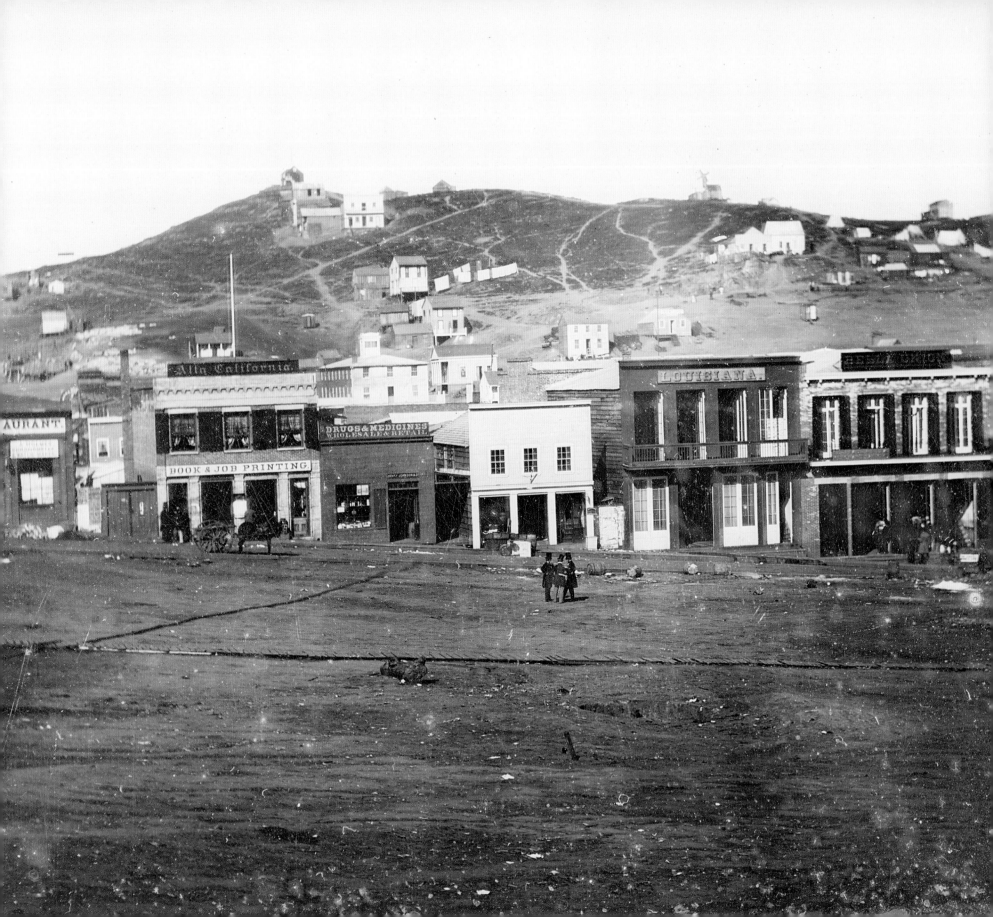

Portsmouth Square CONVERTED TO A "ROOFTOP" GARDEN 1962

Once Gaspar Portola discovered the sheltered harbor of San Francisco Bay in 1769, the rush was on to colonize and protect it. Under pressure from other colonial powers, the King urged settlers to move into the hinterlands of their empire and secure unprotected lands for Spain. By 1776, an expedition under the leadership of Juan de Bautista de Anza founded the mission and presidio at San Francisco.

A small civilian settlement, named "Yerba Buena," after a native herb Indians brewed tea from, began to serve as a trading post and port of supply for the Spanish fleet. Fast forward 70 years and Yerba Buena remained little more than 50 houses gathered around a plaza and the old mission. That plaza stood on the site of today's Portsmouth Square. On July 6, 1846, just after the start of the Mexican War, Commander John B. Montgomery, aboard the USS *Portsmouth*, sailed

into San Francisco Bay, to claim Yerba Buena for America. He raised the U.S. flag in a rededication ceremony at Portsmouth Square.

The square then took the name of his flagship. A strip of beach later to be a permanent road took the name Montgomery Street after the ship captain who claimed the village. Within six months, the first American mayor changed Yerba Buena's name to San Francisco. The concentration of Americans near Portsmouth Square led it to become the early center of city life: the El Dorado gambling hall became a temporary city hall; here stood the first public school in California by 1847; and, in the following year, Sam Brannan displayed his newly acquired gold nugget to other San Franciscans in the square, beginning the Gold Rush.

The square was the site of the Custom House, the Hall of Justice and the first public library and

post office were nearby. The Gold Rush created a massive city that suddenly surrounded the square, with a large adjoining district inhabited by Chinese immigrants. As the city expanded, Andrew Hallidie's first cable car line anchored its eastern end at the square as a popular destination. In the last decades of the 1800s, the area around Portsmouth Square devolved into the city's most dangerous district, characterized by blight, crime and vice.

Once the heart of the city, the square now represented the center of the Barbary Coast. The 1906 earthquake provided a clean slate, as nearly everything around the square was destroyed. The new neighborhood kept a more law-abiding appearance and made the square into a place more upstanding members of society could frequent without fear of street crime. Following the quake, Portsmouth Square was considered part of the new Chinatown neighborhood; it is even nicknamed "the Heart of Chinatown" today.

In 1962, a major renovation took place that included the construction of a four-level underground parking garage, converting the square to what many consider the garage's "roof garden." Some 50,000 vehicles per month utilize the parking garage today. By 1987, the site was due for another restoration. The square received new bathrooms and new elevators from the parking garage. A new playground was created for the young, while new landscaping and monuments created a place to honor important moments in history. Among the monuments are ones commemorating author Robert Louis Stevenson's San Francisco legacy and a replica of the Tiananmen Square's statue of the Goddess of Democracy celebrating China's groundbreaking stand for freedom in 1989.

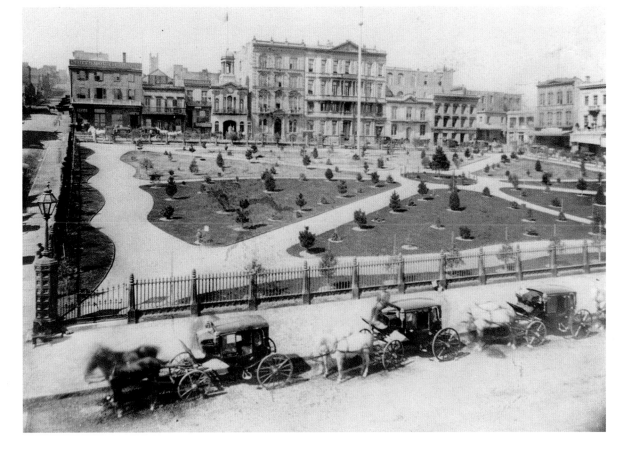

OPPOSITE PAGE *This daguerreotype photo of Portsmouth Square from 1851 shows the nascent community amidst barren, sandy hills. Portsmouth Square is named for the USS* Portsmouth, *a United States Navy sloop-of-war. A detachment of Marines under the command of Second Lieutenant Henry Bulls Watson from the* Portsmouth *rowed ashore and raised the American flag over Yerba Buena (as San Francisco was then called) on July 9, 1846, seizing California for the United States.*

LEFT *Portsmouth Square was transformed in 15 years from a frontier town to a bustling city with genteel squares and cabs for hire.*

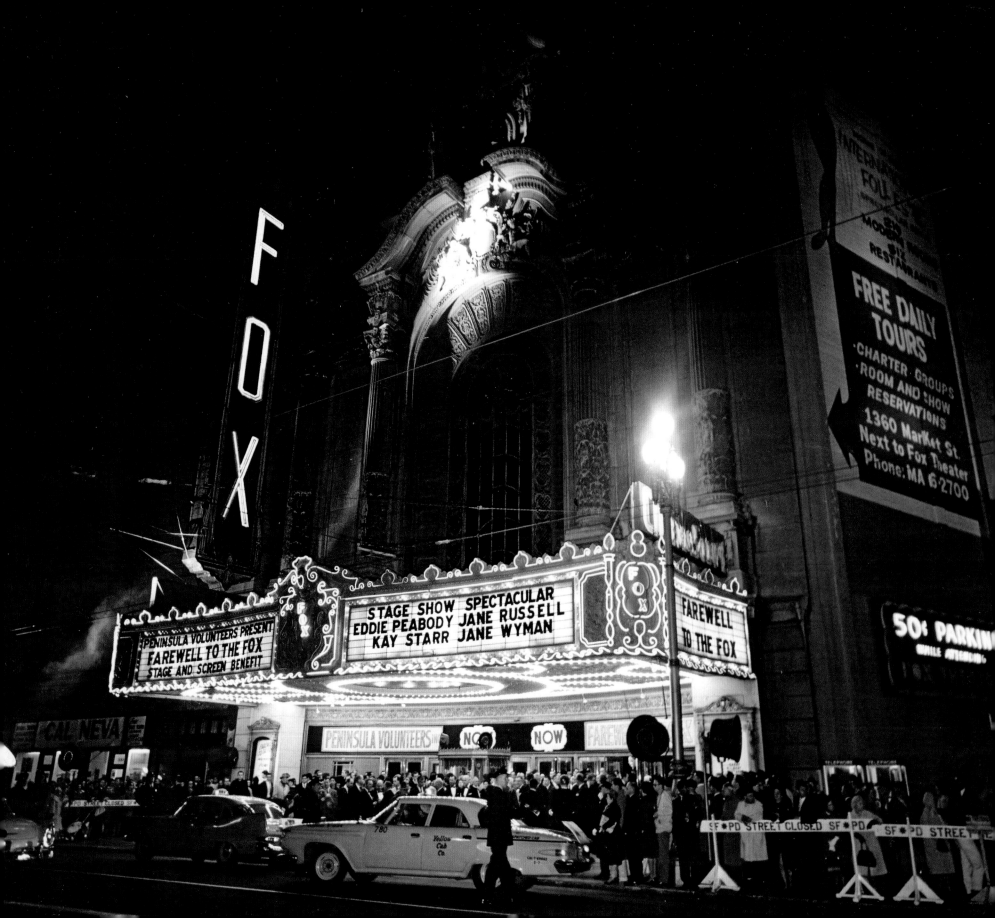

Fox Theatre DEMOLISHED 1963

Of the many neighborhood movie palaces that have come and gone over the years in San Francisco, the ultimate crown jewel had to be the Fox Theatre. Today, locals thank their lucky stars that storied institutions like the Castro Theatre, the Roxy and the Red Vic have survived into the current era. However, they pale in comparison to the magnificent 1929 Fox Theatre at 1350 Market Street. Capable of seating more than 4,600 people, the Fox was designed by Thomas W. Lamb, an architect specializing in theaters. Movie pioneer William Fox, founder of the Fox Film Corporation (entirely separate from 20th Century Fox, named for Darryl Zanuck's wife Virginia Fox), seeking to create distribution for his films, constructed the opulent theater to complement his other venues in Brooklyn, Atlanta, Detroit and St. Louis.

The Fox West Coast Theatres chain continued to grow with theaters appearing in nearly every American city by 1930. Opening night on June 28, 1929 featured the debut of *Behind the Curtain*, a Charlie Chan mystery. Pipe organs often comprised a cherished part of the movie palace experience, but the Fox took this to a new level. Consisting of some 4,000 pipes, grouped like copses of trees and built into vaults surrounding the auditorium, the sound quality was unparalleled.

The theater suffered financial difficulties almost immediately as the Depression set in, even closing for a year in the 1930s. After the war years, the Fox stumbled again as Hollywood lost its direction under the growing popularity of television. Theater Manager Robert Apple stood watch over the last few years of the theater in the 1960s and used every promotional tool he could to preserve it.

While nearly everyone who set foot in the Fox adored the magnificent lobby, the detail and decoration, and the several levels of balcony and box seating, the Fox West Coast Theatre Company hadn't seen a profit from the building in quite some time. After the local neighborhood heard of the Fox's troubles, a grass roots "Save the Fox" preservation effort appeared well ahead of today's more established historic preservation movement. Apple capitalized on the Fox's greatest asset, the pipe organ, and called in famous keyboardists to perform a midnight series of concerts to reestablish interest in the theater. While many theater operators scoffed at the effort, the concerts helped fund the Fox for a couple of extra years. In 1962, an era when many historic public buildings fell in favor of more modern tastes, the announcement came that the theater would be demolished.

The Fox's last day of showing movies, February 12, 1963, featured Boris Karloff in *The Raven* and Carl Boehm in *Peeping Tom*. On February 16, a "Farewell to the Fox" celebration was held, attracting many of Hollywood's finest. An auction followed on February 28 with the wrecking crane poised overhead. The crane finished its job on August 12, when no trace of the Fox remained. At first, the Fox Theatre was intended to front an office building that was never built. In the end, this idea came to fruition, as today on the site stands Fox Plaza, a typical modern office tower.

OPPOSITE PAGE *A "Farewell to the Fox" benefit concert was organized at the theater for February 16, 1963. The wrecking ball moved in on April 4, 1963. A year later, the same demolition team removed another much-loved San Francisco landmark, the Palace of Fine Arts. However, unlike the Palace, plans to preserve the facade of the Fox came to nothing.*

BELOW *The glorious auditorium of the 4,600-seat theater.*

TOP RIGHT *One of the grand staircases that swept movie-goers back into the ornate lobby.*

BOTTOM RIGHT *A reception held in the foyer of the theater that truly deserved the title "movie palace." Many of the fixtures and fittings were sold off prior to demolition.*

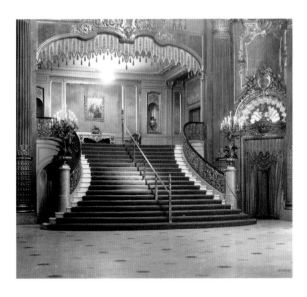

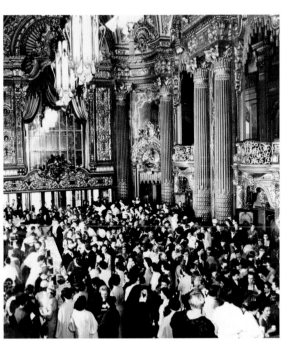

Alcatraz Prison CLOSED 1963

Before the British arrived in San Francisco Bay in 1826 aboard the HMS *Blossom* the island we know today as "Yerba Buena" was called "Alcatraz," the name the Spanish mapmaker aboard the 1775 *San Carlos* gave it. The *Blossom*'s mapmaker changed all that either by mistake or by design. The Spanish "Alcatraz" lay just off the coast of the village of Yerba Buena, as early settlers called San Francisco. When the *Blossom*'s mapmaker submitted his design, he called the large island "Yerba Buena" and transferred the name "Alcatraz" to a smaller island. The names stuck.

On November 6, 1850 President Millard Fillmore signed papers that deeded the island to the United States government. The U.S. Army turned the island into a fortification consisting of a pair of batteries at the south and north end of the island respectively. A two-story brick wall enclosed each battery. Plans included powder magazines, underground cisterns to hold water and warehouses for provisions.

The army put West Point graduate and Mexican War veteran Zealous Bates Tower in charge of outfitting the island. (Tower was also in charge of building Fort Point.) Along with the batteries, the army built barracks, shops, storehouses and a wharf. In 1854 Alcatraz received its first weapons. By 1858 the U.S. Army had added a third battery and by 1861 the small island bristled with 124 guns.

When the Civil War broke out, Confederate sympathizers in San Francisco hoped to take over Alcatraz and make it a Confederate bastion. Colonel Albert Sidney Johnston outfitted the island bastion with some 10,000 muskets and 150,000 cartridges of ammunition.

Johnston's move made the island the most powerful fort west of the Mississippi River. California Confederates gave up on the idea of taking over Alcatraz. "I have heard foolish talk about an attempt to seize the strongholds of government

under my charge," Johnston was quoted as saying. "Knowing this, I have prepared for emergencies, and will defend the property of the United States with every resource at my command, and with the last drop of blood in my body. Tell that to our Southern friends." Ironically, soon after he made this statement Johnston changed his allegiance. He served the Confederacy as a general and was killed at the Battle of Shiloh.

On August 27, 1861, the army turned Alcatraz into the military prison for the Department of the Pacific. Those loyal to the victorious Union saw to it that Confederate sympathizers caught celebrating the death of President Lincoln were sent to Alcatraz. In January 1895, 19 Hopi leaders from northern Arizona were sent to Alcatraz after refusing to comply with mandatory government education programs for their children. In 1934, the federal government converted the island into a maximum-security, minimum-privilege federal prison.

In 1963, Attorney General Robert Kennedy closed Alcatraz Prison because it had become the most expensive state or federal institution to maintain. Native American protests were held on the island between 1969 and 1971. Indians saw themselves as taking over Federal land that the tribes hadn't been compensated for. The site is now a national park.

OPPOSITE PAGE AND TOP RIGHT *The Alcatraz prison train barge crosses San Francisco harbor and unloads prisoners at the island in 1934. Al Capone was transferred to the jail via the secure train in August of that year.*

RIGHT *Alcatraz in its role as a military prison, as it looked from a passing ship in 1902.*

FAR RIGHT *Members of the American Indian Movement took over the island of Alcatraz in 1969 in a protest over federal government polices.*

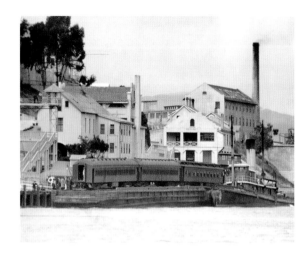

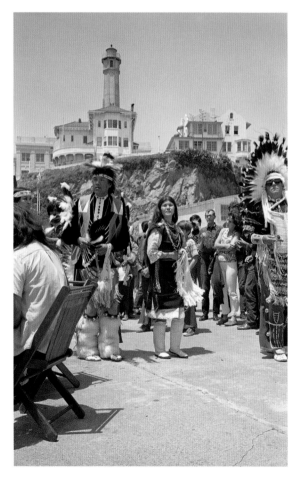

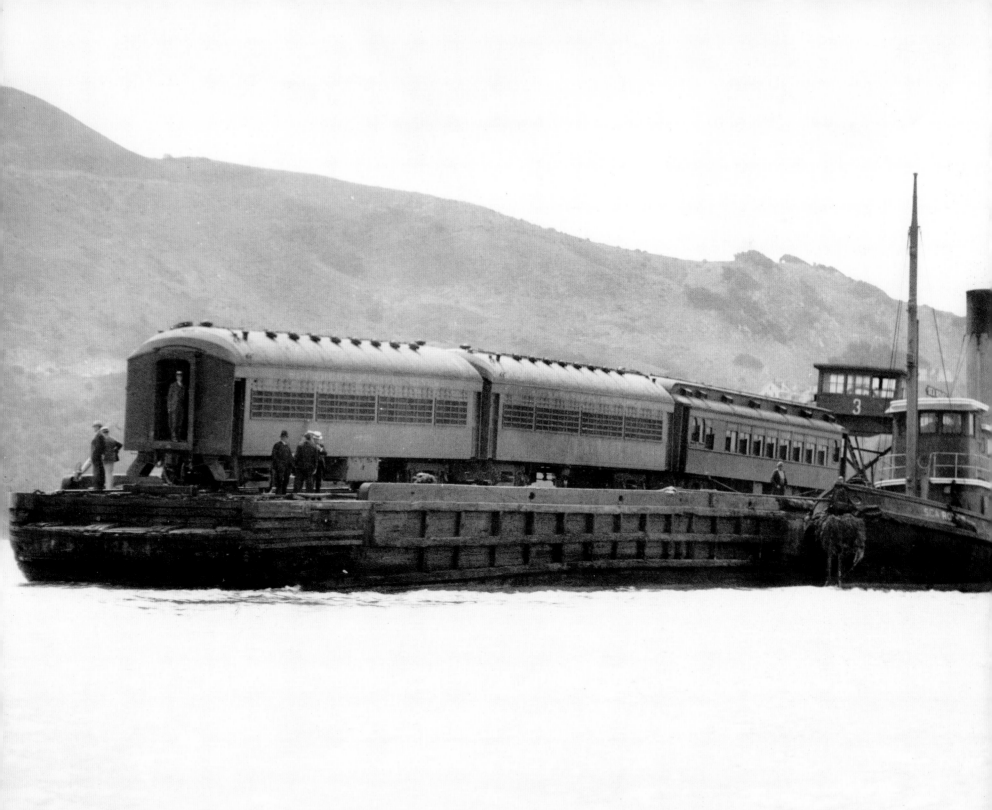

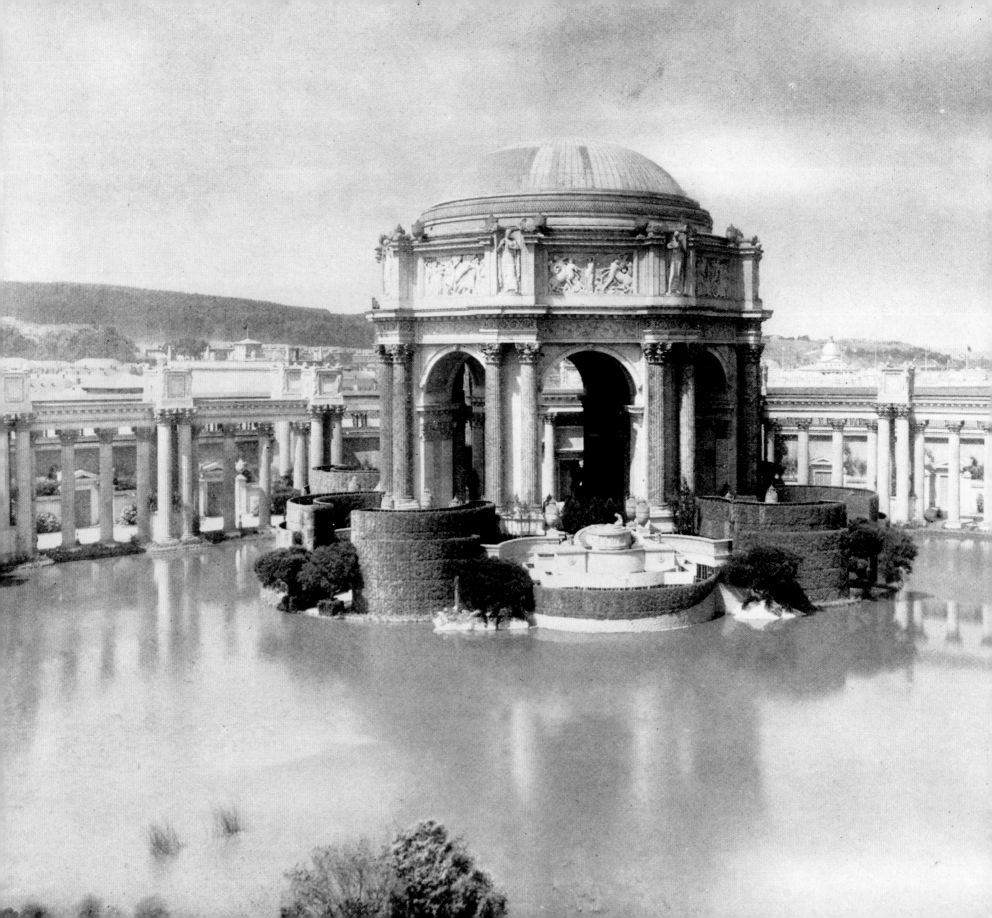

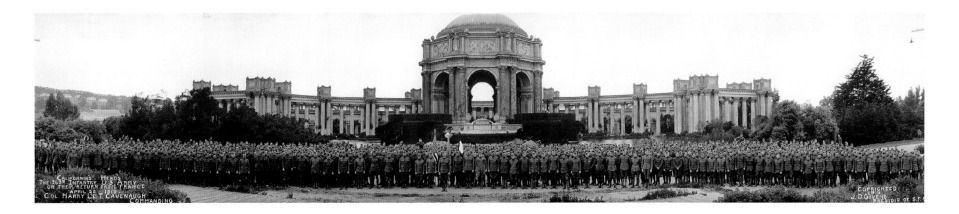

Palace of Fine Arts REBUILT 1964

Architect Bernard Maybeck designed the Palace of Fine Arts for the Panama-Pacific International Exposition of 1915. Maybeck's best-known legacy to San Francisco architecture was designed in the Beaux Arts style. His initial sketches for the Palace impressed Willis Polk, who chaired the Board of Architects for the exposition, and Polk turned over its design to Maybeck.

Even before the Exposition had ended, Phoebe Apperson Hearst was leading the way to save Bernard Maybeck's Palace of Fine Arts from the wrecking ball. She helped create the Palace Preservation League, which guaranteed a continued use for the building after the fair had ended. It continued to host art exhibitions and, during the Depression, the rotunda ceiling murals by Robert Reid were replaced by Works Progress Administration artworks. By that time the use of the building had changed dramatically and the exhibition hall housed 18 tennis courts between 1934 and 1940.

By the 1930s the Palace's wood footings and pile caps had deteriorated and were replaced with concrete beams. In 1964 the crumbling structure was closed to the public and builder Frank Modglin stepped in. Over the next three years he stripped the palace down to its steel framework and rebuilt it using concrete castings of the original. The rotunda dome was also waterproofed at that time. Only the center portion of the original Palace survives today. A plaque on the rotunda reads: "In Honor of B. F. Modglin, Builder of the Reconstruction for the Palace of Fine Arts, 1964–67."

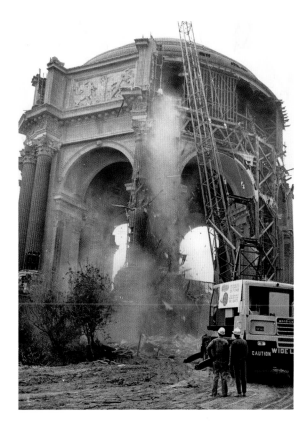

OPPOSITE *The Palace of Fine Arts Building was one of 10 palaces at the fair, including those of Agriculture, Transportation and the Liberal Arts.*

ABOVE *The Palace was torn down in 1964 and rebuilt on the original steel structure using casts of Maybeck's first building. It was given a seismic retrofit in 2009.*

363rd INFANTRY REGIMENT

In the photo above, members of the 363rd Infantry Regiment of the 91st Infantry Battalion pose in front of the Palace of Fine Arts on April 22, 1919, with their commanding officer Colonel Harry Cavenaugh. The next day the city of San Francisco feted the men with a parade on Market Street. Only San Franciscans made up the regiment, so San Francisco considered the 363rd its own.

After training at Fort Lewis, Washington, the regiment sailed for Europe, arriving in September 1918. The soldiers fought in four engagements—at San Mihiel, Lorraine (Aubreville), Meuse-Argonne and Ypres-Lys —until Armistice Day on November 11. After the parade, the Army deactivated the regiment at the Presidio of San Francisco and the men went back to civilian life.

A City Hall plaque also reminds us that in the three months the 363rd fought in Europe, it suffered 1,340 casualties, 360 men dead and 980 wounded. During the fighting they advanced some 21 miles into enemy territory. Sergeant Lloyd M. Seibert and First Sergeant Chester H. West led their men against machine gun nests that were holding up the 363rd's advance. Sergeant Phillip C. Katz spent his first day of battle rescuing wounded soldiers while under machine-gun fire, even though he also had been wounded. Seibert, West and Katz were each awarded the Medal of Honor.

Crocker Building DEMOLISHED 1966

William Crocker envisioned a great office building—the finest San Francisco had ever seen—as a monument to his father. He wished to thank his father for investing in his future, which provided him with the basis for his own career and wealth, Crocker National Bank. Under William's presidency the bank had grown and needed a new, larger, more impressive home. The result was one of Arthur Page Brown's masterpieces. He designed and built the Crocker Building for the sum of $1.4 million.

The magnificent building was dubbed the city's second skyscraper; second only to the Chronicle Building a block down Market Street, which went up in 1889 using the city's first steel-frame construction. The Crocker Building was the largest single structure west of the Mississippi at the time, and the building used significant tonnage of home-forged steel from San Francisco's Phoenix Iron Works. The design of the 11-story flat-iron building at Market, Montgomery and Post streets may have included the hand of renowned Bay Area architect Bernard Maybeck who joined Brown's staff in 1891.

Once the Crocker Building went up, Brown moved his architecture office to room 238. Many San Franciscans began to acknowledge that Brown's office brought an academic elite into the city. Besides Maybeck, notable architects of the day congregated in the Crocker Building, including Charles M. Rousseau, James A. Miller and Edward R. Swain. The team worked on commissions for the 1894 Midwinter Fair in Golden Gate Park, the 1893 World's Columbian Exposition, and permanent amenities at Golden Gate Park, including a carousel at the Children's Playground and a bridge at Stow Lake. Brown's best-known work, however, is the 1898 San Francisco Ferry Building standing today at the foot of Market Street.

OPPOSITE PAGE *Arthur Page Brown, who designed the Ferry Building, worked extensively for the Crocker family. William Crocker commissioned him to design the Crocker Building dedicated to his father. It was completed in 1891.*

ABOVE RIGHT *The robustness of the Crocker Building (far left) is evident in this post-earthquake photo. After the 1906 earthquake and fire, the surrounding area of Montgomery and Post streets was devastated.*

RIGHT *Six years later, in 1912, the opulent buildings at the intersection of Market, Post and Montgomery demonstrate how quickly the city recovered.*

The Crocker Building survived in the 1906 earthquake with William's Crocker National Bank on the ground floor; one of the few financial institutions remaining on its feet and able to provide financing for reconstruction. William himself provided financing as well as a new home for the Grace Cathedral in the form of his family's estate atop Nob Hill.

The Crocker Building survived geologic forces but couldn't survive economic forces. The city's second skyscraper was torn down in 1966 to make way for the Aetna office tower that opened in 1969.

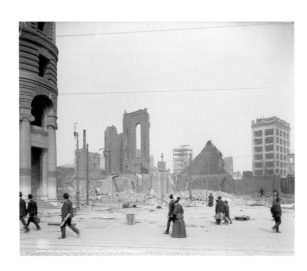

CHARLES CROCKER

In a way, powerful California railroad magnate Charles Crocker came full circle one day in 1886. While visiting the state of his birth, New York, the 64-year-old suffered an injurious carriage accident. The injuries he suffered resulted in his death two years later. Charles left his wife, Mary, in charge of his tidy $400 million estate. Soon after Charles died, Mary Crocker invited New York architect Arthur Page Brown to San Francisco to design her husband's tomb at Mountain View Cemetery in Oakland (above). Brown didn't exactly lack work designing to the tastes of the fabulously wealthy, but taking Mary's invitation and moving to San Francisco proved a historic career move. With $100,000 Brown created a somber Greek temple-like structure for the eternal resting place of the formidable Charles. In October 1889, just over a year after Charles died, and just as his tomb neared completion, Mary retired for her afternoon nap, never to awake. She was lain to rest alongside her husband. William Crocker, Charles and Mary's son, perhaps despondent over losing both parents, asked Brown to stick around and finish Grace Church, the nascent Grace Cathedral at Stockton and California streets. Brown also polished off the Old People's Home at Pine and Pierce streets he'd promised to build for Mary before her death. But William still desired more to memorialize the lives of Charles and Mary Crocker. The Crocker Building was a suitably grand monument.

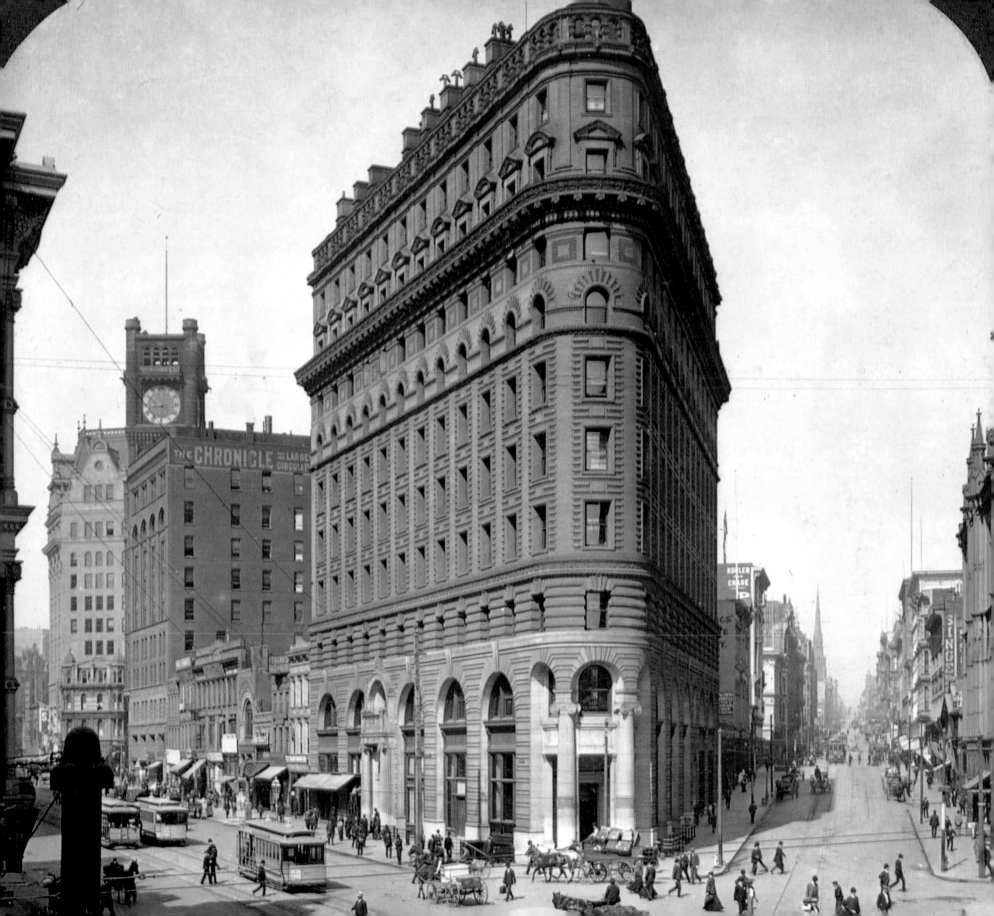

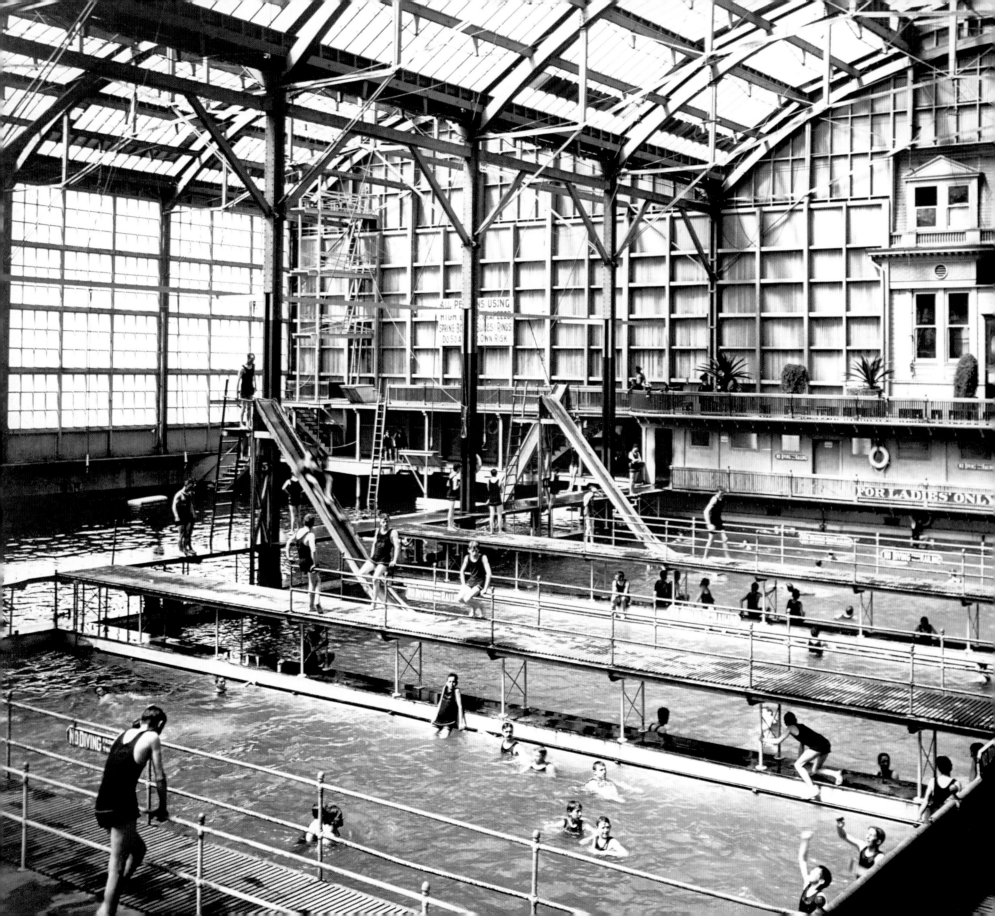

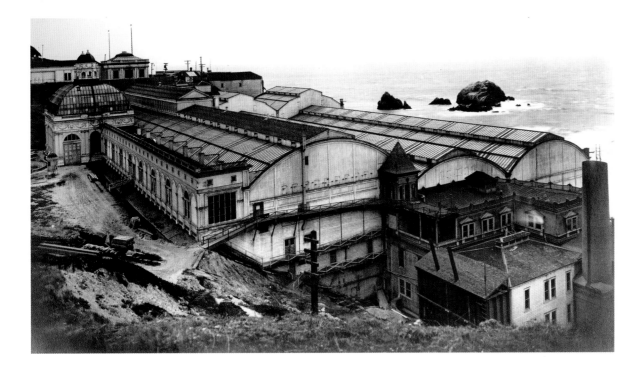

The Sutro Baths BURNED 1966

Adolph Sutro opened his eponymous baths in 1896, the same year he christened the second Cliff House. The baths were so famous that Thomas Edison visited the following year and filmed San Franciscans "taking the waters." The baths had seven swimming pools to accommodate up to 10,000 people at a time. All together, the pools held 1.7 million gallons of water and could be filled in one hour by high tides. The pools' waters were set at different temperatures, ranging in 10-degree gaps, from ice-cold to a steaming 80 degrees. Visitors could swing on trapezes, skim down slides, leap from springboards and soar through the air from a high dive. For a nominal rental fee, a swimmer could take the waters wearing one of the bath's 20,000 bathing suits and dry off with one of the 40,000 available towels. A visitor to the baths not only had a choice of the seven different swimming pools—one with fresh water and six salt water—but could also visit a museum displaying Sutro's extensive collection of artifacts from his travels; a concert hall, with seating for 8,000; and, for a period, an ice-skating rink.

The Sutro Baths were severely damaged by the 1906 earthquake. The glass walls proved too fragile for the temblor.

The baths struggled for years, mostly due to the very high operating and maintenance costs. In 1952, Sutro's grandson grew tired of losing money every year. He sold the baths to George Whitney, owner of Playland at the Beach, for $250,000. Whitney was not able to properly maintain the building's intricate pumping system and he closed the baths in 1966. That same year, the revered structure burned in what many called a suspicious fire.

A developer stepped in with plans for homes and a shopping center on the site. In 1980 the National Park Service put an end to these plans, purchasing the property for some $5 million and adding the site of the famous baths to the Golden Gate National Recreation Area.

OPPOSITE PAGE *An enormous glass structure encased the seven pools, which were filled with steam-heated sea water piped in from the Pacific.*

ABOVE *The Sutro Baths, which were built at the base of the rocks near the Cliff House, opened in 1896 and became one of the most sociable locations in the city.*

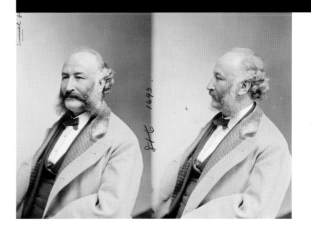

Hippies of Haight-Ashbury END OF AN ERA 1967

By the middle of the 1960s, the Haight-Ashbury neighborhood became the center of the San Francisco Renaissance and, with it, the rise of a drug culture and rock 'n' roll lifestyle that had firmly established itself in place of the fading Beat generation. College and high-school students began streaming into the Haight district during the spring break of 1967. San Francisco's government leaders, determined to stop the influx of young people once schools let out for the summer, unwittingly brought additional attention to the scene, and an ongoing series of articles in local papers alerted the national media to the hippies' growing numbers. By spring, Haight community leaders responded by forming the Council of the Summer of Love, giving the word-of-mouth event an official-sounding name.

The mainstream media's coverage of hippie life in the Haight-Ashbury district drew the attention of youth from all over America. Hunter S. Thompson labeled the district "Hashbury" in the *New York Times Magazine*, and the activities in the area made for good newsprint. During that year, the neighborhood's fame reached its peak as it became the haven for a number of top psychedelic rock performers and groups of the time. Acts like Jefferson Airplane, the Grateful Dead and Janis Joplin all lived a short distance from the famous intersection. They played gigs organised by Bill Graham at the Fillmore auditorium. They not only immortalized the scene in song, but also knew many within the community as friends and family.

During the Summer of Love, psychedelic rock music was entering the mainstream, receiving more and more commercial radio airplay. The song "San Francisco (Be Sure to Wear Flowers in Your Hair)," written by John Phillips of the Mamas & the Papas, became a hit single in 1967. The Monterey Pop Festival that year further cemented the status of psychedelic music as a part of mainstream culture and promoted Haight bands such as the Grateful Dead, Big Brother and the Holding Company, and Jefferson Airplane to national stardom. A July 7, *Time* magazine cover story on "The Hippies: Philosophy of a Subculture," and an August CBS News television report on "The Hippie Temptation" exposed the Haight-Ashbury district to enormous national attention and popularized the movement across the country and around the world.

END OF THE SUMMER OF LOVE

The now legendary Summer of Love attracted a wide range of people of various ages: teenagers and college students drawn by their peers and the allure of joining a cultural utopia; middle-class vacationers; and even partying military personnel from bases within driving distance. But by the end of the summer of 1967 Haight-Ashbury could no longer accommodate this rapid influx of people, and its scene quickly deteriorated. Overcrowding, homelessness, hunger, drug problems and crime became prevalent. Many people simply left in the fall to resume their college studies. On October 6, 1967, those remaining staged a mock funeral, "The Death of the Hippie" ceremony, to signal the end of the played-out scene. Mary Kasper, one of the mock funeral organisers, explained the event as follows: "We wanted to signal that this was the end of it, don't come out. Stay where you are! Bring the revolution to where you live. Don't come here because it's over and done with." That message was taken literally as the large crowds did not come back in the following years. The neighborhood, and in particular Haight Street, fell back into decline from the 1970s to the 1980s.

LEFT AND RIGHT *Customers peruse posters in the popular psychedelic poster shop, Print Mint, in the Haight-Ashbury district in July 1967.*

ABOVE *A psychedelic "Salvation Army" bus crosses an intersection in the Haight-Ashbury district during the Summer of Love, August 1967.*

TOP RIGHT *The symbolic "Death of the Hippie" parade on Haight Street, October 6, 1967.*

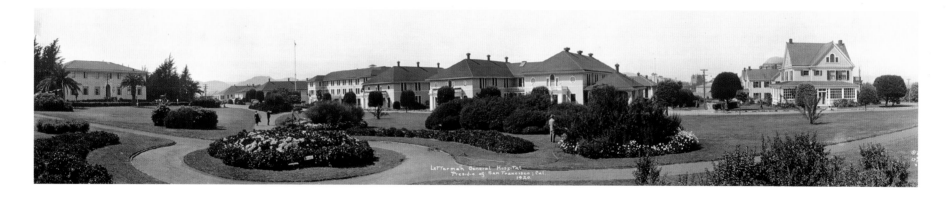

Letterman Hospital PARTIALLY DEMOLISHED 1970s

Between 1899 and 1902 the Army built the 300-bed Army Hospital at the Presidio to handle sick and wounded soldiers from the Spanish-American War. It served as the Army's base hospital for soldiers serving in Hawaii and the Philippines.

Covered corridors linked the wards, which wrapped themselves around a rectangular central green. On November 13, 1911, the Army renamed the facility to honor Major Jonathan Letterman, the medical director of the Army of the Potomac during the Civil War and the man some consider the founding father of military medicine. Today, 12 surviving buildings of this original complex survive and serve as the Thoreau Center for Sustainability.

By the time World War I drew to a close, Letterman Hospital was the Army's largest general hospital. It cared for many of that war's returning wounded. To deal with the influx, the Army built East Hospital, an orderly array of 21 frame buildings just west of the O'Reilly Avenue Parade Ground. According to Presidio Trust historian Randolph Delehanty, by 1921, Letterman had 56 permanent buildings and 29 temporary ones staffed by 41 medical officers, 58 nurses and 484 enlisted men.

In 1960, the Army began planning for a more modern hospital. The East Hospital was demolished and in 1969 a 10-story, 550-bed, reinforced concrete facility opened on the site. Two years later, the Letterman Army Institute of Research opened in four concrete buildings that Delehanty says housed research in artificial blood, laser physics, and the treatment of trauma.

Parts of the 1899 quadrangle were demolished in the 1970s to make space for housing for nurses and enlisted men; the remaining historic buildings housed support services. By the late 1980s, Letterman was serving retired military personnel and their dependents. The Army deactivated both the hospital and the research institute in 1994, when it turned over the Presidio, including the hospital grounds, to the National Park Service.

The 1969 hospital building came down in 2002. Three years later the Letterman Digital Arts Center opened on the site. The 23-acre office and digital production center consists of the George Lucas Educational Foundation, Industrial Light & Magic, Lucas Arts Entertainment Co., Lucas Online, Lucas Learning, and the THX Group.

RIGHT *Students of Katherine Delmar Burke School for Girls spent part of their day singing Christmas carols at Letterman General Hospital on December 21, 1954.*

TOP *This panoramic photograph shows Letterman General Hospital in 1920.*

BELOW *World War II army medics perform a gas attack drill at Letterman.*

Fleishhacker Pool & Bathhouse **CLOSED 1971**

Sitting briefly on San Francisco's Park Commission, businessman Herbert Fleishhacker bought the land and provided initial investment for a new playground and zoo for the city. He also paid entirely for a regulation-size (and temperature) pool. At 1,000 feet long, and 100 feet wide—with a 160-foot-wide section in the center—Fleishhacker Pool was the largest heated saltwater swimming pool in the world at the time. Some 5,000 people attended the opening, paying admission to the parks department.

Located near today's San Francisco Zoo, the pool pumped filtered salt water in from the ocean and then heated 2,800 gallons a minute until it reached 72 degrees Fahrenheit to qualify to host swim meets. The 6.5 million gallons in the pool were just too expensive to heat and the city kept looking for ways to cut expenses. *Tarzan* star Johnny Weissmuller frequently made appearances to race, dive or perform acrobatics, and the U.S. Army used the pool for stream fording practice.

As the decades passed, its condition steadily declined. A storm in 1971 damaged the intake and outflow pipes, resulting in a failed conversion to fresh water. The pool was closed that same year, as the city couldn't afford repairs. The pool was filled in, concrete removed, and the land ceded to the adjoining zoo, but the bathhouse remains to this day, in disrepair, a hidden enclave of the homeless. Fleishhacker himself left his bank in disgrace in 1938 after a couple of embarrassing judgments were filed against him, but the remainder of his life he spent as a philanthropist financier.

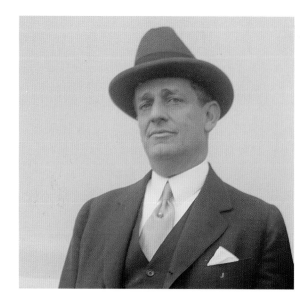

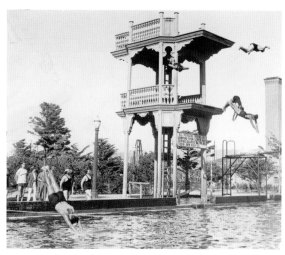

OPPOSITE PAGE *An aerial view of the pool, which at 1,000 feet long was once the biggest swimming pool in the United States—and one that took a lot of heating. In 1929 Herb started building the Fleishhacker Zoo next door.*

LEFT *A crowd gathers to watch competitive swimming at Fleishhacker Pool, which opened in April 1925, with the American Amateur Union men's swimming championship.*

ABOVE *Divers take the plunge from the two-tiered tower at Fleishhacker Pool. The pool was said to accommodate up to 10,000 bathers and needed 6.5 million gallons of seawater to fill it up.*

HERB FLEISHHACKER

Native San Franciscan, Herbert Fleishhacker (left) ate, drank and slept business. From humble beginnings as the bookkeeper in his father's paper business, Herbert took to traveling sales for the company, discovering on his way the sheer lack of a paper mill in Oregon. At Oregon City he took his first dive into business, creating the state's first paper mill (a success), followed by a lumber company in Eugene (a success), then he returned to California and built an electric power company (yet another success).

Next he set up the Truckee River and Sacramento Valley power companies. By the time he turned 30 he held interest in a dozen factories or companies. In 1905 he married May Belle Greenbaum, with whom he had three children. He divested himself of a number of his properties and turned his head toward finance in 1907. He took a position managing the London, Paris & American Bank of San Francisco, the wealthiest bank west of the Rockies—what better way to keep an eye on the fortune he'd just made? When the bank merged and reorganized, he bought himself a position as a vice president. By 1911, he was elected president. Herbert already sat as the president of two power companies and a railroad company, served as a vice president for four companies, and was a director on so many boards that biographers have difficulty listing them all. By the time 1915 rolled around, Fleishhacker sat in an ideal position to finance the Panama-Pacific International Exposition, a unique opportunity which clearly paid off as fair organizers wheeled the daily receipts right into his bank each night. With the power of his bank behind him, Fleishhacker invested in farming, mining, shipping, oil, hotels and cement. By 1925 he wanted to give something back. The Fleishhacker Pool was his gift to San Francisco.

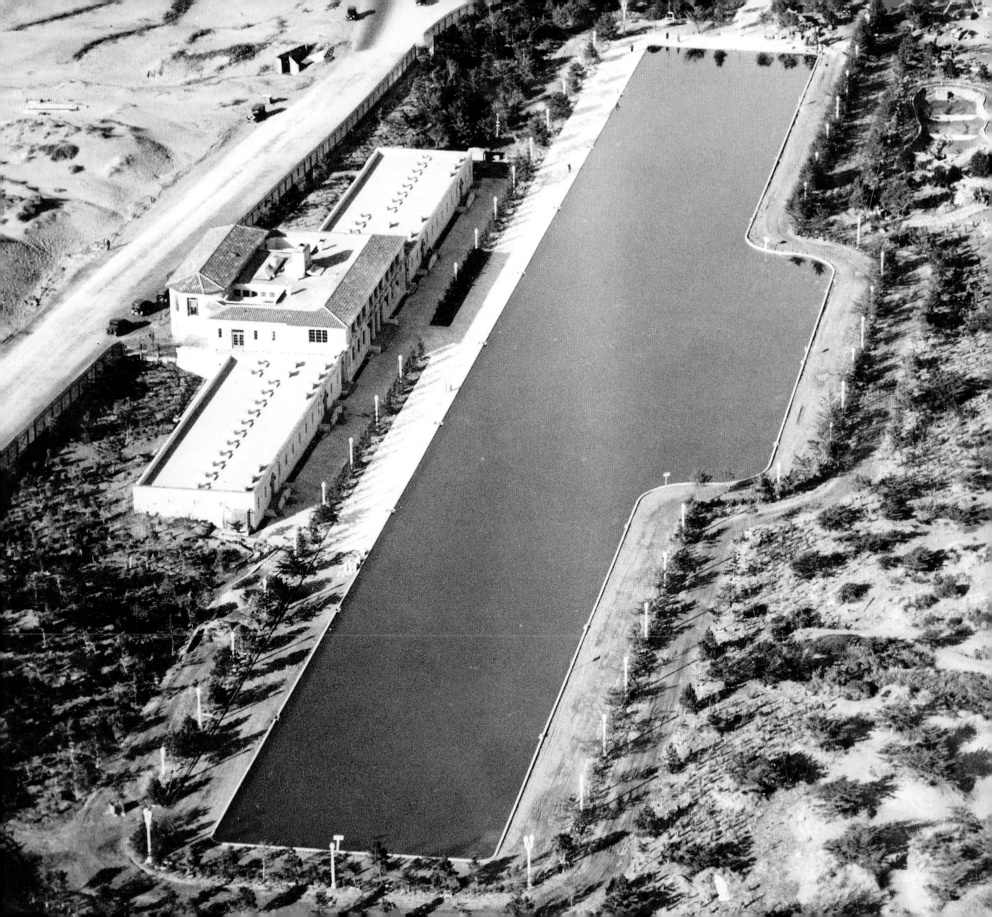

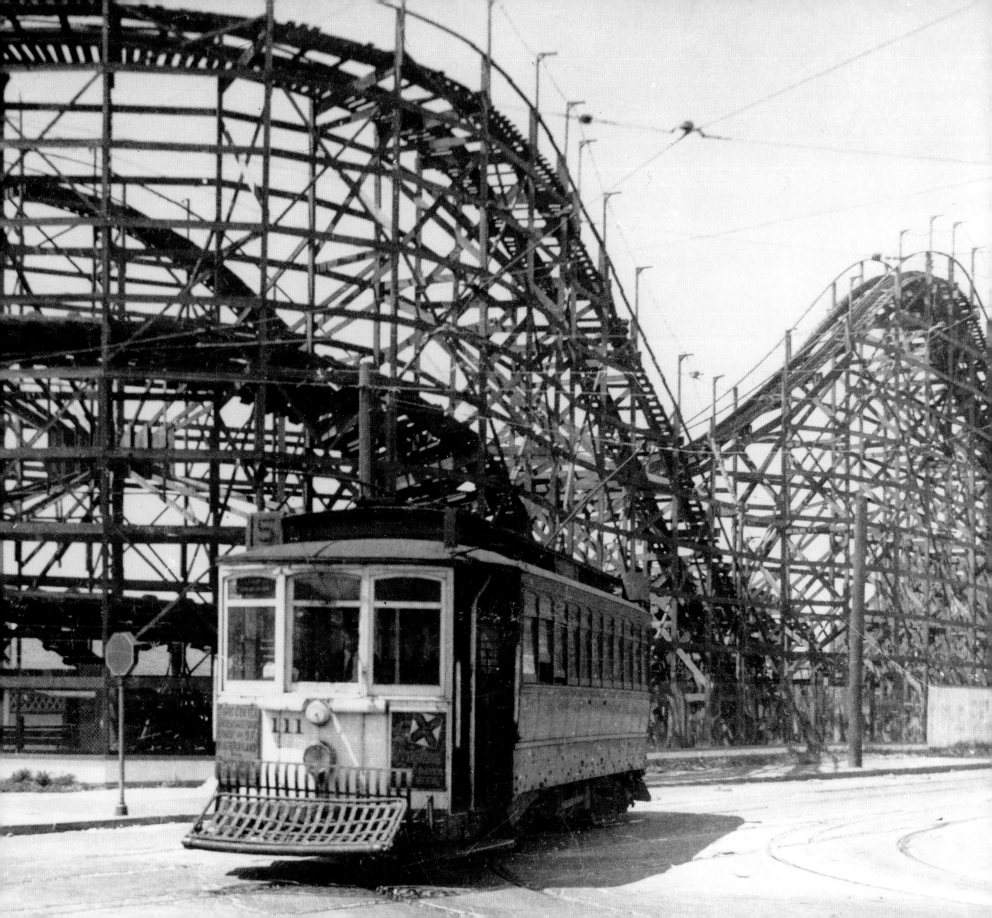

Playland at the Beach CLOSED 1972

Some 81 amusement parks across space and time have shared the name Luna Park. The carousel maker Charles Looff first used the name for the amusement park he designed at Coney Island. In Melbourne, Australia, a Luna Park opened in 1906 as part of Frederick Ingersoll's international amusement empire of 44 Luna Parks. George and Leo Whitney, Seattle-born Americans, made names for themselves at Melbourne's Luna Park. They had pioneered a quick-finish photography process that allowed visitors to take their photos home with them, rather than having to wait for a lengthy development process.

Leo did the photography and ran his own studio while George focused on the arcade and shooting gallery. The disruption of World War I sent the brothers separate ways for a time, but both could be found in San Francisco by 1923. Within a year they'd set up four shooting galleries and Leo's quick-finish photo gallery at Arthur Looff's Chutes-at-the-Beach.

By 1926, George Whitney took over management of the park at Ocean Beach and renamed it Playland at the Beach, or, as generations of devotees knew it, "Playland."

George invented a chocolate-covered ice cream treat called the "It's It" just for Playland in 1928. By 1929, he also owned and managed Topsy Roost, a "chicken shack" restaurant and nightclub next door to Playland.

By 1934 the park had grown to encompass four city blocks of arcades, shooting galleries, rides and five eateries. When individual concessionaires began to fail during the Great Depression, the Whitneys bought them out. By the 1940s, they had purchased the Looff carousel and Big Dipper and also the Cliff House in 1937. Other attractions included Laughing Sal, who greeted visitors waiting in line to enter the Fun House, its mirrored corridors echoing with giggles.

George Whitney came to be known as "the Barnum of the Golden Gate" as he promoted Playland far and wide while continuing to buy up attractions in the area. Longtime favorites had to come down after several decades of use: Shoot-the-Chutes disappeared in 1950 and the Big Dipper in 1955. By 1952, George had bought out Leo and added the grandest attraction of them all, Sutro Baths, to his holdings. Shortly after this, he passed away and left the park in the hands of his son, George Whitney, Jr., or "Junior," in 1958.

Junior and Bob Frazier worked the reins of Playland until the offers from seaside developers became too tempting. In September 1972, favorites like the Diving Bell, the Fun House, the Airplane Swing and Noah's Ark fell to the wrecking ball to make way for condominiums. Millions of memories forged in that four-block area live on today in San Francisco and elsewhere. Playland holds a mythical place in San Franciscans' hearts—an almost dreamlike sense of euphoria takes over as people describe their memories of the park. Across the Bay in El Cerrito, Richard Tuck, an amusement park aficionado and collector of Playland artifacts, created a museum to the former park, "Playland-Not-at-the-Beach" in 2008. Tuck, a local businessman, kept Playland alive, in a sense, recognizing the historic significance of the place and preserving what he could of the park's ebullient spirit. His museum offers playable pinball machines, artifacts and art of amusements long past. In a *San Francisco Chronicle* article, Tuck said, "With Playland, I've met adults who are 80, 90 years old—with a 12-year-old inside."

Tuck died in April 2011, but the spirit of both Playland, and Playland-Not-at-the-Beach, live on across the Bay in El Cerrito.

OPPOSITE PAGE *A streetcar parked in front of the giant rollercoaster at Playland at the Beach in 1940.*

BELOW LEFT *A staged publicity shot from 1938 featuring what Playland described as "electric automobiles."*

BELOW *A view of Playland from the Sutro Heights in the 1920s.*

BOTTOM *Children pose on the clown seat in front of the Mad Mine at Playland in September 1972, just days before it was demolished.*

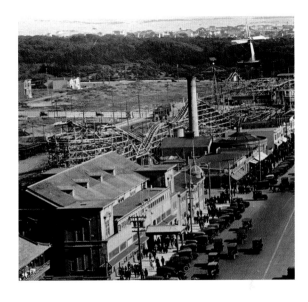

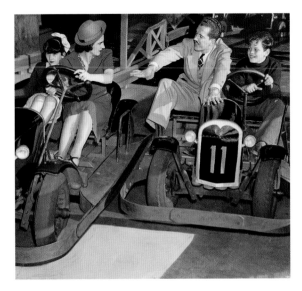

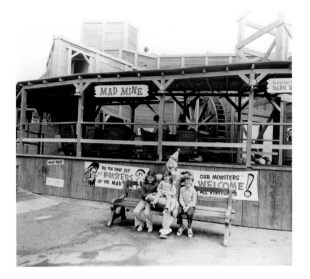

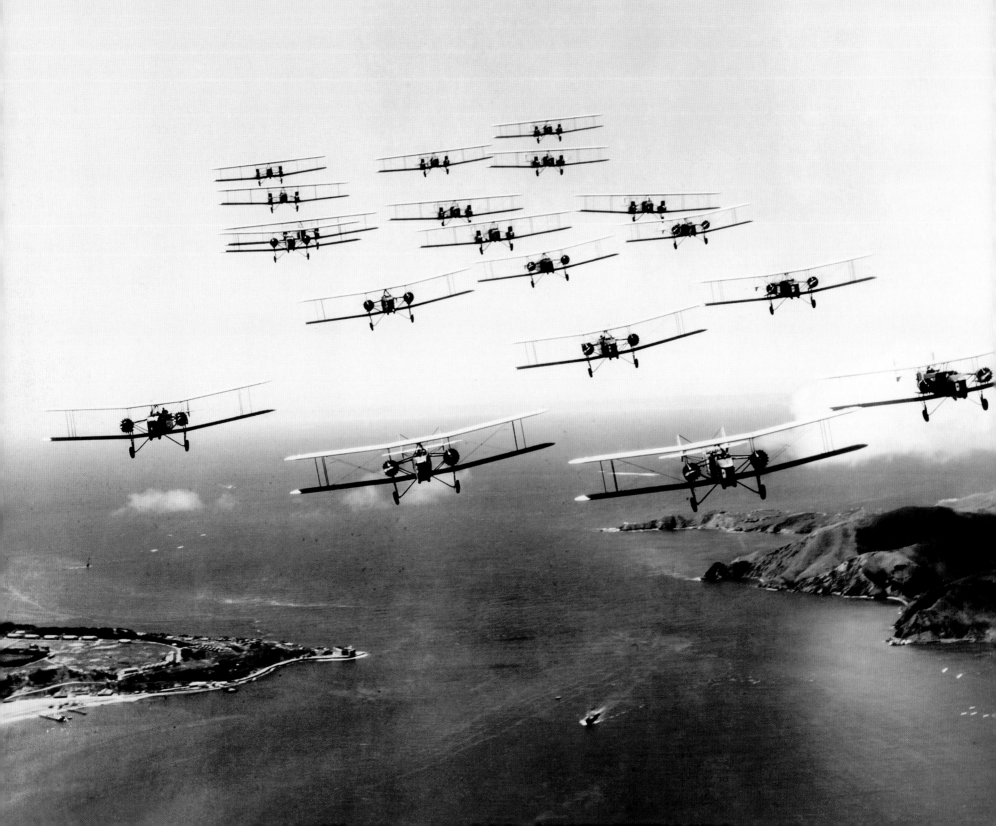

Crissy Field DECOMMISSIONED 1974

Crissy Field began life as the Flying Field at the Presidio. Largely due to the efforts of legendary pilot Henry "Hap" Arnold, the airfield was renamed to honor Major Dana H. Crissy, who crashed his plane and died on October 8, 1919, in Salt Lake City, Utah.

Crissy Field gained fame as the site of many early aviation milestones, including Farr Nutter and Ray Little's transcontinental flight that helped launch national airmail service. On August 21, 1923, the first day of the four-day demonstration of the transcontinental service, airmail pilot Claire K. Vance completed the westbound flight, landing at Crissy Field at 6:24 p.m. Crissy Field was also the terminus of the Air Service's "dawn to dusk" transcontinental speed flight on June 23, 1924 (see sidebar).

In 1925, two navy seaplanes took off from Crissy Field in the first attempt to fly from the continental United States to Hawaii. Expected to last 26 hours, the trip took 12 days and was only partially completed by one plane, whose crew had to be rescued at sea. Two years later, army lieutenants Lester J. Maitland and Albert F. Hegenberger flew non-stop from Oakland to the islands aboard a three-engine Fokker "Bird of Paradise."

The coming of the Golden Gate Bridge in 1936 was the beginning of the end for Crissy Field's life as an airport. In 1936 some of Crissy Field's traffic was diverted to Hamilton Field in Marin County, safely away from the bridge.

Crissy Field took on a new role on the eve of America's entry into World War II. The U.S. Army established a secret school at Crissy Field to teach Japanese. Classes began in an abandoned airplane hangar on November 1, 1941, with four instructors and 60 students

In the years after World War II, the Sixth Army Flight Detachment operated light airplanes and helicopters from Crissy. In the 1960s "Crissy Army Air Field" traffic consisted primarily of liaison and Med-Evac flights that brought soldiers wounded in Vietnam from Travis Air Force Base near Sacramento to Letterman Hospital at the nearby Presidio.

The airfield operated until 1974. Its closure left San Francisco County as the only California county without an airport. (San Francisco International Airport is in San Mateo County.)

AVIATION HISTORY

The first successful dawn-to-dusk transcontinental flight ended at Crissy Field and helped secure the airfield's place in aviation history. On June 23, 1924, Lieutenant Russell Maughan took off from Mitchel Field on Long Island, New York, at 3:58 a.m. He landed at Crissy Field some fifteen hours later at 9:46 p.m. in front of 50,000 spectators. Maughan flew through rain and fog on the first leg, averaging 135 mph and reaching McCook Field in Dayton, Ohio at 8:10 a.m. He encountered thunderstorms between Dayton and St. Joseph, Missouri, but reached Saint Joseph without incident. Maughan then flew to North Platte, Nebraska. On the next leg, he encountered a strong headwind and landed at the airmail field adjacent to the Bonneville Salt Flats at 6:30 p.m. Clouds made the last leg of the flight difficult. Maughan knew the terrain from Utah to San Francisco well. He recognized enough landmarks to approach San Francisco from the north and used a light on Alcatraz to guide him to Crissy Field, where he touched down at 9:46 p.m.

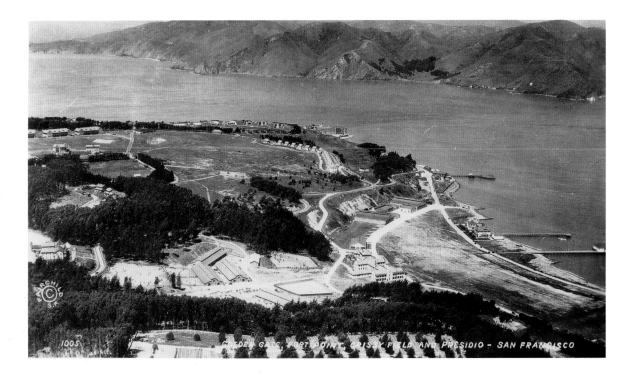

OPPOSITE PAGE *A squadron of Keystone LB-7 medium bombers, of the 15th Photo Section out of Crissy Field, in formation over San Francisco Bay in 1930.*

LEFT *Fort Point, Crissy Field and the Presidio looking toward the Golden Gate.*

BELOW *Bombers over Crissy Field in 1933.*

Southern Pacific Station DEMOLISHED 1975

In the nineteenth century, the railroad meant modernity, prosperity, even survival for some California towns. Exhausted from the dry, dusty manure-strewn roads, taxpayers in San Francisco, San Mateo and Santa Clara counties promised to split the cost of a railroad with a company of railroad builders. The contract created the San Francisco & San Jose Railroad, the city's first railroad, in 1863. The first terminal sat at Market and Valencia streets, but as the line extended, the station moved further downtown to Brannan, between Third and Fourth streets.

The San Francisco & San Jose Railroad Company was consolidated into the Southern Pacific Railroad (SP) in 1870. In 1875, the terminal was relocated to Fourth Street and in 1912, SP joined the city's rebirth with a new two-story, 14,000-square-foot Mission Revival-style terminal at Third and Townsend. The *San Francisco Chronicle*

interviewed railroad officials who assured the populace that the essential passenger depot serving the city would be ready in time for the Panama-Pacific International Exposition in 1915. According to the passenger traffic manager, Charles S. Fee, "on the first floor will be located the waiting-rooms and the main entrance to the waiting-rooms will be from Third street, with another entrance from Townsend street. From the waiting-rooms will be open compartments for telephone and telegraph service, a news stand, women's retiring room and men's lavatory. In the latter there will be both free and pay service, a system in vogue in Eastern passenger stations and now applied here for the first time." Indeed, the depot was ready for the exposition.

Passengers waited on five platforms serving 11 tracks and along the way they were enlightened by frescoes of mission scenes depicting the early

settlement of California, in resonance with the building's architecture. The magnificent Mission-style railroad terminal was the pinnacle of modern travel. Along with hundreds of streetcars, cable cars, automobiles and horse-drawn jitneys, the railroad was able to handle the crowd of about 8.6 million visitors to the 1915 Expo with ease.

To celebrate the grand new building's arrival, SP ran the "Mission Line" that visited nearly all of the historic California missions in the chain. However, the rise of the automobile spelled the demise of this icon when plans were hatched to connect I-280 with I-80 five decades later. While the highway was never built, the station still paid the ultimate price. In 1975 the dilapidated station, after some restoration effort, fell to the wrecking ball. A shelter considered temporary at first, replaced it at Fourth and Townsend the following year. In almost a coup de grace over the railroad, the empty space that was once the elegant station temporarily became a trailer park.

Ridership had reached an all time low on the SP lines in the early 1970s, and the company petitioned the counties to abandon service altogether. The three counties that originally built the San Francisco and San Jose Railroad line all stepped up again and agreed to subsidize passenger fares to ensure service continued. New ticket pricing stimulated ridership and set the stage for the state-run Caltrans to take over the line in 1980. Recently, the area has found new life through redevelopment around AT&T Park. Townsend was renamed King Street and a statue of Willy Mays in front of AT&T Park can now "Say-Hey" to San Francisco Giants fans gathering before games in the vicinity of the old train station.

OPPOSITE PAGE *The handsome Southern Pacific Railroad Station at Third and Townsend streets, pictured in the early 1950s, came face to face with the wrecking ball in 1975.*

LEFT *The Mission Revival style building photographed in August 1963.*

City of Paris DEMOLISHED 1981

That fateful discovery in the glittering hills of California in 1848 created and destroyed countless fortunes in the years after, but it certainly wasn't the miners' fortunes that lasted. Felix Verdier arrived first in 1850 with a ship he'd chartered christened *Ville de Paris* or "*City of Paris.*"

Felix made stockings in Nîmes, France and understood his countrymen all too well. If thousands of Frenchmen were heading to California to dig for gold in the middle of nowhere, they'd be desperate for certain fineries. So he filled his craft with lace, fabrics and wine.

His cargo didn't even reach dry land before it was sold to miners that rowed right up to the *City of Paris* and bought it all. Without delay, Felix returned to France and filled up another boat, and this time brought his brother Emile along. The brothers set up a permanent store on Kearney Street in 1851. They christened the store City of Paris, hoping it would emulate the success of their ship. They also took the ship's motto: *Fluctuat nec mergitur* ("It floats and never sinks").

The store moved to an exemplary Beaux-Arts commercial building by architect Clinton Day at Geary and Stockton streets on Union Square in 1896. Under the leadership of later generations of Verdiers, the store flourished and had branches throughout the Bay Area, but the Union Square location remained the main store.

In 1906 the building withstood some repairable damage from the earthquake, but the fire laid waste to the place. By 1909, under the passionate leadership of Paul Verdier, the store was rebuilt and reopened with greater grandiosity. Now six stories, the centerpiece of the new building was its rotunda with a stained-glass representation of the *Ville de Paris* ship that inspired it all. Paul Verdier searched the world over for the finest goods to bring to the city he felt deserved the world's best.

He designed the store as a set of specialty shops, with the family's storied specialty, lace, being a focal point. San Franciscans relied on the store for everything the modern woman needed: an endless array of fabrics, decorative objects, silk stockings, hats and other fashions, handheld mirrors and clocks.

Paul worked long and hard until his death in 1966. After more than 120 years of success, the Verdier family fell on hard times and the City of Paris Dry Goods Co. declared bankruptcy in 1972. The operation was reopened by another company as the Liberty House at the City of Paris for a time until it was sold to Neiman Marcus. The new owner planned a new building for their prestigious Union Square location. In 1980, the idea of losing the building designated as a City and National Landmark upset many longtime residents. Regardless, the store fell to the wrecking ball the following year.

While the new Neiman Marcus was built in its place, parts of the original building, most notably the dome, were preserved in the new design. Some 2,600 pieces of the original rotunda were restored in Massachusetts. When it returned to San Francisco in 1982, the dome was given a new place of appreciation in the store: in the restaurant just 100 feet from its original site. The hopeful motto still proclaims in Latin: *Fluctuat nec mergitur* as the *Ville de Paris* sets sail for its new home in the golden state.

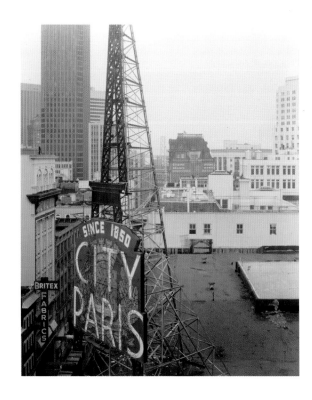

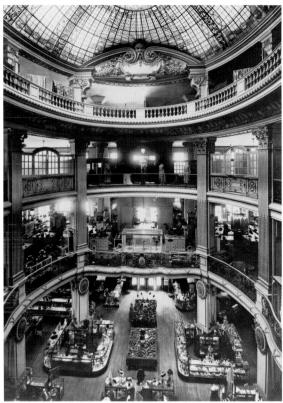

OPPOSITE PAGE *The City of Paris department store, a San Francisco institution, photographed in 1979. Despite its listing on the National Register of Historical Places and its designation as a California Historical Landmark, the store was demolished in 1981.*

ABOVE RIGHT *A replica Eiffel Tower helped prop up the store's illuminated sign for many years.*

RIGHT *The rotunda looking north, circa 1920.*

LEFT *A detail of the fabulous glass dome that once soared above the rotunda, but has since found a new home in the replacement store.*

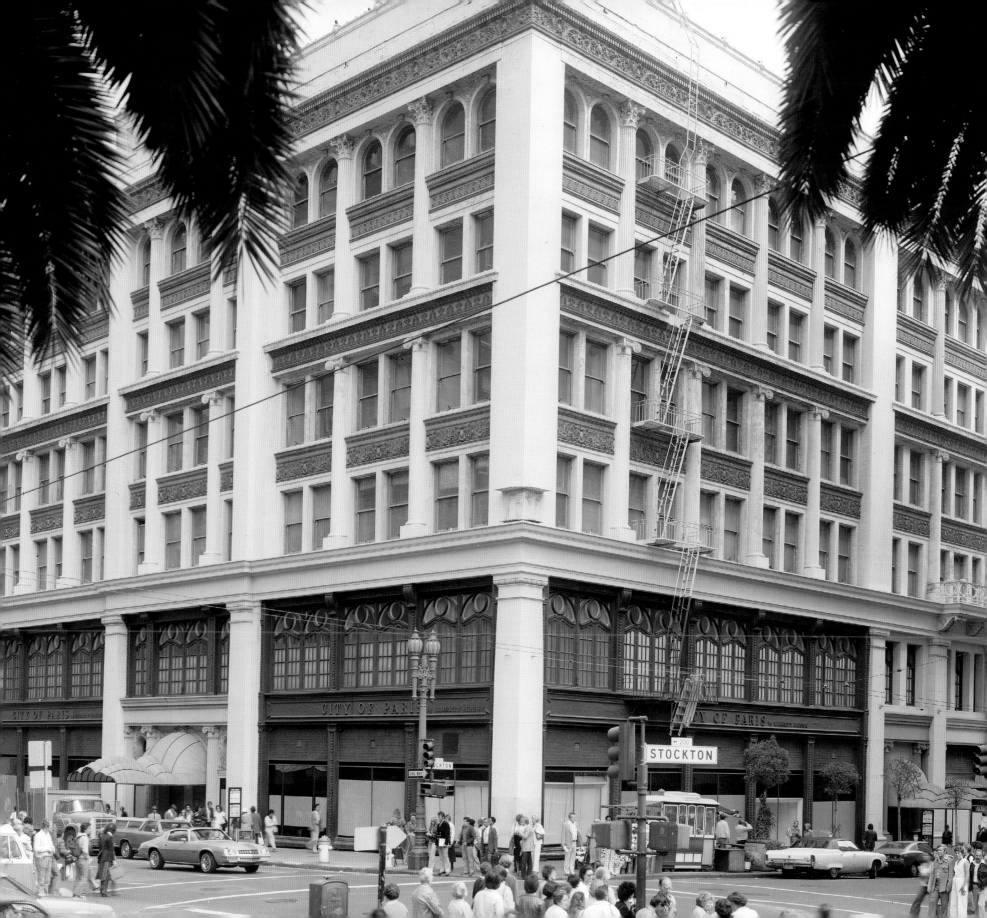

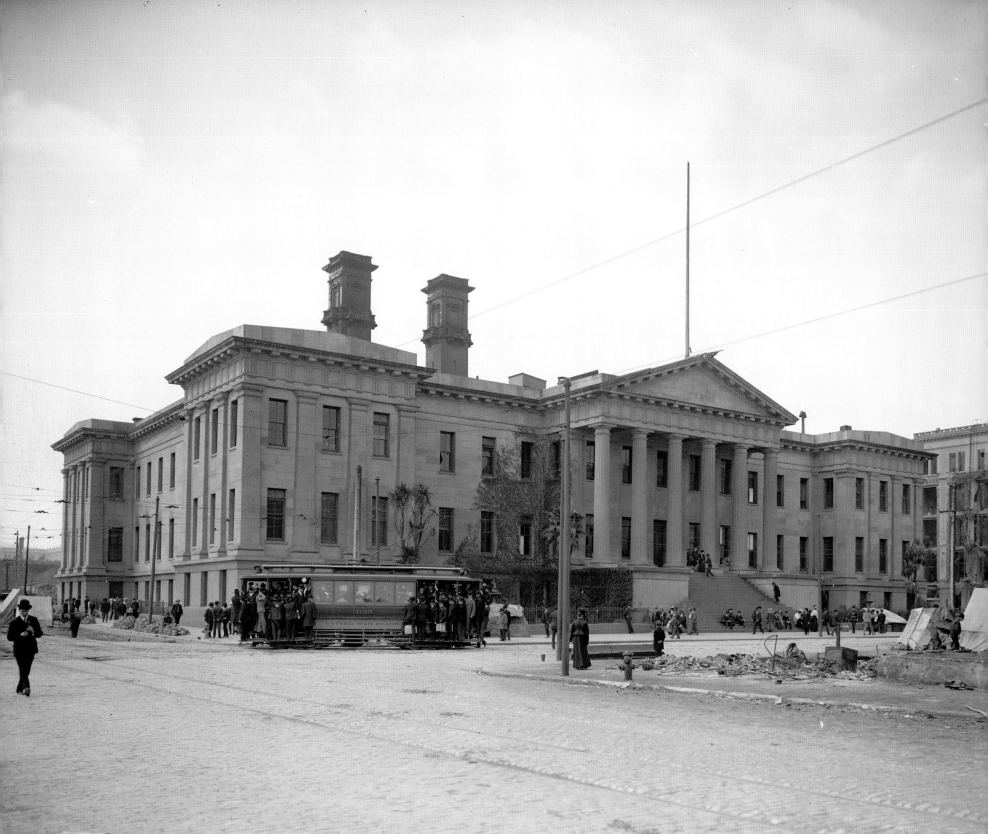

019231. U.S. MINT AFTER THE EARTHQUAKE, SAN FRANCISCO, CAL.

U.S. Mint CLOSED 1988

Four years after California became a state in 1850, President Millard Fillmore recommended that a branch of the United States Mint be established in California. The United States Congress authorized the mint on July 3, 1852. California's first branch mint opened on April 3, 1854 at 608–610 Commercial Street in San Francisco. This mint originally stood just feet from the shores of Yerba Buena Cove near the Long Wharf. From April 3 to December 31, 1854, the mint produced $4,084,207 in gold pieces. Until the mint opened, men like David Broderick and J.G. Kellogg made fortunes turning out, for example, $20 gold pieces containing just $16 worth of gold. Kellogg's coin looked strikingly similar to legitimate coins. However, closer inspection would reveal "Kellogg & Co." instead of the word "Liberty," and "San Francisco, California" in place of the "United States of America." In order to strike "legal tender," the federal government had to ship the gold to its mint in Philadelphia.

In 1869 architects of the Treasury came to town and work began on a second mint building at Fifth and Mission streets. A. E. Mullet designed the building, which resembled a Greek temple. Granite from Rocklin California formed the building's base and the upper floors' brick masonry walls were faced with blue-gray sandstone. Mullet's building was designed on a concrete and granite foundation to prevent tunneling into the building's vaults.

The finished building opened in 1875, and coin production at the mint went on uninterrupted until April 18, 1906, when the Great San Francisco Earthquake and Fire struck. Mint employees and soldiers stood fighting the fire around the building with a one-inch hose for seven hours.

When the temblor struck, the building held some $300 million, fully a third of the United States' gold reserves. The sandstone façade and thick iron shutters fortunately made the building practically impervious to fire. After the earthquake the building became the treasury for disaster relief funds and served as the city's emergency bank. Coining operations resumed soon afterward and continued until 1937, when the mint workers moved to a larger, more modern facility on Duboce Avenue at Hermann Street.

The building was repurposed several times (see boxed text) before the assay office finally closed in 1988, ending the Mint's service to the public.

OPPOSITE PAGE *It's standing room only on the streetcar crossing the front of the U.S. Mint building on Mission and Fifth streets in 1906.*

ABOVE RIGHT *Pulling further back from the main photo it becomes apparent how close the building came to the devastation in the Great Fire and Earthquake of 1906.*

BELOW *Buses have replaced streetcars in this 1958 photo of the building.*

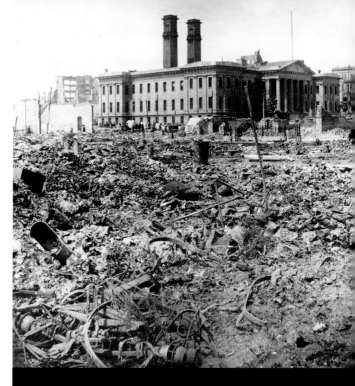

CITY BUYS MINT FOR A BUCK

After 1937, the Treasury Department and other government agencies occupied the "Old Mint" building at Fifth and Mission streets. In 1961 Mullet's building was designated a National Historic Landmark. Eight years later, the building was declared government surplus and San Francisco State College requested its use as a campus. However, the government decided to preserve the building for court offices and a museum. The building was partially restored, and in 1972 the Old Mint Museum opened in the building's eastern wing. The Treasury Department used the rest for offices. In 1994 the Treasury Department planned to close the building permanently because it did not wish to make costly seismic upgrades. Senators Barbara Boxer and Dianne Feinstein stepped in and managed to keep the building open until December 30, 1995, when the building became property of the General Services Administration. In 2003 the federal government sold the structure to the City of San Francisco for one dollar. The city paid with a silver dollar that had been struck at the mint in 1879. The building is currently vacant.

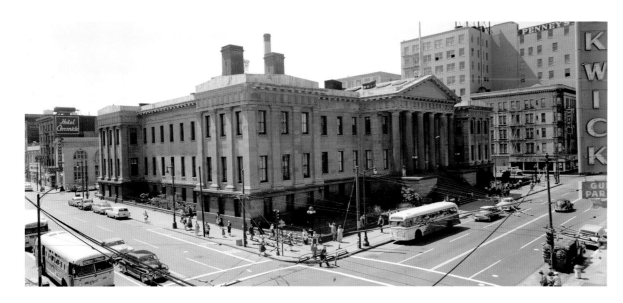

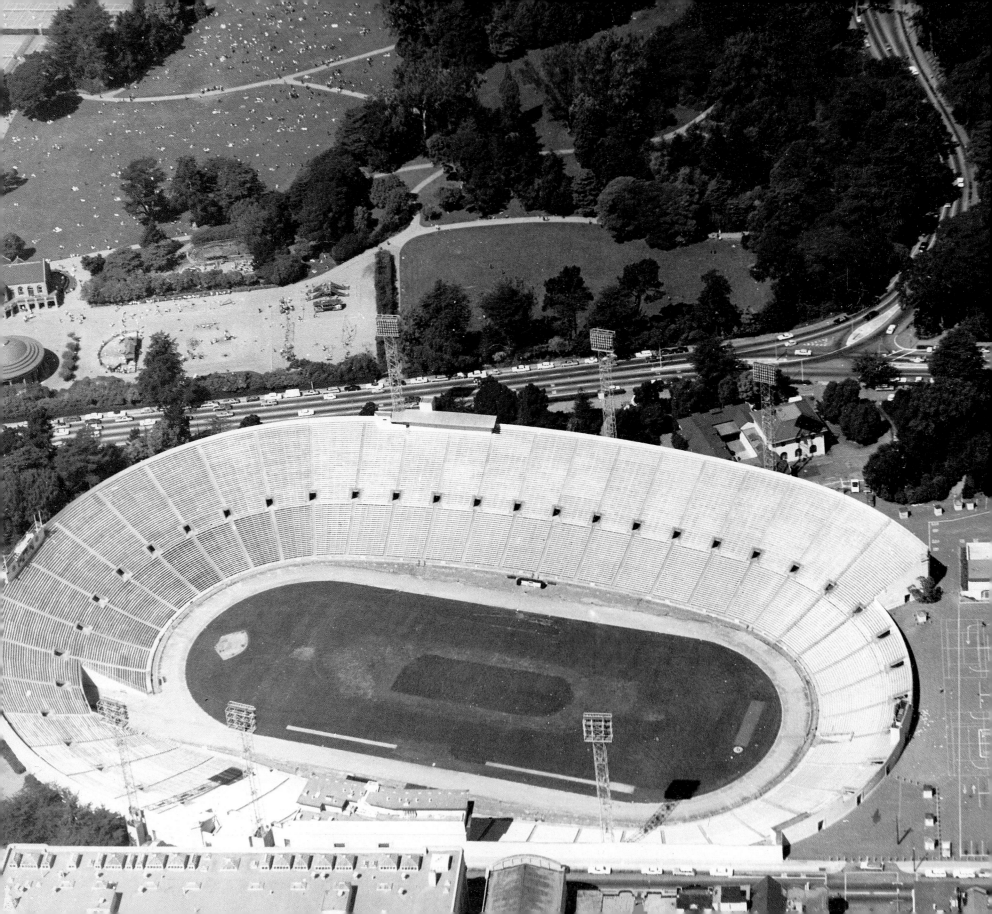

The "Old" Kezar Stadium DEMOLISHED 1989

Who knew he played football? On December 26, 1927, George Herman "Babe" Ruth, Jr. kicked off in the inaugural East-West Shrine College All-Star Football Game played each year at Kezar Stadium in San Francisco. The West won the football game 16-6. Today, the game is played at Stanford Stadium. That same year the Sultan of Swat hit his most-in-a-season record-setting 60th home run.

Three years earlier, in 1924, the city's park department received a $100,000 gift from Mary Kezar, who wished to create a memorial to her mother and uncles who were early San Francisco settlers. The Park Commission raised an additional $200,000 for the creation of a 59,942-seat stadium in Golden Gate Park. The stadium took just one year to complete and on its opening day, May 2, 1925, a two-mile foot race was held.

During the 1930s the stadium provided the venue for endless entertainments: track and field meets, auto races, motorcycle races, baseball, boxing, rugby, cricket and more. At this time, at least three local schools used Kezar as their home field.

As of 1946, Kezar Stadium hosted the National Football League's San Francisco 49ers. Some might say San Francisco owes its professional football tradition to the head of a lumberjack business, Anthony J. Morabito. For years Morabito lobbied the NFL to sponsor a San Francisco football team. Finally Tony's efforts paid off, and the 49ers first season began on September 8, 1946 when they played the New York Yankees. Of the eight teams that took the field for the All-American Football Conference in 1946, only San Francisco and the Cleveland Browns retain their original city and mascot combination.

By 1960, San Francisco played as part of the National Football League, while an upstart franchise called the Oakland Raiders, from across the Bay, signed up for the American Football League. Oakland played just its first year in Kezar Stadium before perennial owner Al Davis opened the Oakland Coliseum. The 1966 reorganization merged the NFL and AFL to create the NFL we know today.

The 49ers continued to play at Kezar until 1971 when they moved to the more expansive Candlestick Park. But it wasn't just fun and games at Kezar. In 1967 some 100,000 people marched from San Francisco city hall to Kezar to protest against the Vietnam War and hear Vietnam vet David Duncan

speak. Kezar also played host to a parade of concert performers that includes many rock icons of the 1960s and 1970s. The stadium even got to feature in the 1971 movie *Dirty Harry* with Clint Eastwood. Who could forget the scene on Kezar's field under the night sky as Harry extracts information at gunpoint from the stadium manager and villain, Scorpio?

Rarely does the onset of an American earthquake get broadcast live on television internationally. The Loma Prieta 6.9 earthquake interrupted a World Series game between the San Francisco Giants and the Oakland Athletics at Candlestick Park on October 17, 1989. As fans left the barely damaged stadium, disappointed the game had been halted for a structural review of the stadium, they had little knowledge of the destruction wrought on their city. The city's other stadium, Kezar, far across town, suffered extensive damage and had to be demolished. The smaller, 9,044-seat stadium, which replaced it, now plays host to a number of soccer teams and provides an all-weather track and sports field for recreational use. As in the past, local universities continue to make use of the new facility's field.

OPPOSITE PAGE *This 1968 aerial view of Golden Gate Park highlighted Kezar Stadium and the Children's Playground next door.*

BELOW LEFT *Kezar Stadium played host to fans of both the Oakland Raiders and the San Francisco 49ers.*

BELOW *Girls representing the Selma High School step out at Kezar Stadium in December 1963 to start "the parade of youthful beauty" that marked the annual East-West game.*

Hunters Point CLOSED 1991

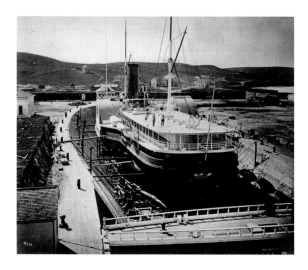

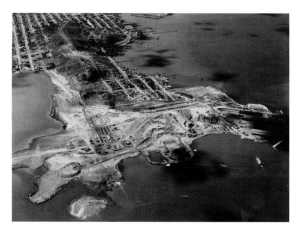

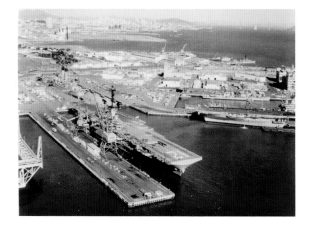

India Basin and South Basin define Hunters Point, which lies on San Francisco Bay, just to the north of Candlestick Point, where the San Francisco 49ers play football. India Basin—once home to an extensive collection of dry docks and shipyards—got its name from the India Rice Mill Company, whose ships once docked there. It was at India Basin that shipwrights built author Jack London's ship, the *Snark*, as well as the scow schooner *Alma*, which is now on display at Hyde Street Pier.

Hunters Point itself bears the family name of three brothers who settled there: Robert, Philip and John Hunter. In 1867, the point gained importance as the first permanent dry dock on the Pacific Coast. The following year, the California Dry Dock Company hired Alexis von Schmidt to build its facilities. On October 22, 1868—the day after the "Great San Francisco Earthquake"—the side-wheeler *Ajax* became the first ship to dock at Schmidt's creation. The following month, an article in the *San Francisco Chronicle* described the successful docking of Pacific Mail Steamship's Company's side-wheel passenger steamer *Colorado*, boasting about the dry dock builders' ingenuity.

By 1892 some 1,500 men were working at Hunters Point, whose shipyards were bringing in between $2 million and $4 million a year. At the turn of the twentieth century, the San Francisco Dry Dock Company owned the shipyard; the enterprise had grown to accommodate some 3,500 workers. On February 3, 1903, the USS *Ohio* tied up as the first visitor to the company's brand-new Dry Dock No. 2. At the time of its construction, it was the largest graving dock on the Pacific Coast.

President Theodore Roosevelt's Great White Fleet arrived in San Francisco in 1907. Before the fleet continued its round-the-world odyssey it was repaired at Hunters Point. Union Iron Works serviced all 23 vessels in the fleet in the record time of 27 days. The feat so impressed the Navy that it investigated acquiring the point as a shipyard.

By 1917 the oldest dry dock had fallen into disrepair and Dry Dock No. 3 was built in its place. The new dock, which incorporated parts of the original Dry Dock No. 1, became one of the largest dry docks in the world.

Hunters Point had been home to a community of Chinese shrimp fishermen and their families. The fishermen arrived in 1870 and stayed there until the late 1930s, when development along the bay shore, and the pollution that came with it, spelled the end of the shrimp industry. The Navy evicted the Chinese to make way for the Hunters Point Navy Base.

In 1939, the Navy purchased 47 acres for $3,993,572 to build Hunters Point Shipyard, which it operated from 1939 until 1976. At its peak, the shipyard employed nearly 18,000 workers. Many of the employees lived in nearby Bayview-Hunters Point, which the Navy took over in 1942. After the Navy left, Triple A Machine Shop Inc. leased the shipyard and used it as a commercial ship repair facility for 10 years.

In 1980 artists began renovating some of the buildings at Hunters Point. "The Point," as it is known, is now home to a large artist community. The shipyard has 936 acres: 503 on land and 433 under water.

In 1991, the Navy closed its Hunters Point facility and divided it into six separate parcels to facilitate its cleanup and reuse. The Navy remains responsible for locating all polluted areas in each parcel and creating an appropriate clean-up plan.

RIGHT *The massive 16-inch guns of the USS Iowa were the same caliber as those installed in the Panama Mounts at Fort Funston. This photograph shows the ship being refitted in Dry Dock No. 4 in 1945.*

TOP LEFT *A paddle wheel steamer in dry dock at Hunters Point in 1867.*

MIDDLE LEFT *This aerial view from August 1942 shows Hunters Point during the rapid phase of development early in World War II. Excavations had begun for Dry Dock No. 4.*

BOTTOM LEFT *The USS Hornet berthed at Hunters Point in 1966. The Hornet participated in two major events in U.S. history—World War II and the Apollo missions—and is now a floating museum in Alameda.*

INDEX